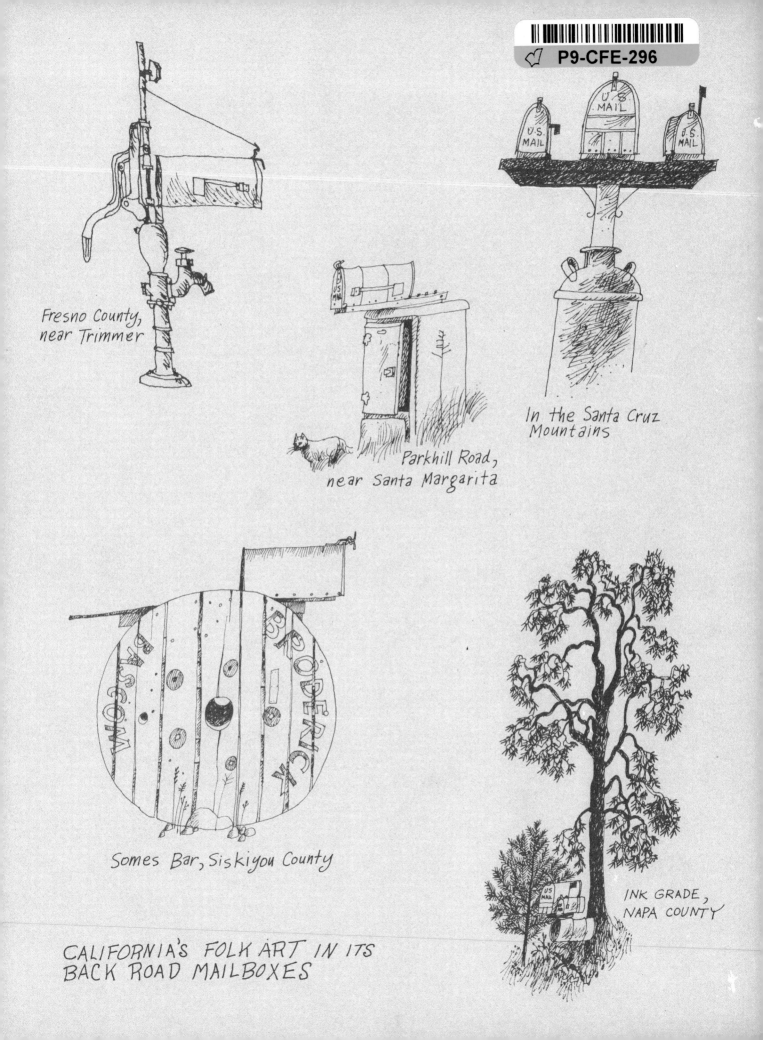

Fresno County, near Trimmer

Parkhill Road, near Santa Margarita

In the Santa Cruz Mountains

Somes Bar, Siskiyou County

INK GRADE, NAPA COUNTY

CALIFORNIA'S FOLK ART IN ITS
BACK ROAD MAILBOXES

BACK ROADS of California

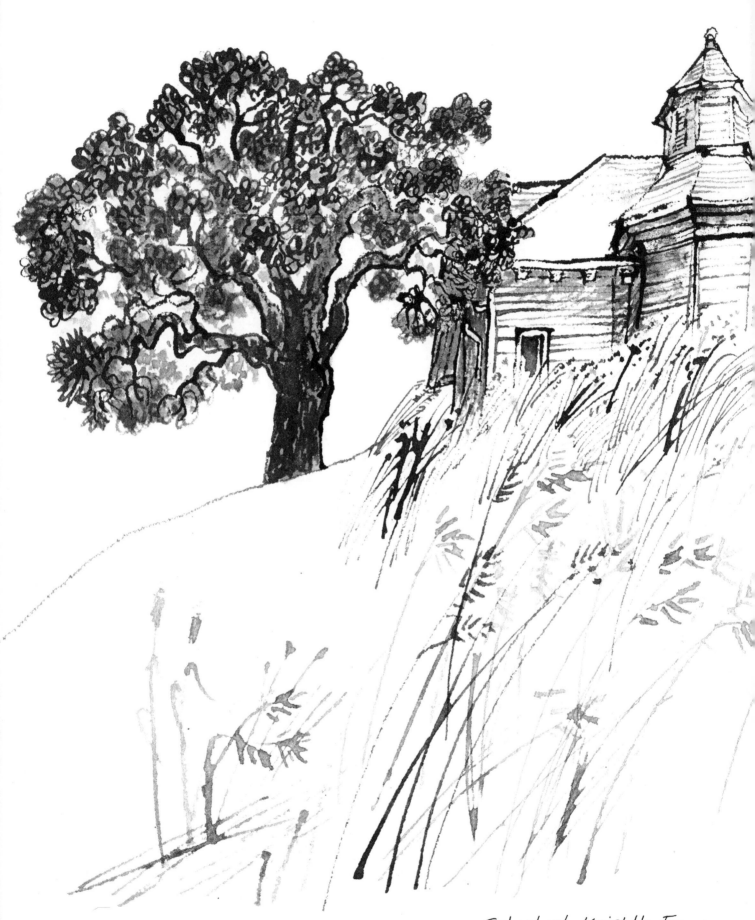

School at Knight's Ferry

Sunset

BACK ROADS
of California

Sketches and Trip Notes by EARL THOLLANDER

Supervising Editor: JACK McDOWELL

Special Travel Features: *Dorothy Krell*
Graphics: *John Channing Rudd*
Regional Maps: *Joseph Seney*
Layout and Travel Research: *Carol Goforth*

LANE MAGAZINE & BOOK COMPANY, MENLO PARK, CALIFORNIA

ENJOY THE ROADS!
DON'T RUIN THEM FOR OTHERS.

DON'T LITTER. DON'T TRESPASS
ON POSTED PROPERTY. DON'T
DAMAGE FENCES OR LEAVE GATES
OPEN. DON'T PICK CROPS
...
DRIVE CAREFULLY!

This book was lithographed and bound by Graphic Arts Center, Portland, Oregon, from film prepared in their plant. Type is Optima, composed by Atherton's Advertising Typography, Inc., Palo Alto, California. Paper for the body is Lane Offset Book, Handmade Finish, made by Northwest Paper Co., Cloquet, Minnesota.

Seventh Printing September 1975

Executive Editor, Sunset Books: David E. Clark

Front Cover: *View from Franz Valley Road, north of Santa Rosa.* Back Cover: *Honey Run covered bridge, east of Chico.*

ANOTHER WAY TO GET THERE

Freeways, highways, and parkways weave a busy fretwork of travel corridors over the face of California. A straight-line course is the thing today; but the shortest distance between two points is not always the most pleasurable way. Roundabout, alternate roads in the West have for several years been reported on by *Sunset Magazine,* and this book is an outgrowth of that reporting. It is a careful sampling of some of California's most interesting back roads and leisurely side trips.

A good many of those trips are over nicely paved thoroughfares paralleling main highways. Others take off on unimproved, tortuous routes whose charm is in their ruggedness. Most back-road adventurers derive great pleasure in exploring such little-known places and they delight even in occasionally getting lost. Because the maps in this book are intended to serve only as general guides, travelers who want to insure against getting lost are advised to avail themselves of service station maps, or, better yet, detailed automobile club maps (though the latter are usually available only to club members). County maps are sometimes obtainable through chambers of commerce or at map stores. Always inquire locally before venturing onto remote roads, because conditions can change from one day to the next.

Earl Thollander's personal approach to travel, to art, and to writing speaks of a relaxed outlook and a love for the smallest detail, both of which qualify him as a good spokesman for ventures off the beaten track.

Because California has such a wealth of country byways, many reader favorites may not appear in this selection. Travelers are encouraged to let us know of any other good back roads they would like to share.

<div align="right">THE SUNSET EDITORS</div>

CONTENTS

Central Valley and the Sierra

Northern California

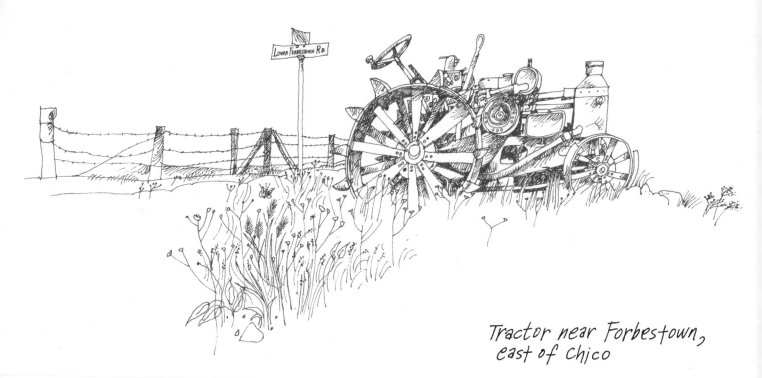

Tractor near Forbestown,
east of Chico

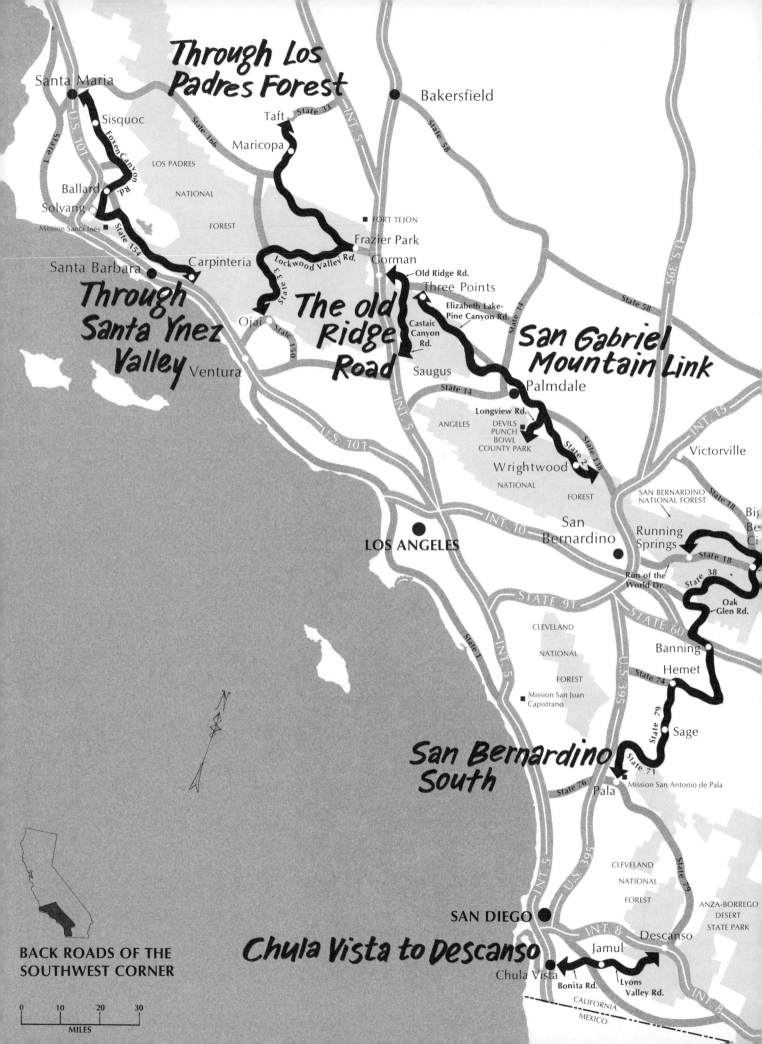

Through Los
Padres Forest

Santa Maria
Sisquoc
Taft State 33
Bakersfield
Maricopa
State 58
LOS PADRES
State 166
Foxen Canyon Rd.
Ballard
NATIONAL
State 1
Solvang
FORT TEJON
Mission Santa Inés
State 154
Frazier Park
FOREST
Carpinteria
Lockwood Valley Rd.
Gorman
Santa Barbara
Old Ridge Rd.
Three Points
Through
State 3
The old
Elizabeth Lake-
Pine Canyon Rd.
San Gabriel
State 14
State 58
Santa Ynez
Ridge
Castaic
Canyon
Rd.
Mountain Link
Ojai
Valley
State 150
Road
U.S. 395
Ventura
Saugus
State 14
Palmdale
Victorville
INT. 15
U.S. 101
Longview Rd.
State 2
State 138
ANGELES
DEVILS
PUNCH
BOWL
COUNTY PARK
Wrightwood
State 18
SAN BERNARDINO
NATIONAL FOREST
Big
Be
Ci
INT. 5
NATIONAL
FOREST
State 38
LOS ANGELES
San
Bernardino
Running
Springs
Oak
Glen Rd.
INT. 10
Rim of the
World Dr.
STATE 91
STATE 60
Banning
State 1
CLEVELAND
INT. 5
U.S. 395
Hemet
State 74
NATIONAL
Mission San Juan
Capistrano
FOREST
State 79
Sage
San Bernardino
South
State 71
State 76
Mission San Antonio de Pala
Pala
CLEVELAND
NATIONAL
BACK ROADS OF THE
SOUTHWEST CORNER
FOREST
INT. 5
ANZA-BORREGO
DESERT
STATE PARK
State 79
SAN DIEGO
Descanso
U.S. 395
Chula Vista to Descanso
Jamul
INT. 8
0 10 20 30
MILES
Chula Vista
Bonita Rd.
Lyons
Valley Rd.
CALIFORNIA
MEXICO
INT. 8

East from San Diego—San Gabriels,
San Bernardinos—Bakersfield South

THE SOUTHWEST CORNER

**The back roads of Southern California's western corner generally lead inland
—into coastal valleys and into mountain ranges that begin in low hills
near the sea and rise to timbered high country and rugged wilderness before
dropping down to desert on the eastern side.**

From the border to San Juan Capistrano, Interstate 5 gives access to the coastal
communities at the southern end of the state, and U.S. 101 explores the shore
northwest of Los Angeles. Where these travel corridors swing inland at Los
Angeles, State 1 and Interstate 405 skirt the western edge of the city,
never far from the ocean.

In San Diego's back country, quiet byways lead to old gold mining towns
and charming mission chapels that welcome today's visitors as they welcomed
the Indians whom they first served. California's history began in this south-
western corner of the state when Juan Rodriguez Cabrillo landed at Point Loma
in 1542, and it was on San Diego's Presidio Hill that the first of California's
twenty-one Franciscan missions was established.

Local roads meander along the cool, forested backbone of the San Jacinto
Mountains that separate the wheat and orchard country of the San Jacinto
Valley from the desert of the Coachella Valley and the sun-drenched resorts
of the Palm Springs area. Through the San Bernardino Mountains, highest of
the ranges that separate Los Angeles from the inland desert, winds Rim of the
World Drive. It leads to resort areas around Lake Arrowhead and Big Bear
Lake, and from it quiet side roads take off into wooded hills and valleys.
Stretching from near the coast to the Mojave Desert, the San Gabriel
Mountains form the northern skyline of Los Angeles. Spur roads from foothill
communities penetrate their front-range canyons, and the Angeles Crest
Highway gives access to higher country and views into the wild and rough
San Gabriel Wilderness Area.

The Lonely Route from Chula Vista to Descanso

At Chula Vista, turn off Interstate Highway 5 onto County Road S17. It becomes Bonita Road. Where Bonita makes a sharp left keep going on San Miguel Road to Proctor Valley Road.

The landscape is dry and treeless. This is a desolate trip, but it is an interesting one, if you're in the mood Melody Road and Campo Road brought me to Jamul and the Indian "St. Mary" Church.

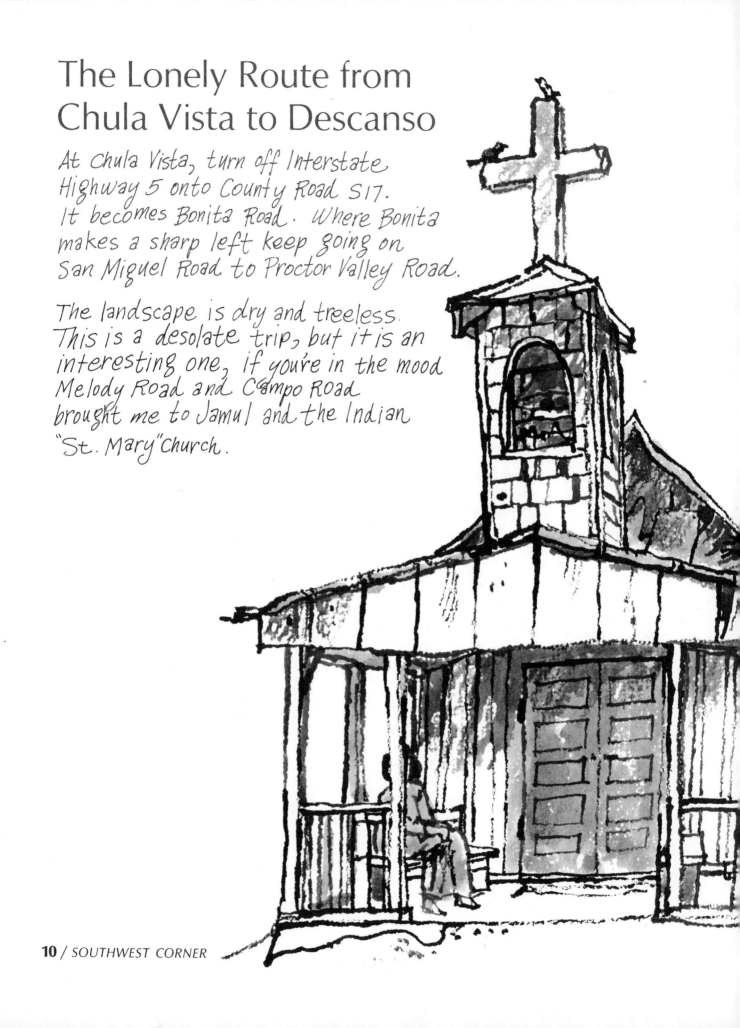

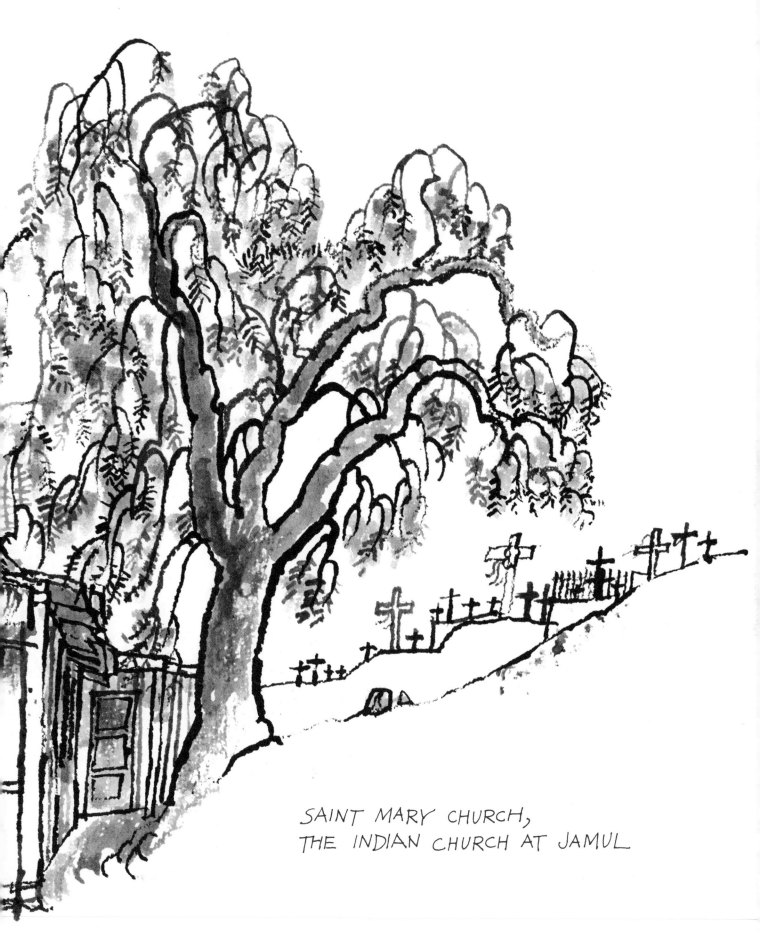

SAINT MARY CHURCH,
THE INDIAN CHURCH AT JAMUL

I drove up the steep, rutty, dirt road past miserable, poverty-stricken Indian hutches walking uphill—finally, the last section of road.
"This is St. Mary church", a large Indian lady told me "It is only used for funerals." The adjoining cemetery is colorful, for each cross is festooned with plastic flowers and paper streamers. The crosses are mostly wooden and painted, either black or white. Somehow, the plastic flowers were used so creatively and lovingly I didn't mind their fakery.
Out of Jamul I traveled on Lyons and Japatul Valley Roads to Descanso and Interstate 8. The trip from Chula Vista had been 37 miles.

LYONS PEAK AND FIRE
LOOKOUT FROM LYONS
VALLEY ROAD

San Bernardino South, the Leisurely Way

San Bernardino to "Rim of the World Drive" via Highways 18 or 30 is about 20 uphill miles.

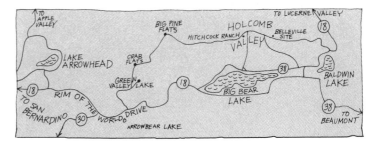

Past Arrowbear Lake you can turn off toward Green Valley Lake, but before reaching there drive left onto a dirt road heading for Big Pine Flats and Holcomb Valley. I enjoyed the day going through this historic gold mining country. I think I started at the right place, too, because other roads in are straight and easy. I built up considerable respect for the land, winding through forests of white fir, cedar, piñon pine, ponderosa, and jeffrey.

BELLEVILLE'S LAST SHACK

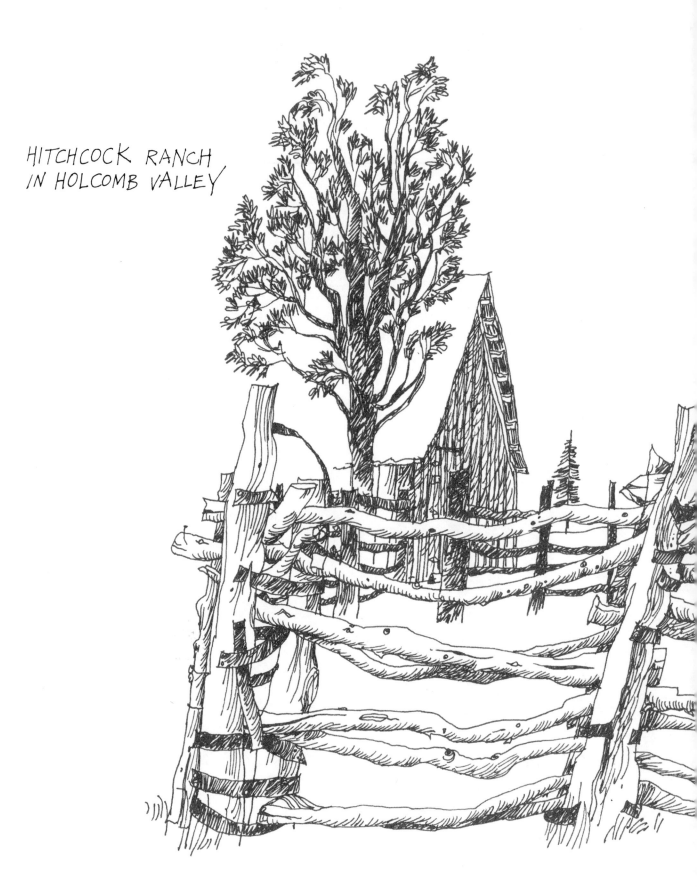

HITCHCOCK RANCH
IN HOLCOMB VALLEY

Farther on, I inspected the area where the town of Belleville once stood. I sketched the only dwelling visible, sitting picturesquely among the rocks. I located it from "Hangman's Tree".

A marker here says "Holcomb Valley, named for William Francis "Bill" Holcomb, pioneer prospector who, in this valley discovered southern California's richest gold field, May 5, 1860."

I traveled from Holcomb Valley on Highways 18 and 38 past the San Gorgonio Wilderness.

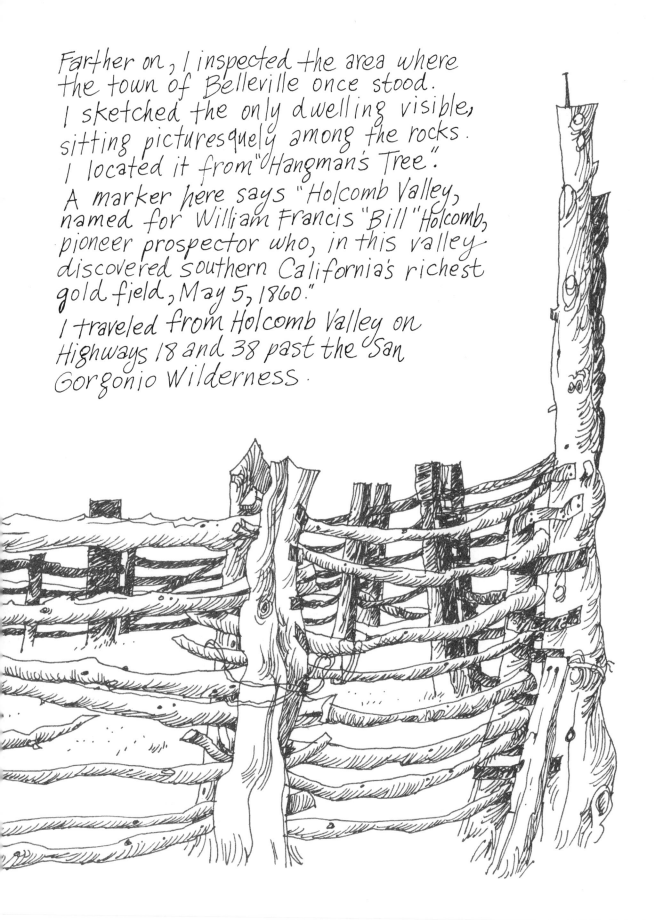

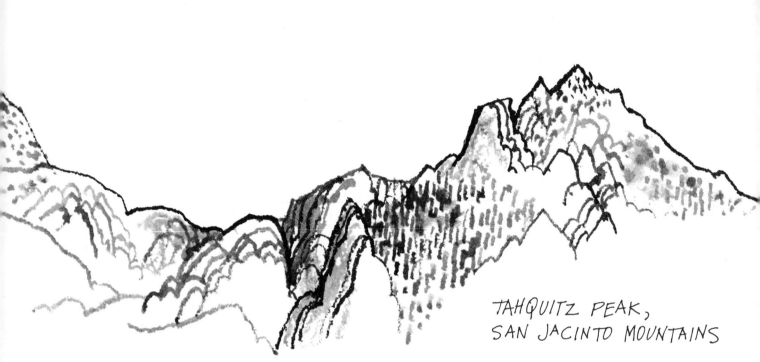

TAHQUITZ PEAK,
SAN JACINTO MOUNTAINS

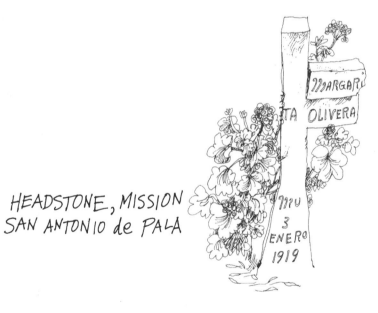

HEADSTONE, MISSION
SAN ANTONIO de PALA

The Little-Known Chapel at Pala

The only remaining asistencia, or sub-mission, of a score or more that were established by the California missions is San Antonio de Pala. It is a branch of Mission San Luis Rey, which lies five miles east of Oceanside. Still in active use as a parish church, Pala serves the Pauma Indians as it did when it was founded in 1815. At its peak, the chapel was used by more than a thousand Indians, who worked the fields in the sheltered San Luis Rey River valley. After secularization of the missions by the Mexican government and the American occupation that followed, the church property passed into private ownership. San Antonio de Pala was closed until 1903 when the Landmarks Club purchased it and returned it to the Catholic Church.

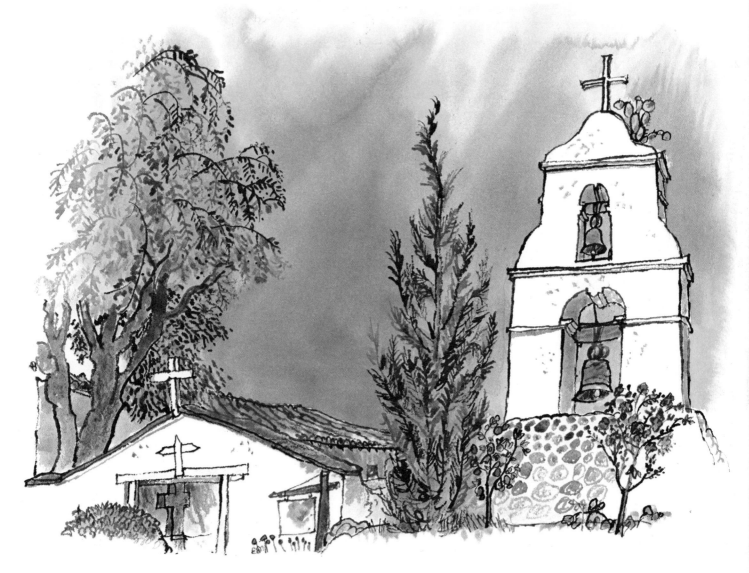

THE CAMPANILE, SAN ANTONIO DE PALA

Heading to Banning, I turned south
and went west through the San Jacinto
Mountains toward Mountain Center,
then went west to Hemet on State 74.
Through Diamond Valley, south of Hemet,
I came to the village of Sage and its
old fashioned gas station.
Pala Road turns off Highway 71 farther south
and leads to Mission San Antonio de Pala.
School was out for the day and I was all but
surrounded by Indian boys and girls watching me
draw. Even the principal of the school gave
an approving smile as she passed me in the garden.
In 1916 a flood destroyed the campanile
It was immediately restored, using the same
materials. A young Indian boy told me that
he had been allowed to ring the campanile bells
once for mass. They are also rung, he said,
when someone dies and during the funeral procession.

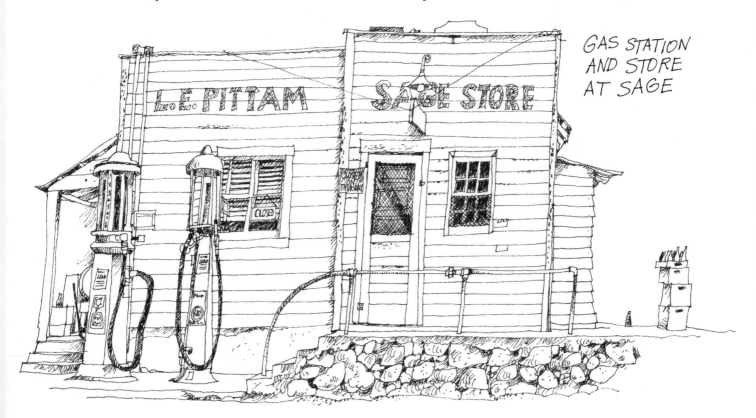

GAS STATION
AND STORE
AT SAGE

San Gabriel Mountain Link— Interstate 5 to Interstate 15

Highway 138 heads east from Interstate 5 near Gorman and Lebec. County Road N2 (Pine Canyon Road) branches off 138 to the right 9 miles later.

You can go to Three Points, turn onto Elizabeth Lake Road, then head past the lake to San Francisquito Canyon Road. At oak-shaded Green Valley I made a sketch, my first, of a realtor's office, returning to Pine Canyon Road via Bouquet Canyon.

THE REALTOR,
SPUNKY CANYON

SAN GABRIEL'S
HIGH ROCKS

I sketched the old log cabin near
Three Points. Two friendly horses
put their runny noses over my
drawing, and I had to shoo them
away. There were so many flies,
one fell in my ink bottle, while
others would follow my
pen around and suck the
ink before it dried.

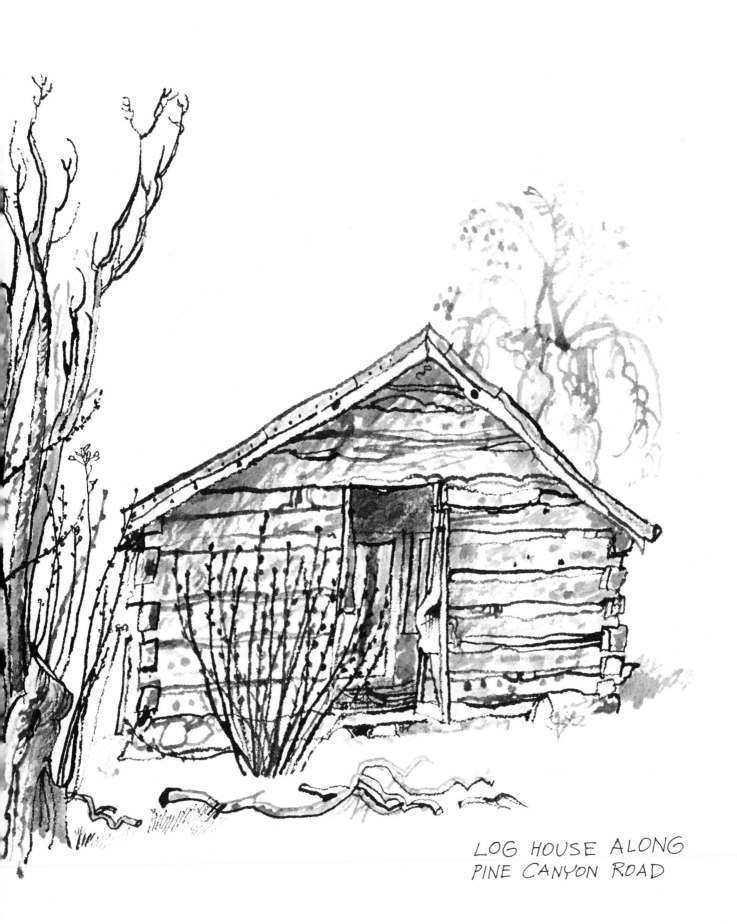

LOG HOUSE ALONG
PINE CANYON ROAD

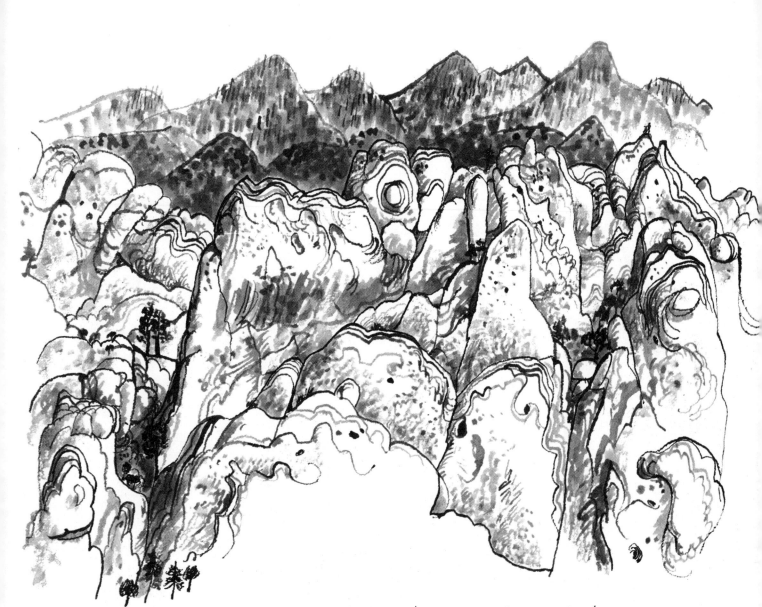

THE JOSTLED ROCKS OF DEVIL'S PUNCHBOWL

Devil's Punchbowl and the Rock Candy Mountains

In the semidesert country on the north slopes of the San Gabriel Mountains, a 25-mile-long displacement of a spectacular rock formation crossed by the San Andreas Fault resulted in two upthrusts known as Devil's Punchbowl and the Rock Candy Mountains. Devil's Punchbowl is now a Los Angeles County park. A paved road leads to a canyon rim overlooking the formations, and a mile-long trail down into the main canyon gives a close-up look at dun-colored, weather-etched rocks and cliffs.

The Punchbowl is actually three bowls, carved by streams flowing toward the desert. Exposed fins of the jutting outcrop extend for three miles in a band that reaches a width of nearly a mile and stands out sharply against the surrounding chaparral.

The Rock Candy Mountains, the other part of the original formation, can be seen for about a half mile on both sides of State 138 near Cajon Junction, southeast of Punchbowl.

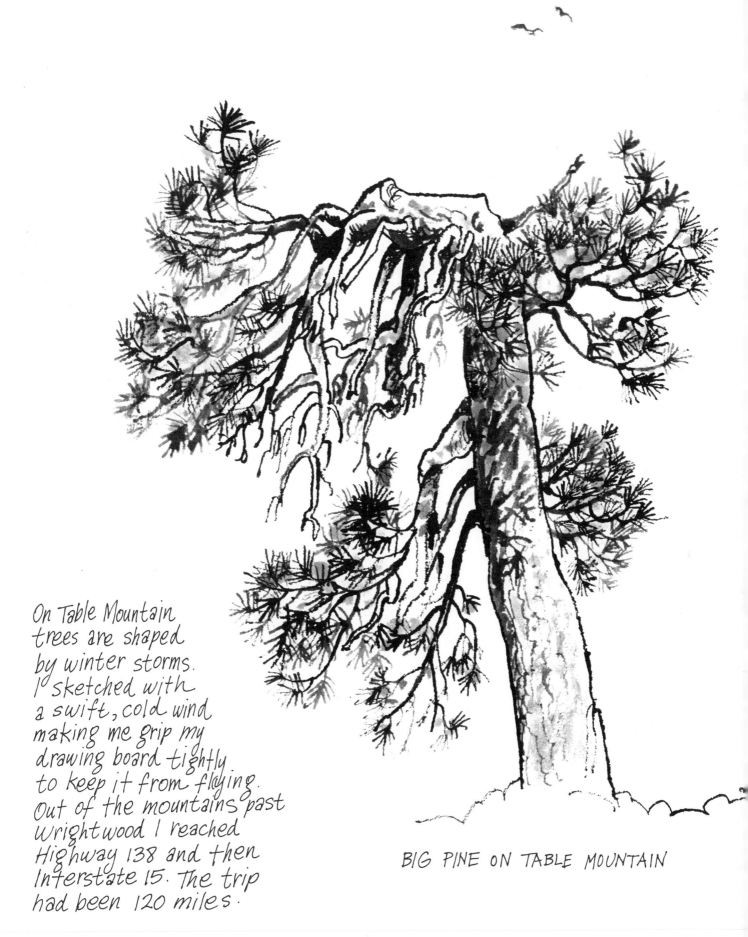

On Table Mountain
trees are shaped
by winter storms.
I sketched with
a swift, cold wind
making me grip my
drawing board tightly
to keep it from flying.
Out of the mountains past
Wrightwood I reached
Highway 138 and then
Interstate 15. The trip
had been 120 miles.

BIG PINE ON TABLE MOUNTAIN

From Bakersfield to Ventura, through Los Padres National Forest

From Taft to Ojai is about 85 miles through Los Padres National Forest.

Clearing Frazier Park and Lake of the Woods, you can enjoy a 30 mile, leisurely drive through Los Padres National Forest. It is piñon pine country with an occasional "grandaddy" pine towering over the diminutive piñons. I eventually reached Highway 33-39 miles from Ojai. Backroads of Ojai are lined by orange groves and thick rock walls. Most attractive was Carne Road with its date palms and flowers.

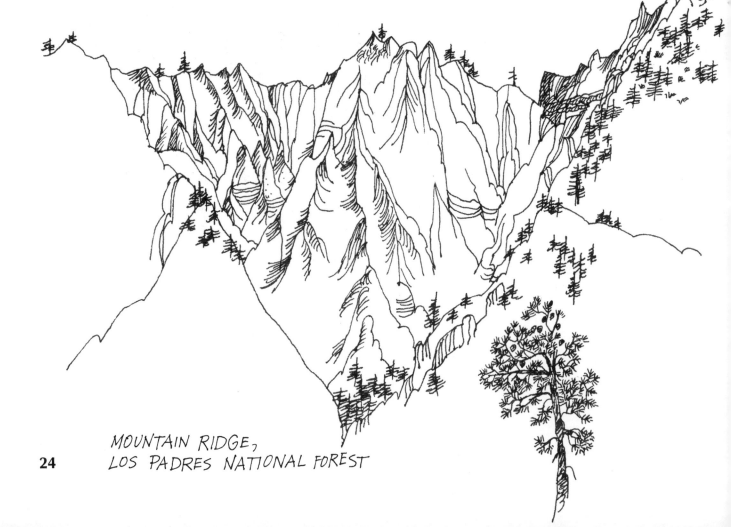

MOUNTAIN RIDGE,
LOS PADRES NATIONAL FOREST

24

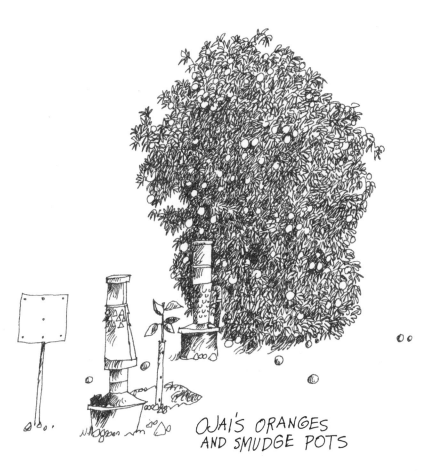

OJAI'S ORANGES
AND SMUDGE POTS

Historical Fort Tejon

Valley oaks shade the restored buildings of Fort Tejon, a cool oasis along Interstate 5 north of Tejon Pass. The fort was established in 1854. It originally was headquarters for the 1st U.S. Dragoons, sent to protect the friendly Indians of the Sebastian Reservation and to control Grapevine Pass, through which rustlers drove cattle and horses from the San Joaquin Valley to southern markets. Later it housed units of the U.S. Army Camel Corps, which experimented with the use of camels for transporting supplies to isolated posts in the southwest deserts—an idea that was abandoned when it was found that the tender feet of the camels were not suited to the rocky soil of the Fort Tejon region. Ten years after its founding, the fort became inactive. Today the 210-acre property is a historical monument. The visitors' center contains displays of artifacts relating to the fort, and oak-shaded tables make inviting spots to spread a picnic lunch.

Santa Barbara — Santa Ynez Valley — Santa Maria

It is 30 miles from Santa Barbara to Santa Ynez over San Marcos Pass. Foxen Canyon Road, after Los Olivos goes to Sisquoc and Santa Maria.

Near Solvang there is pleasing country landscape on Armour, Happy Canyon, Roblar, and Alamo Pintado Roads. At Ballard schoolhouse on Base Line Avenue, where I stopped to sketch, the Mother's Club of the 1883 red and white school were having their annual, fund-raising chicken barbecue. A little girl asked me," Did you draw all that?" Another, annoyed that a contemporary would ask such an obvious question, replied,"What do you think he did, tear it out of a magazine?"

I said to a small boy just arriving breathlessly on the scene, "what a nice place to have a picnic." He replied,"What a great place to YELL!" One little girl saw someone photographing the historic school and said to me, quite casually, "but your drawing will be nicer and quite special." I'd never felt more highly complimented.

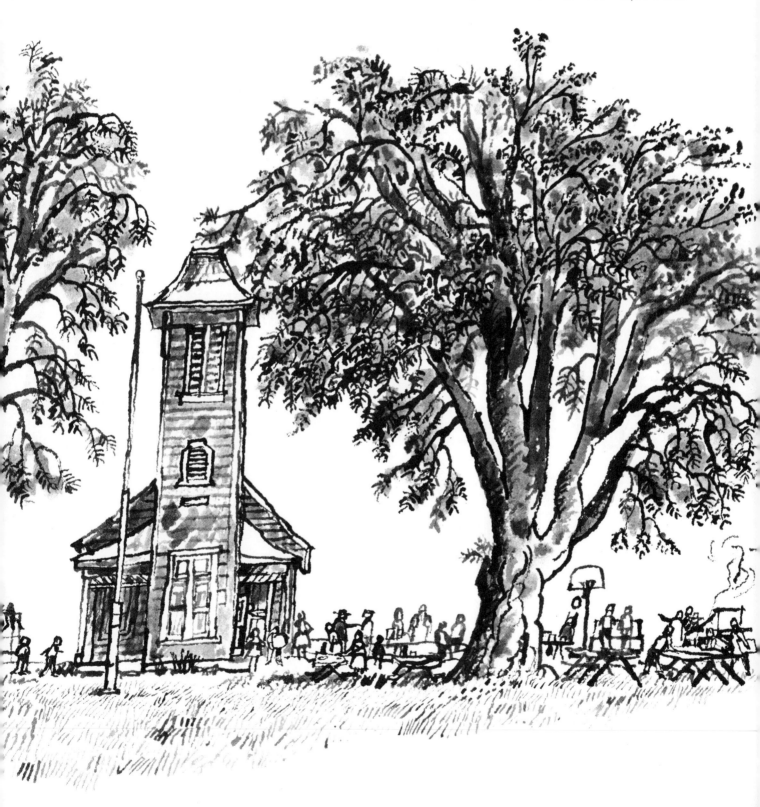

BALLARD SCHOOLHOUSE

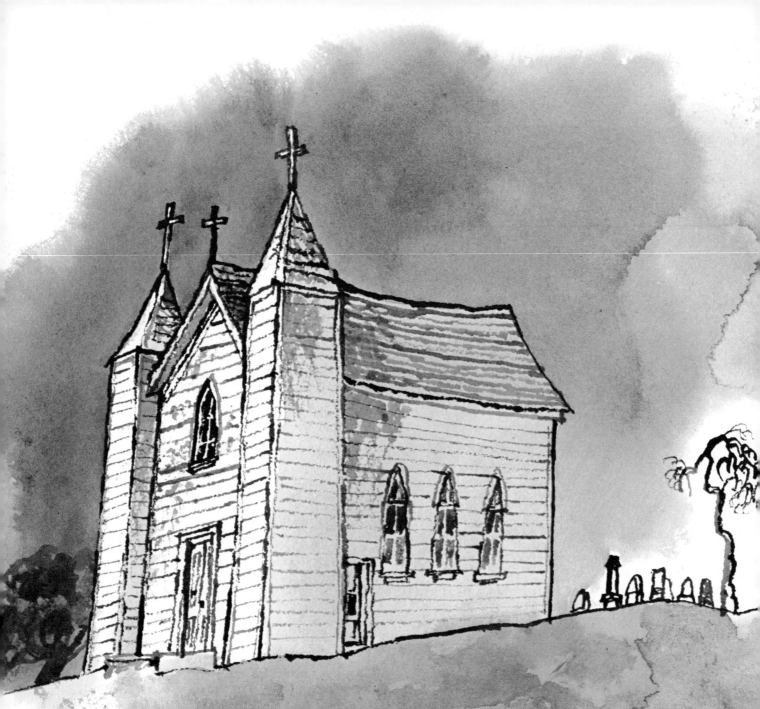

HIGH ON THE HILL,
SISQUOC CHURCH, 1875

It is not far from Ballard to Mission Santa Inés, and the Danish town of Solvang. Atterdag Road, off Highway 246, becomes Chalk Hill Road (Ballard Canyon Road) out of Solvang, and along here is the neatly kept Danish Cemetery. Many of the graves are simple wooden crosses, with names freshly re-painted. Chalk Hill brings you to Foxen Canyon Road, Highway 176, and Santa Maria. I stopped to sketch Sisquoc Church along Foxen Canyon. The eaves are riddled with woodpecker holes. From a larger hole a mean-looking hawk, too young to fly, screamed for food.

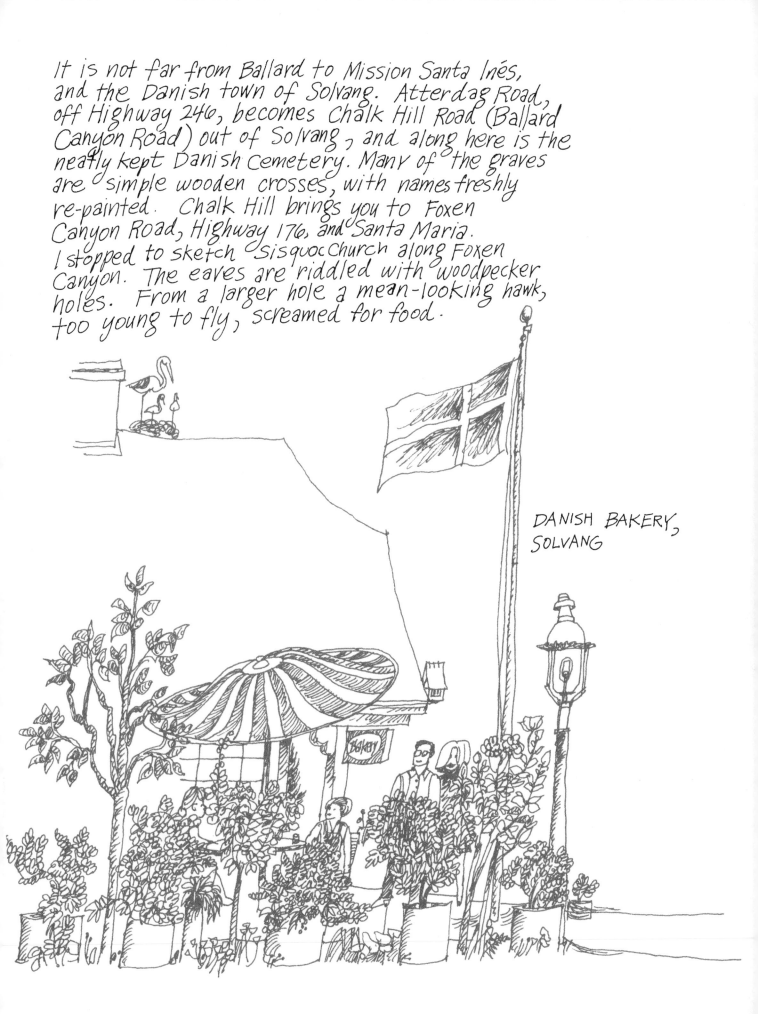

DANISH BAKERY, SOLVANG

The Old Ridge Road
from Saugus to Gorman

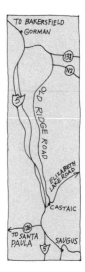

Interstate 5, near Saugus, took me to Castaic and the Lake Hughes - Elizabeth Lake Road. Instead of turning onto the Lake Road proper I continued on the unmarked blacktop. A sign said "NOT A THROUGH STREET." This was the "Old Ridge Road"!

Concrete and steel rods hold the historic road in place. The aged surface is still in evidence. It is worthwhile traveling simply to see the views of huge, uninhabited mountain masses. Look toward the setting sun and the mountains are hazy and blue. Looking east they are pink. A 40 mile journey, the Ridge Road connects with county road N2 and on to Gorman.

MAN RESHAPES A MOUNTAIN
TO MAKE A HIGHWAY BELOW

SOME SOUTHERN
CALIFORNIA
WILDFLOWERS

TREE TOBACCO IN BLOOM
WITH ITS BRIGHT YELLOW,
TRUMPET-LIKE FLOWERS

BLACK SAGE GIVES A
PURPLE HUE TO A
WHOLE MOUNTAINSIDE

Wildflowers and Wild Waters: Three Canyon Drives

Three gentle canyons near the west end of the San Gabriel Mountains can be used as approaches to the poppy fields of Antelope Valley to the north, and connecting roads near and above the heads of the canyons make for convenient loop trips from Interstate 5. Picnic spots are many and inviting along the way.

Bouquet Canyon, with its weekend cabins and roadside campgrounds, is the most popular. Elizabeth Lake Canyon, least altered of the three, is perhaps the prettiest. Near the head of Bouquet Canyon, the road swings around Bouquet Reservoir, part of the Los Angeles Aqueduct, built at a cost of twenty-three million dollars to supply water to the San Fernando Valley. The drive over to Green Valley and the head of San Francisquito Canyon goes through the site of St. Francis Dam, which broke without warning on March 13, 1928, shortly after it was completed, sending billions of gallons of water rushing down San Francisquito Creek, destroying bridges, homes, crops, and killing some five hundred people.

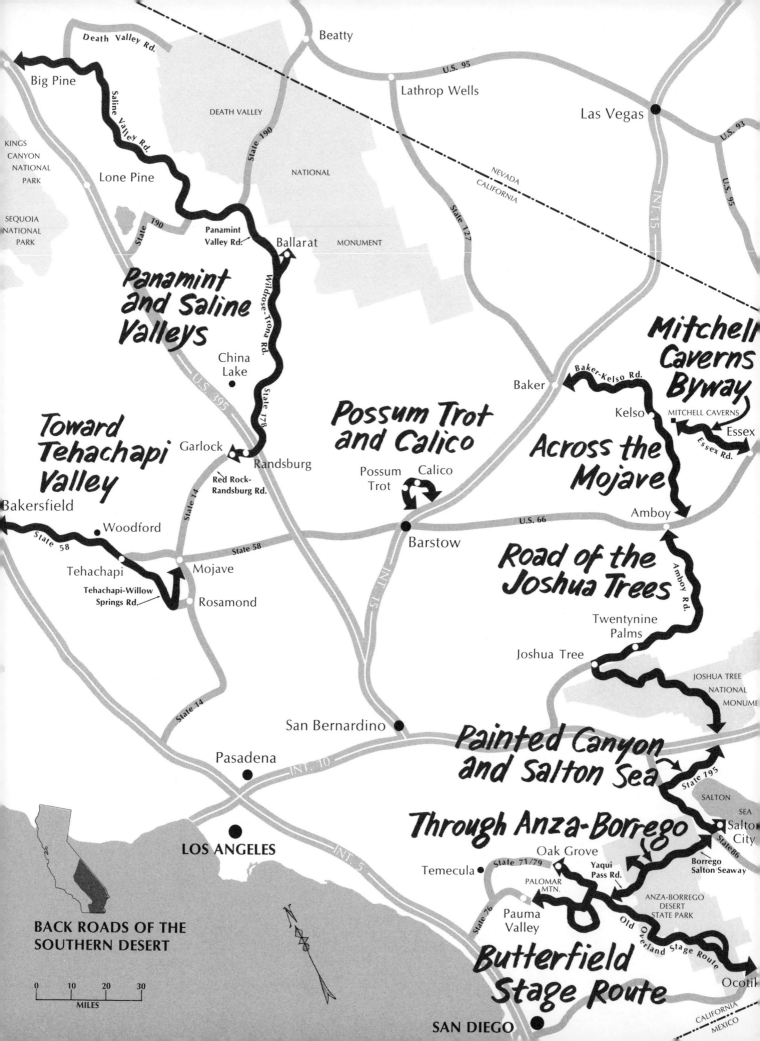

Death Valley Rd.

Beatty

U.S. 95

Big Pine

Saline Valley Rd.

DEATH VALLEY

Lathrop Wells

Las Vegas

KINGS
CANYON
NATIONAL
PARK

Lone Pine

State 190

NATIONAL

NEVADA

CALIFORNIA

U.S. 93

U.S. 95

INT 15

SEQUOIA
NATIONAL
PARK

State 190

Panamint
Valley Rd.

Ballarat

MONUMENT

State 127

Panamint
and Saline
Valleys

Wildrose-Trona Rd.

Mitchell
Caverns
Byway

China
Lake

Baker-Kelso Rd.

State 395

U.S. 395

Baker

Kelso

MITCHELL CAVERNS

State 178

Possum Trot
and Calico

Essex

Essex Rd.

Toward
Tehachapi
Valley

Garlock

Randsburg

Possum
Trot

Calico

Across the
Mojave

Bakersfield

Red Rock-
Randsburg Rd.

U.S. 66

Amboy

Woodford

State 14

State 58

Barstow

Road of the
Joshua Trees

State 58

Amboy Rd.

Tehachapi

Mojave

Tehachapi-Willow
Springs Rd.

Rosamond

INT 15

Twentynine
Palms

Joshua Tree

JOSHUA TREE
NATIONAL
MONUME

State 14

San Bernardino

Painted Canyon
and Salton Sea

State 195

SALTON

Pasadena

INT 10

Through Anza-Borrego

SEA

Salton
City

State 86

Oak Grove

Yaqui
Pass Rd.

Borrego
Salton Seaway

INT 5

LOS ANGELES

Temecula

State 71/79

PALOMAR
MTN.

ANZA-BORREGO
DESERT
STATE PARK

State 76

Pauma
Valley

Old Overland Stage Route

BACK ROADS OF THE
SOUTHERN DESERT

Butterfield
Stage Route

Ocoti

0 10 20 30
MILES

CALIFORNIA

MEXICO

SAN DIEGO

Anza-Borrego, Mojave Byways — Saline, Panamint, and Tehachapi Valleys

THE SOUTHERN DESERT

The lure of the desert lies away from the main routes, in the lonely expanses that stretch to a purple-shadowed mountain horizon. Here, Joshua trees replace billboards along the roadside. Desert creatures scurry across rocks, and windswept dunes register the quiet comings and goings of wildlife.

Just above the Mexican border, Interstate 80 heads east from San Diego to Yuma and beyond. It provides access to roads leading into Anza-Borrego Desert State Park and to the developments around the Salton Sea. Farther north, Interstate 10 reaches the Palm Springs resorts and Joshua Tree National Monument. Interstate 15 follows a northeasterly route through the lonely Mojave, carrying travelers between the metropolitan centers west of Los Angeles and the glitter of Las Vegas. U.S. 395 skirts the Mojave's western edge, and is joined by roads that reach into the stillness of the Panamint and Saline valleys and the strange landscape of Death Valley National Monument.

Adventuresome travelers can explore narrow, fantastically eroded canyons and drive winding roads that climb to far-reaching vistas. They can follow routes traveled by stagecoaches in the 1850's, and peer into the dark depths of now-quiet mines and weathered buildings of old mining towns.

Following winter rains, the desert comes alive with a brief but spectacular display of wildflowers. Thorny ocotillo stalks become tipped with heavy clusters of red flowers; pink verbena blankets the dunes; California poppies streak the hillsides with brilliant orange; yuccas send up huge, creamy plumes.

The casual back road traveler should exercise extreme caution in exploring unmarked desert trails that branch invitingly off the main highway. Many such roads begin on level, firm ground, then dip into gullies that form sand traps. During the rainy season such washes become dangerous raging torrents from water runoff. Unpaved desert roads should never be explored without advice from local residents.

Along the Butterfield Stage Route

The Overland Stage Route, County Road S2, more or less follows the old Butterfield Stage Route. You can begin at Ocotillo, along Interstate 8.

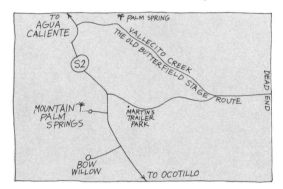

(Map labels:)
TO AGUA CALIENTE
PALM SPRING
VALLECITO CREEK
THE OLD BUTTERFIELD STAGE ROUTE
S2
DEAD END
MOUNTAIN PALM SPRINGS
MARTIN'S TRAILER PARK
BOW WILLOW
TO OCOTILLO

Bow Willow in Anza Borrego Desert State Park, is a good campground. Farther north is a side road to Mountain Palm Springs. You can drive within one-half mile of the palms, then hike to the little oasis. The sandy ground I walked on glittered with mica. The palms give refuge to birds, and they sang continuously as I sketched.

THE OASIS AT MOUNTAIN PALM SPRINGS, ANZA-BORREGO DESERT

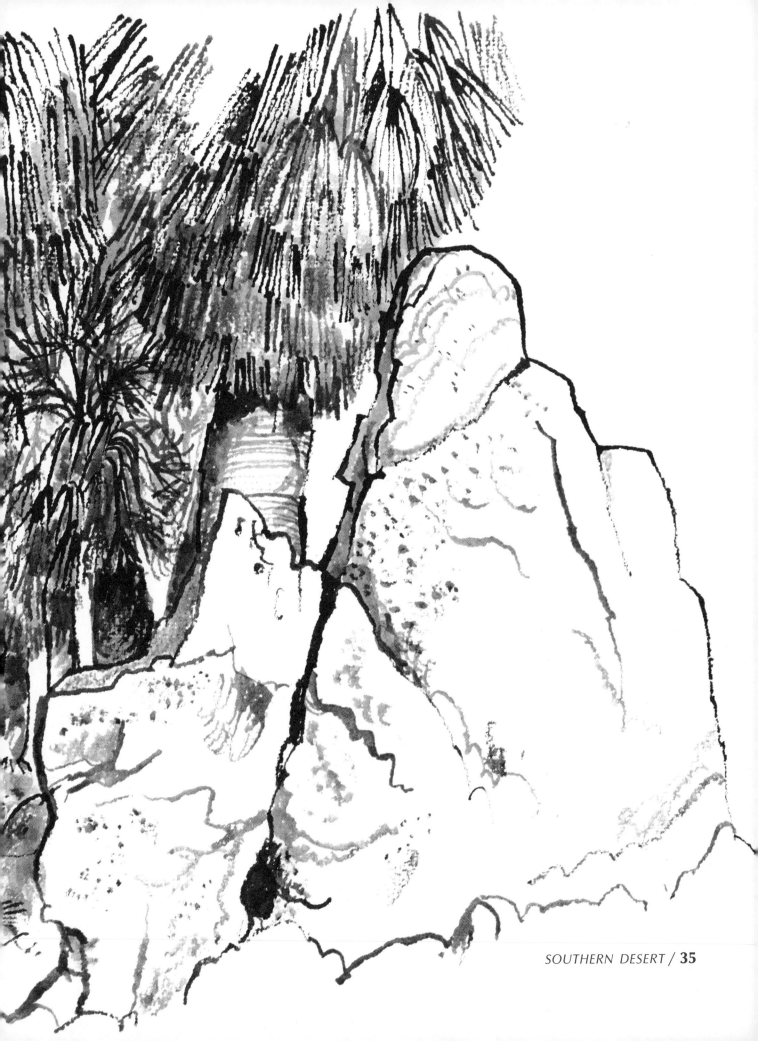

TRAVELING THE BUTTERFIELD
STAGECOACH ROAD,
VALLECITO CREEK

One and a half miles beyond Mountain Palm Springs is a road to Martin's Trailer Park. Go four miles along this road and you intersect the Vallecito Creekbed. Turn left and follow the creekbed back to the highway and you will have traveled over the original Butterfield Stage Route. The creekbed is sandy, and it is not an official road, so check with the Ranger at Bow Willow on this trip. There were no stagecoach tracks, but a feeling of history was with me on this 9½ mile ride. At Vallecito, farther along County Road S2, is the re-created stage station, completed in 1934. In Box Canyon and at another point, both marked, you can see the tracks worn into the rocks by many a stagecoach.

VALLECITO STAGE STATION

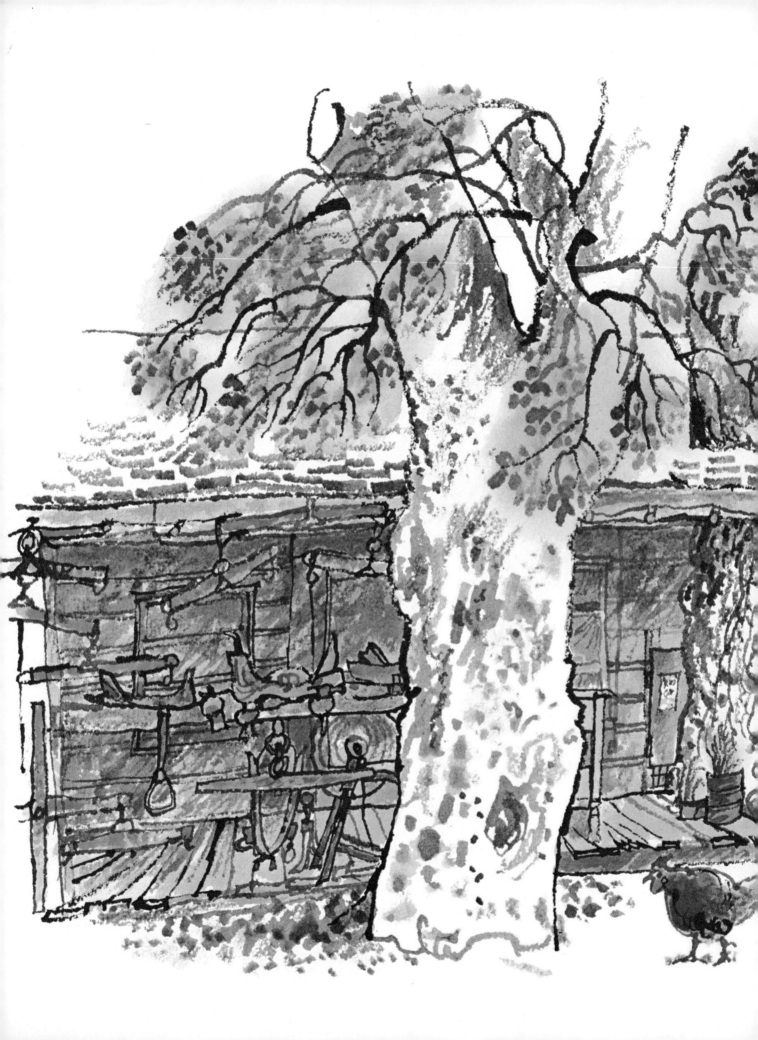

The old Butterfield Stage Route goes up San Felipe Canyon connecting with Highway 79, with 4 miles to go to Warner Springs. At Oak Grove, thirteen miles beyond, the old stage station still stands. The adobe facade has been covered. "People stuck their fingers in the old wall and said, ooh!, it really is adobe," the owner told me. He put wooden siding up to keep the building from dissolving.

WARREN T. HALL RESIDENCE, BUTTERFIELD STAGE STATION MANAGER, 1858, OAK GROVE

TELESCOPE AT
MOUNT PALOMAR

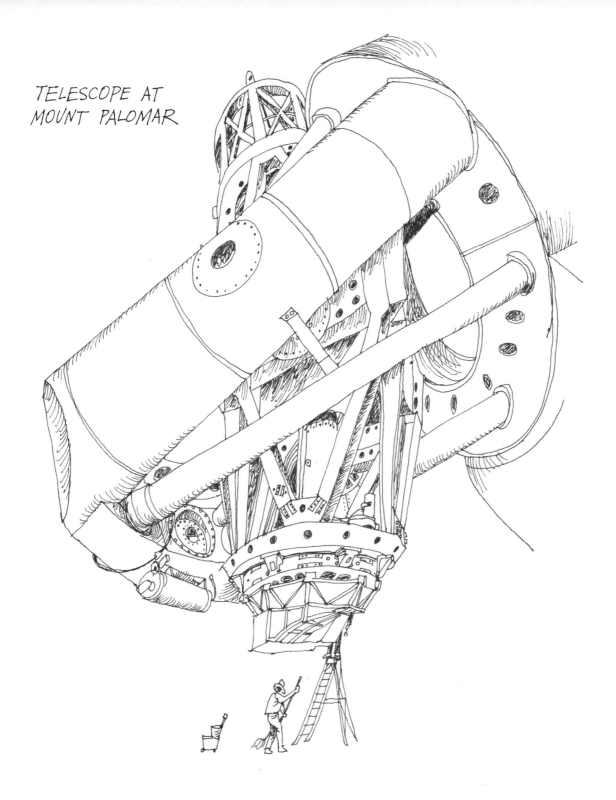

The World's Largest Telescope

From the great silver dome of the observatory on Mount Palomar, the world's largest reflector telescope photographs stars billions of miles away. The Hale, named for astronomer George Ellery Hale, is a 200-inch telescope weighing 500 tons. It is viewed from a gallery in a dome kept at nighttime temperatures, since only a few degrees of variation can cause distortions. The observatory was completed in 1948, twenty years after the Rockefeller Foundation granted six million dollars for the project.

A diversion can be made from the Butterfield Stage Route, south of Warner Springs along Highway 79, to see three Indian Missions. The first is Santa Ysabel, on 79, 2 miles north of the town of the same name. Take Mesa Grande Road a short ½ mile north of the mission, and enjoy the country drive 8 miles to St. Dominick's Chapel. Keep going, winding down the mountain, finally, to turn left onto Highway 76. Two and one-half miles beyond Pauma Valley town, take Pauma Reservation Road one mile to see Pauma Indian Mission. I leaned against an ancient pepper tree to sketch the mission's modest campanile.
A mile south of Pauma Road, the Nate Harrison Grade will take you to Mt. Palomar. Or, for a much less rugged route, go 8 miles more along 76, then make the ascent. Seeing the telescope and the magnificent exhibit of photographs in the museum is important. I left with a greater respect and concern for our earth and for the great spaces beyond.

PAUMA INDIAN MISSION CAMPANILE

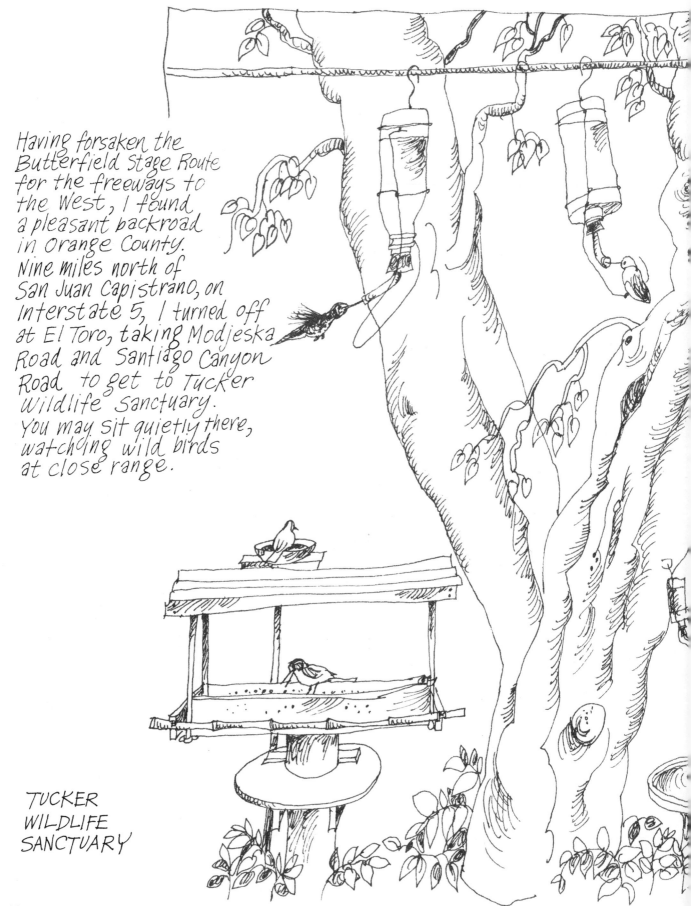

Having forsaken the
Butterfield Stage Route
for the freeways to
the West, I found
a pleasant backroad
in Orange County.
Nine miles north of
San Juan Capistrano, on
Interstate 5, I turned off
at El Toro, taking Modjeska
Road and Santiago Canyon
Road to get to Tucker
Wildlife Sanctuary.
You may sit quietly there,
watching wild birds
at close range.

TUCKER
WILDLIFE
SANCTUARY

Back Road through Anza-Borrego

The most impressive drive into the desert of Anza-Borrego is via the Old Overland Stage Route, turning off onto 'Yaqui Pass Rd.

The view into the desert is deep and truly astounding. Camp at Borrego-Palm Canyon Campground, for there is a delightful and instructive walk through the canyon. I drove the sandy road into Coyote Canyon next day to see the ocotillo and torch cactus in bloom and to be alone in the desert.

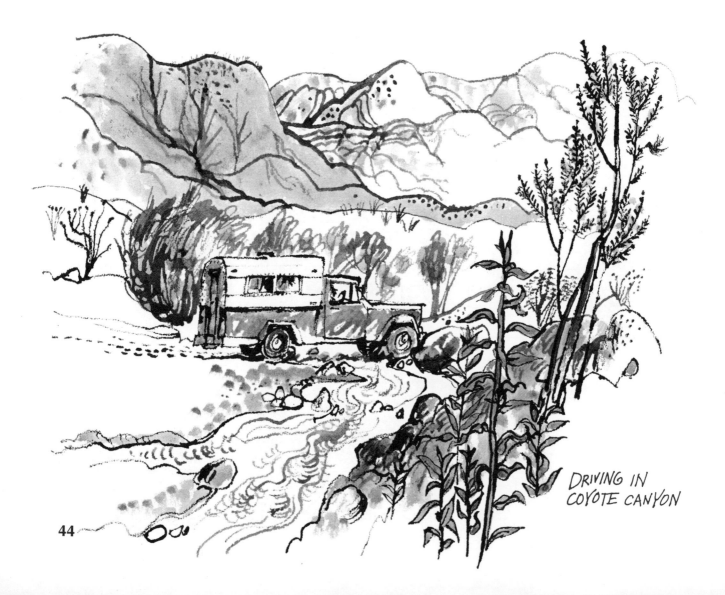

DRIVING IN COYOTE CANYON

OCOTILLO
ALONG COYOTE
CANYON ROAD

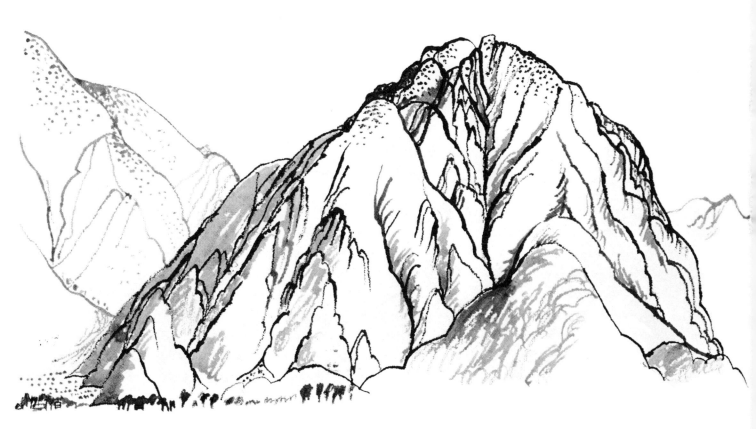

MOUNTAINS OF THE ANZA·BORREGO

Painted Canyon and the Salton Sea

Below Joshua Tree National Monument Highway 195 leads to Mecca and south to Highway 86 and the Salton Sea. This was my lonesome route to Anza-Borrego Desert.

Signs along the way talked of "FLASH FLOODS, WATCH FOR DEBRIS." It is because of an area called "painted Canyon", a Grand Canyon-like place in miniature.

PAINTED CANYON, EAST OF MECCA

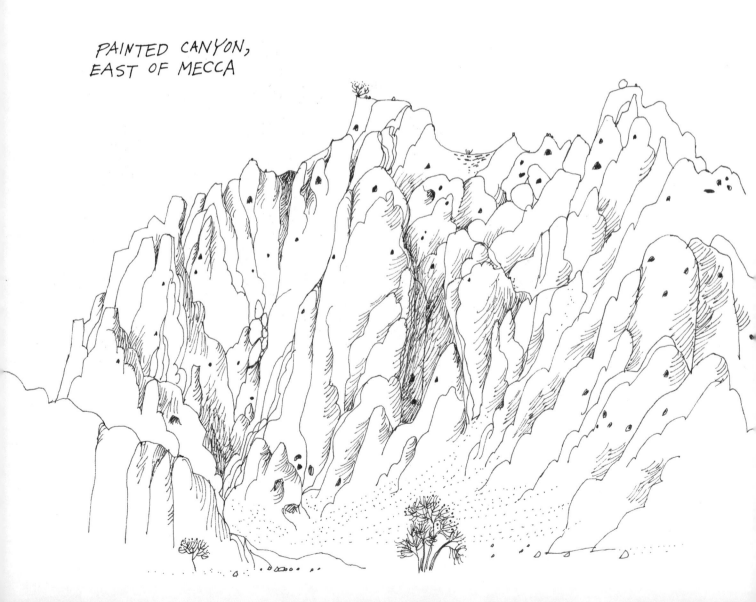

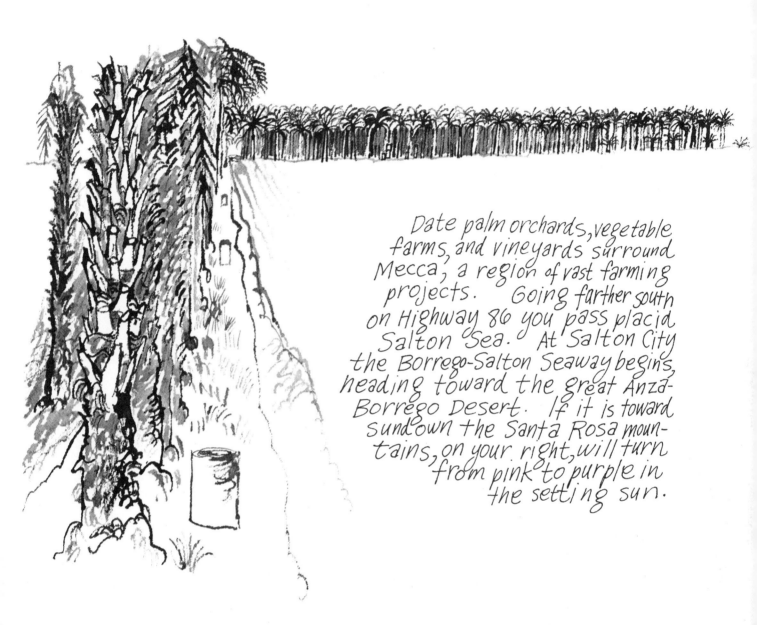

Date palm orchards, vegetable farms, and vineyards surround Mecca, a region of vast farming projects. Going farther south on Highway 86 you pass placid Salton Sea. At Salton City the Borrego-Salton Seaway begins, heading toward the great Anza-Borrego Desert. If it is toward sundown the Santa Rosa mountains, on your right, will turn from pink to purple in the setting sun.

DATE PALMS NEAR MECCA

South from U.S. 66 along the Road of the Joshua Trees

Near Amboy Crater, on Highway 66, Amboy Road goes south to Twenty-Nine Palms. The long way through Joshua Tree National Monument, which I chose, begins at Joshua Tree, 15 miles west of here along Highway 62.

I was happy to leave the desert developments and real estate signs for the magnificence of the Joshua Tree Monument.

SHEEPHOLE MOUNTAINS,
AMBOY ROAD

48

DESERT DWELLERS NEAR
TWENTY-NINE PALMS

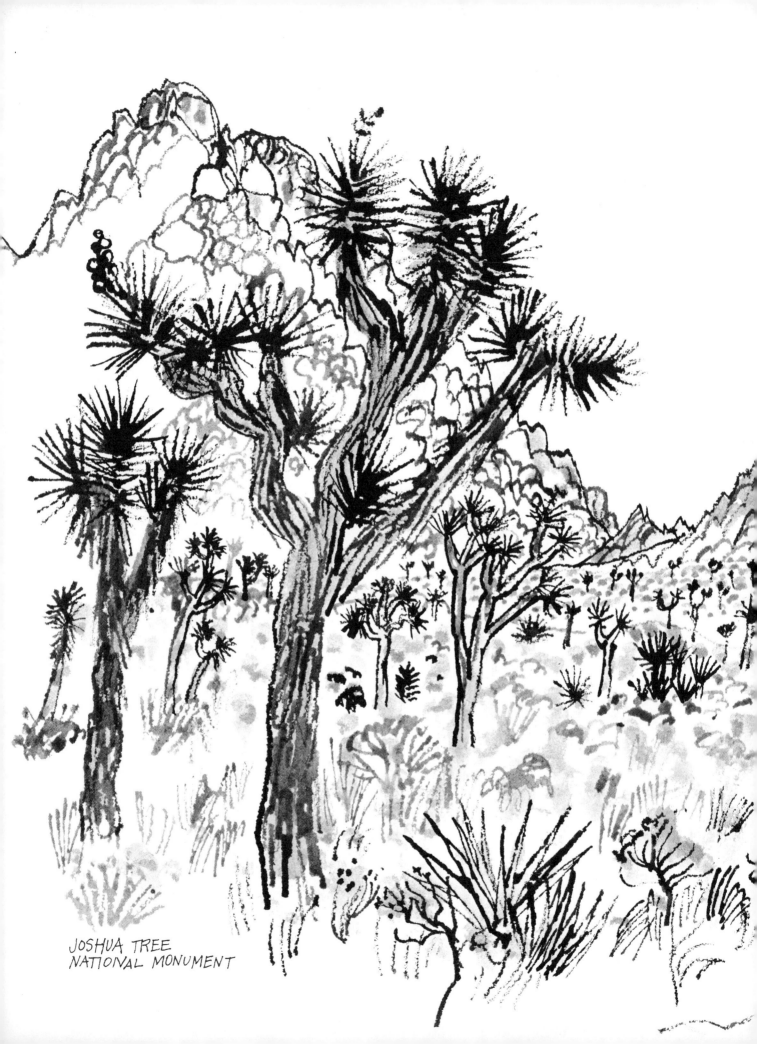

JOSHUA TREE
NATIONAL MONUMENT

The rock formations are as startling as the forests of Joshua trees. Artistic rock compositions are everywhere. Mojave yucca is blooming, a huge flower head of waxy, pale yellow flowers. The nature walk at Cap Rock, along Pinto Basin Road, furnished me with a look at a delightful little creature, a desert cottontail with big eyes and white powderpuff of a tail.

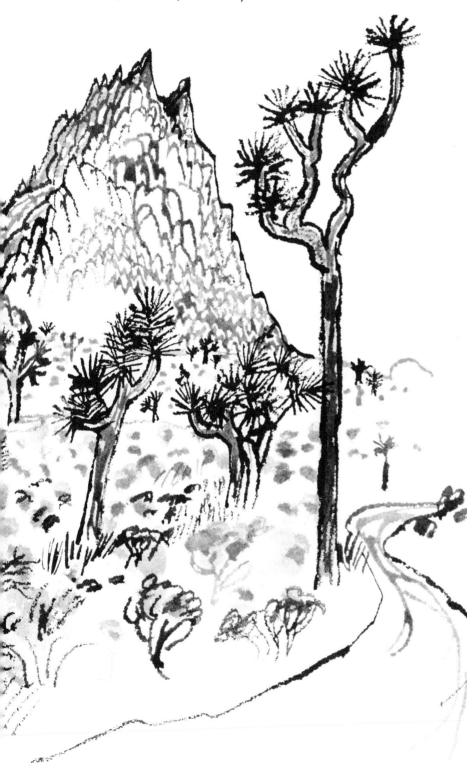

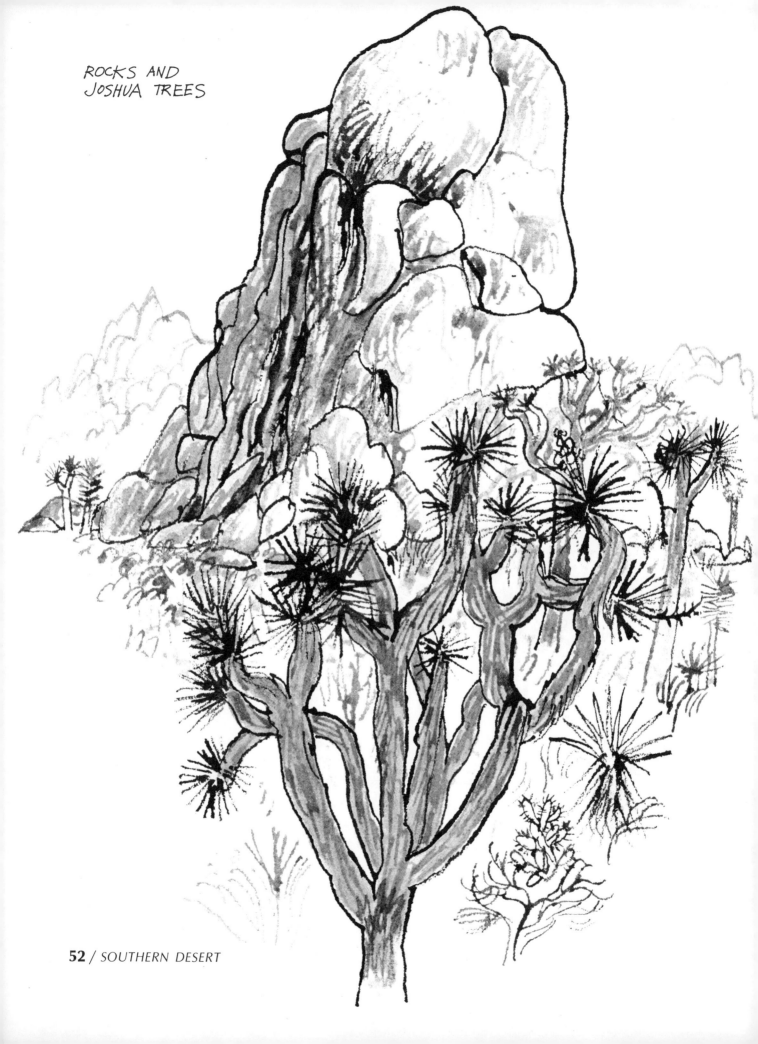

ROCKS AND
JOSHUA TREES

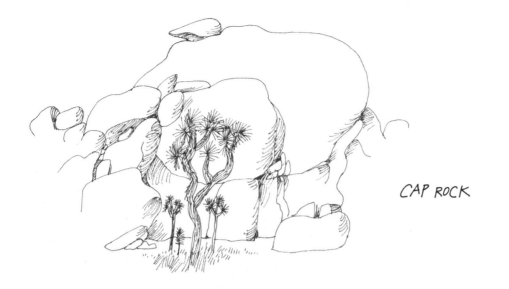

CAP ROCK

SPLIT ROCK

Desert Ecology: The Plants Tell a Story

The meaning of high desert and low desert is illustrated in few places as vividly as in Joshua Tree National Monument. The monument is situated on a high plateau that edges a precipitous drop-off to a below-sea-level desert sink, the Coachella Valley and Salton Sea. Altitudes in the monument range from 1,000 to nearly 6,000 feet. Here, visitors may experience two Southern California deserts: low Colorado and high Mojave.

Indicator plant of the low desert, up to about 3,000 feet, is the creosote bush, but the low desert also displays such beauties as the green-trunked palo verde, the gray smoke tree, and the ocotillo and cholla cacti. The cholla is transitional and crosses over into high-desert, which is marked first by Mojave yucca and juniper. At the upper end of the yucca range is the chief indicator of the Mojave Desert, the Joshua tree. It in turn penetrates the lower edge of piñon-juniper-scrub oak woodland at about 4,200 feet, which ranges on up to the highest elevations of the monument.

Mitchell Caverns Byway off U.S. 66

At Essex, from Highway 66, begins the 23-mile trip to Mitchell Caverns.

At this elevation the beauty of the desert in spring is astounding. It is a vast garden of blooming cactus and desert plants of infinite variety. The caverns are at 4500 feet, and the chocolate-colored mountains behind rise to 6,970 feet, with snow patches up top. Bird calls echo in the canyons. From the entrance of the caverns the view is broad. 300 square miles of the Clipper and Fenner Valleys lie below, and the Hualapai Mountains are clearly seen 85 miles from this point.

THE ROAD TO MITCHELL CAVERNS

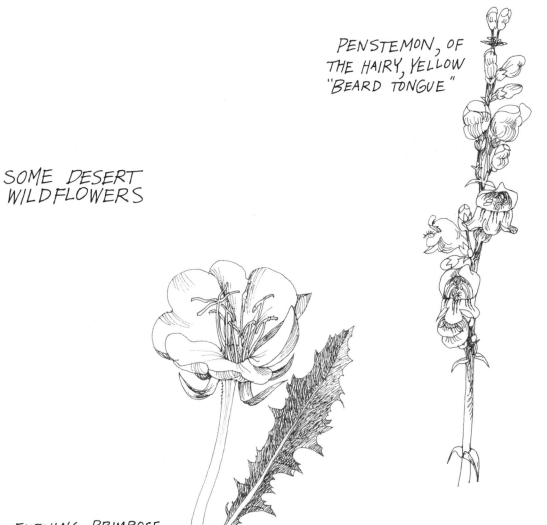

PENSTEMON, OF
THE HAIRY, YELLOW
"BEARD TONGUE"

SOME DESERT
WILDFLOWERS

EVENING PRIMROSE,
MOJAVE DESERT

Easy Spelunking in the Mojave

The only limestone caves in Southern California that are developed for visitors are perched high on the slopes of the craggy Providence Mountains in the eastern Mojave Desert, at Mitchell Caverns State Reserve. For centuries they provided shelter for nomadic Indians that roamed the desert, and later they were known to early settlers and prospectors. Around 1930, a prospector by the name of Jack Mitchell acquired the caves with a mining claim. He took up residence and opened them to the public. Then in 1956 he sold the property to the Department of Parks and Recreation.

This beautiful world of sculptured limestone was originally formed by underground water that dissolved portions of the primeval limestone. Later the water table lowered, emptying the rooms. Mineral-laden surface water dripped from the ceilings of the caverns, and, by depositing calcium carbonate, gradually created the unusually delicate stalactites, stalagmites, cave coral, and stone curtains that decorate the rooms today.

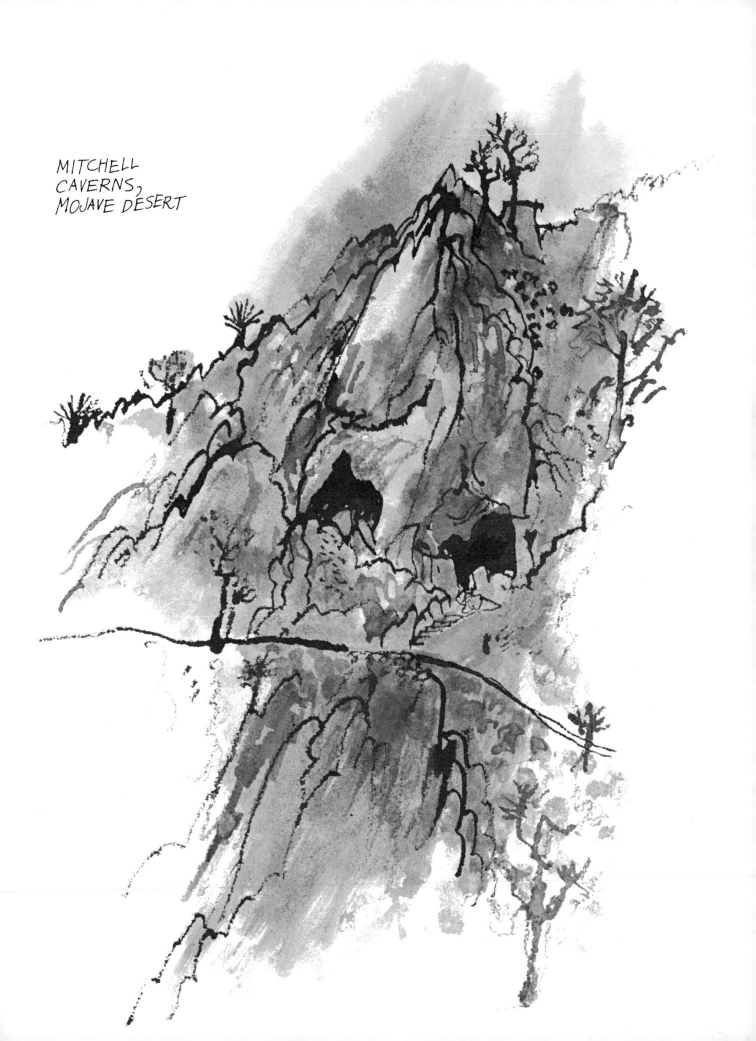

MITCHELL
CAVERNS,
MOJAVE DESERT

Possum Trot and Calico

7 miles past Barstow on Interstate 15, the 3-mile road to Calico begins. Possum Trot is half-way to Calico.

The late Calvin Black, mayor of Possum Trot, named the place, and he and Ruby Black were the entire population. Calvin was a doll-maker, ventriloquist, preacher, entertainer, and artist. In his theatre the dolls are almost as large as people, and some can peddle bicycles, dance, ring bells, and speak. Farther along the road is Calico, the entertaining re-creation of an old mining town.

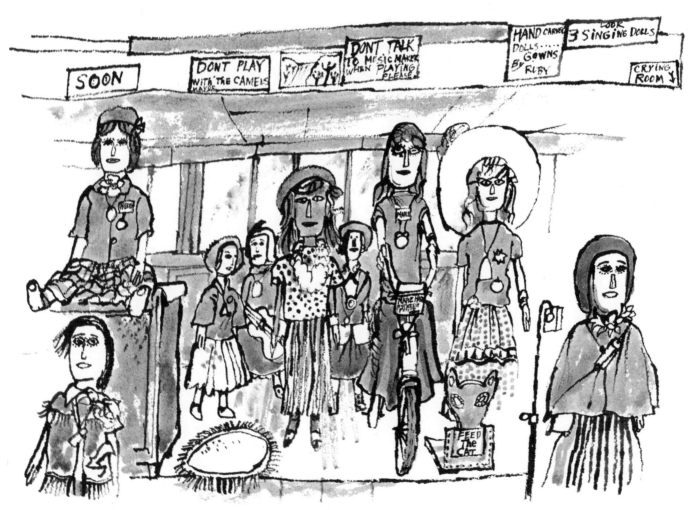

CALVIN BLACK'S DOLL
THEATER AT POSSUM TROT

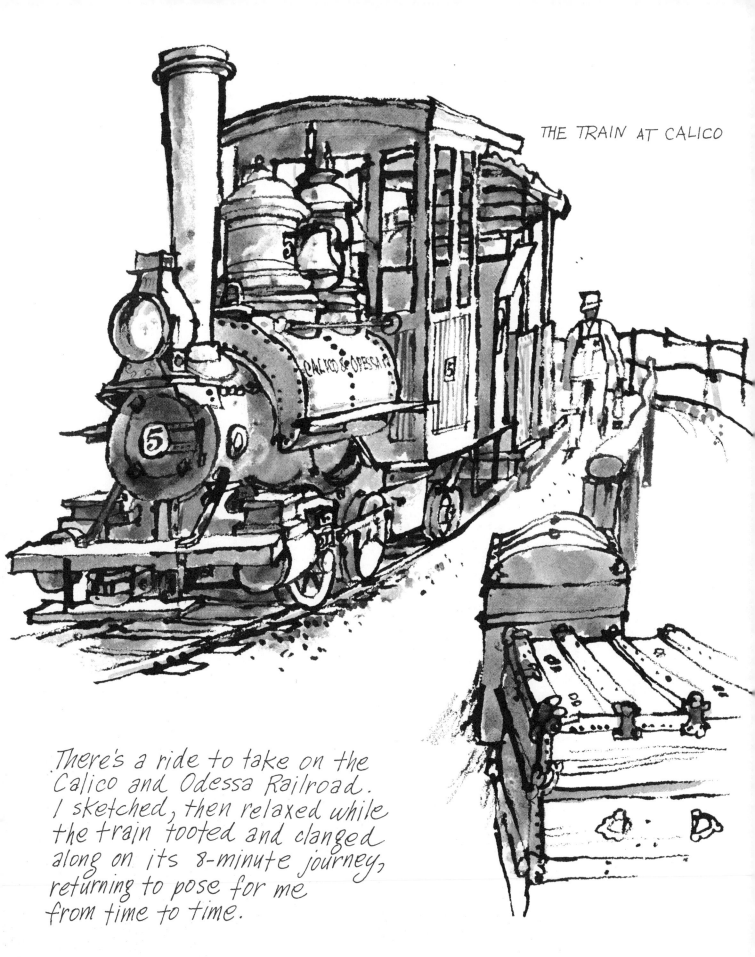

THE TRAIN AT CALICO

CALICO & ODESSA R.R.

There's a ride to take on the
Calico and Odessa Railroad.
I sketched, then relaxed while
the train tooted and clanged
along on its 8-minute journey,
returning to pose for me
from time to time.

Toward the Tehachapi Valley

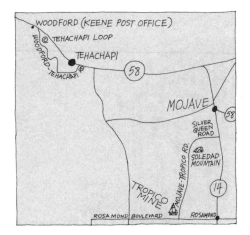

Turn off Highway 58 at Woodford (Keene Post Office) to see the Tehachapi Loop. Just south of the city of Mojave, Silver Queen Road goes past the much-mined Soledad Mountain and to the Tropico Mine.

TURN OF THE CENTURY
POST OFFICE

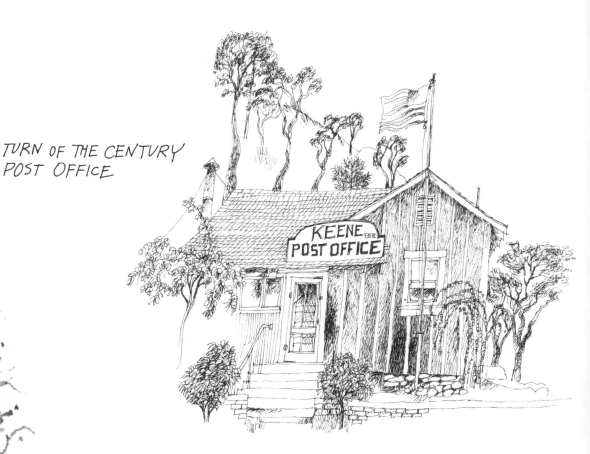

From Keene to Tehachapi an
old two-lane highway passes
a vantage point where you
can look down on the "Loop"
The road then dips down into
the broad Tehachapi Valley and
through fields of dwarf lupine
and the green grass of springtime.

KEENE, CALIFORNIA

Out of Mojave I went along Silver Queen Road,
and stopped to draw the Golden Queen Mine
sitting picturesquely on the side of Soledad
Mountain. Golden Queen was a gold mine
and later a silver mine, but all that was
a long time ago. It hasn't operated
since 1941. At the end of
the Mojave-Tropico Road is
the Tropico Mine. Gold was
taken from the area until
1956, when it became
too expensive to mine.

GOLDEN QUEEN MINE, SOLEDAD MOUNTAIN

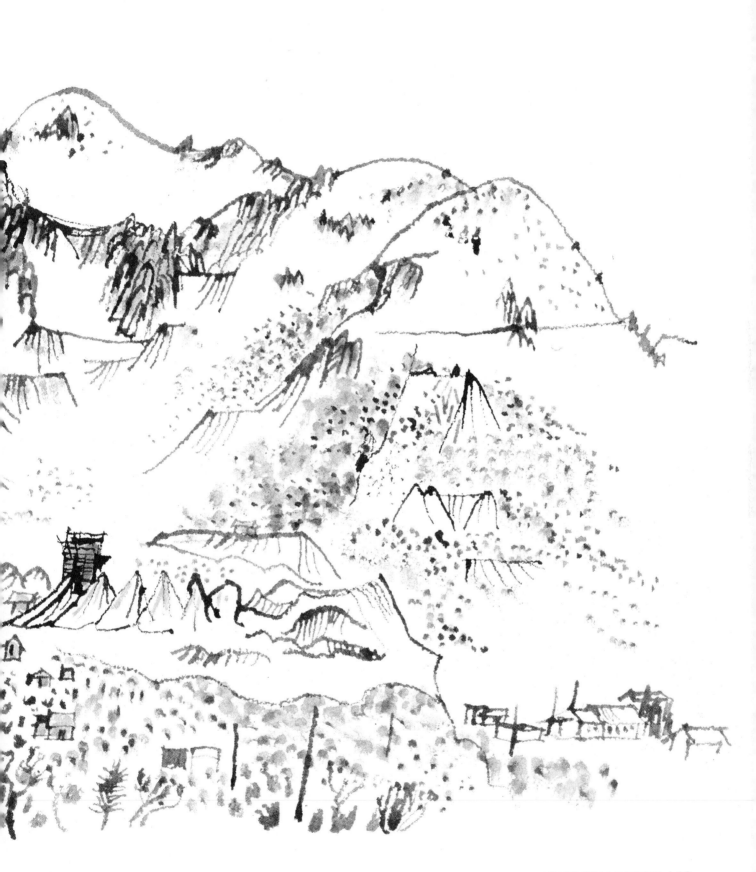

A retired "hard-rock" miner took me through
a portion of the Tropico. There are twelve
miles of tunnels! I looked down a 900-foot
shaft and tried to imagine what it would be
like to be a miner, and go to the bottom.
There was a wooden ladder, but my guide
said that most men rode down in the
big ore bucket. The tour ended
at the "glory hole", where the
vein had enlarged greatly.

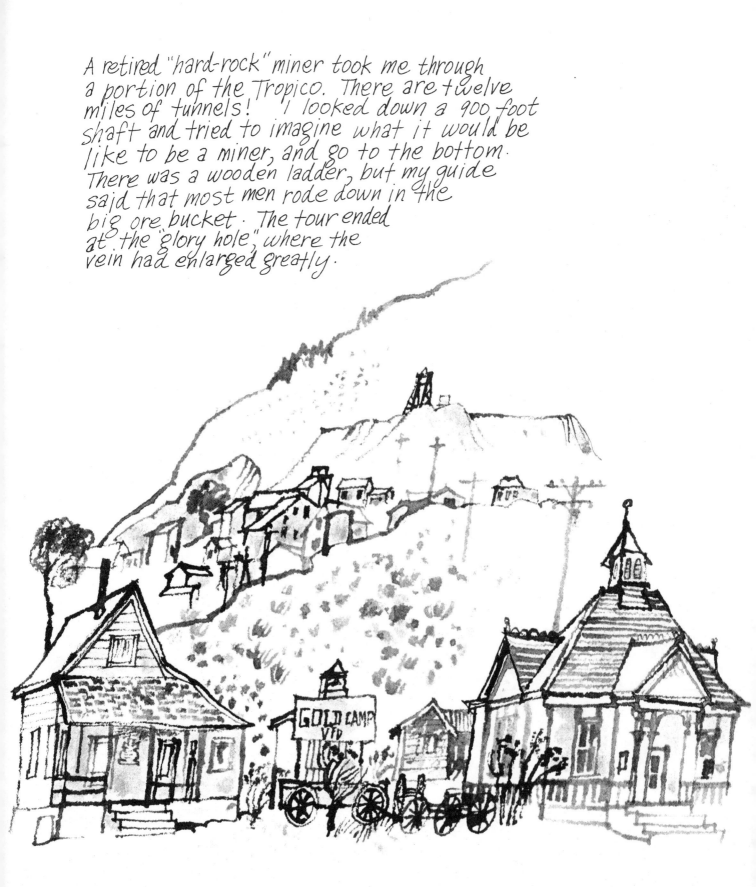

TROPICO GOLD MINE ON THE HILL

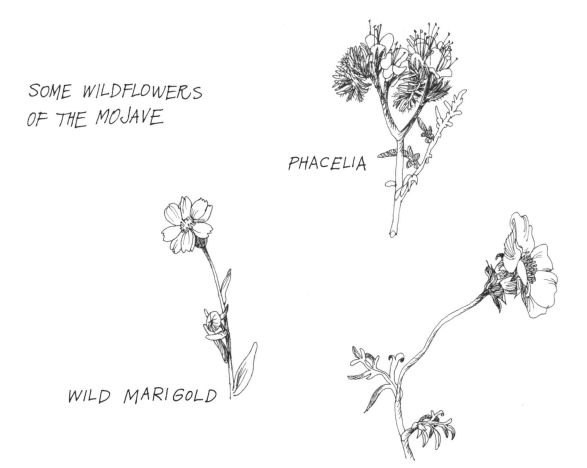

SOME WILDFLOWERS
OF THE MOJAVE

PHACELIA

WILD MARIGOLD

DESERT MARIGOLD

The Grand Tehachapi Loop

One of the greatest accomplishments of railroad engineering, the Tehachapi Loop, can be seen from a vantage point along the Woodford-Tehachapi Road southeast of Woodford. The loop is a complete circle of a 3,795-foot circumference, which allows a train to gain 77 feet of altitude with a practical gradient up the steep Tehachapi Mountains. Completed in 1876, the loop was part of the solution to one of the principal barriers to the construction of a railroad over the Tehachapis—the steep ½-mile grade between the town of Caliente and the summit of Tehachapi, 14 straight-line miles away. The elaborate plan used the maximum gradients and the narrowest curves allowed by law. It winds 28 miles between the two towns, through a series of seventeen tunnels.

The·Baker-Kelso Road across the Mojave

The 60-mile trip begins on Interstate 15 and ends at Highway 66 near Amboy. From Baker the road stretches straight ahead and out of sight toward some distant rocky mountains.

I crossed a cattle guard in a few miles, and draped on a post nearby was a long-dead wildcat. I sketched flowers along the way. It is interesting how so many resemble snapdragons, lilies, marigolds, buttercups, and mustard, but with desert variations. You pass Joshuas and yuccas, then descend into a wide valley to view the spectacular Providence Mountains and the tiny railroad hamlet of Kelso at their base. Kelso has lawn and trees and a cavernous coffee shop where the cook, all in white, greeted me with a cool glass of fresh spring water. There are great mountains to see all the way to 66. The Granite Mountains must be one of nature's great sculptural masterpieces. Then there are the Marble Mountains all purple, chocolate and white.

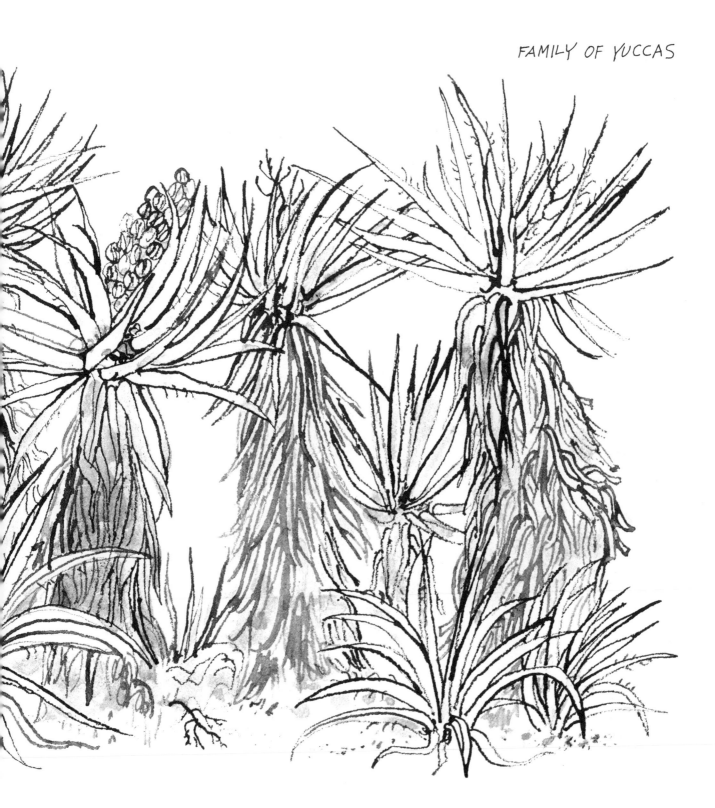

FAMILY OF YUCCAS

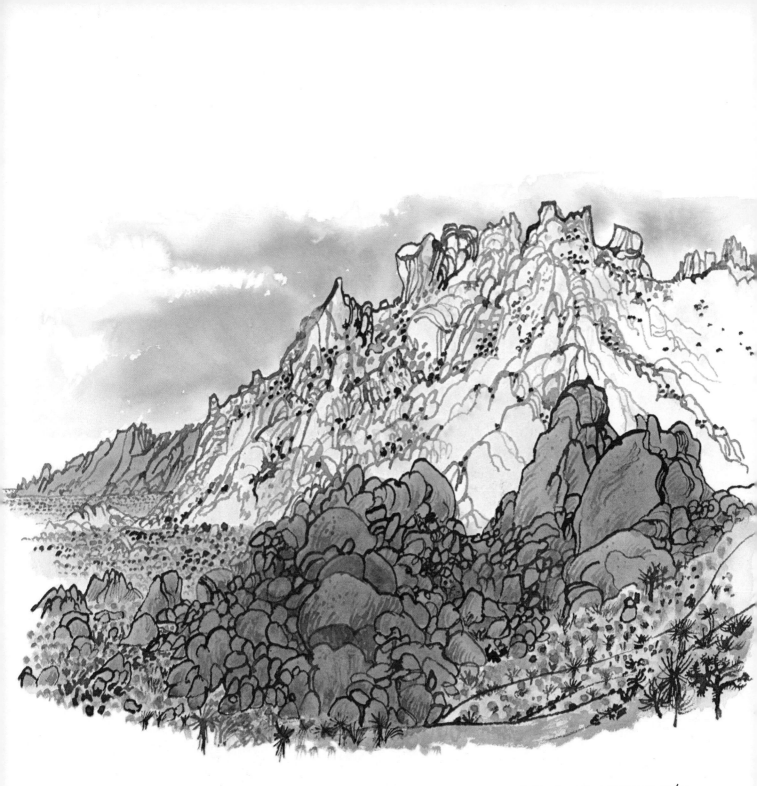

GRANITE MOUNTAINS,
MOJAVE DESERT

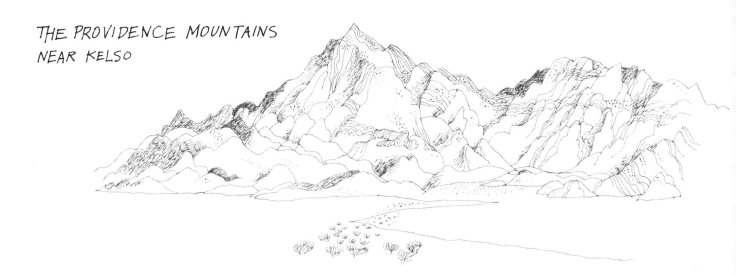

THE PROVIDENCE MOUNTAINS
NEAR KELSO

In Kelso there are lawn and large palms and
cottonwoods. The station itself is a grand
and impressive place in scale. Males can
stay overnight in the hotel, but no ladies,
I was told. I sketched as one of those
long, long freight trains slowly and thunderously
ground to a halt at my back.

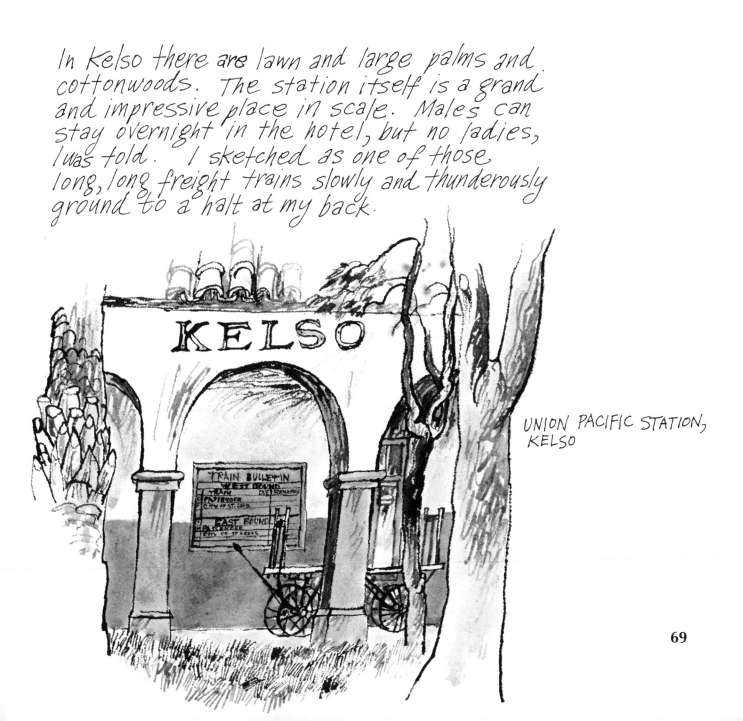

KELSO

TRAIN BULLETIN
WEST BOUND
TRAIN DUE REMARKS
PASSENGER
CITY OF ST. LOUIS

EAST BOUND
PASSENGER
CITY OF ST. LOUIS

UNION PACIFIC STATION,
KELSO

Back Road through
the Panamint and Saline Valleys

Highway 395, north from San Bernardino, and 14, out of Mojave, head for the Panamint Valley. This is also the way to Death Valley. Saline Valley Road leaves Highway 190 farther north, somewhere between Panamint Springs and Keeler.

21 miles from Mojave you can turn off Highway 14 onto the Red Rock-Randsburg Road to see the old mining town of Randsburg. Near Johannesburg, close by, is the Wildrose-Trona Road through Panamint Valley, with its' vast views of desert and mountains. The peaks were rich with color and light in the setting sun. I drove past dry Searles Lake, the Stauffer Chemical Company, Trona, and thence to the turnoff to historic Ballarat.

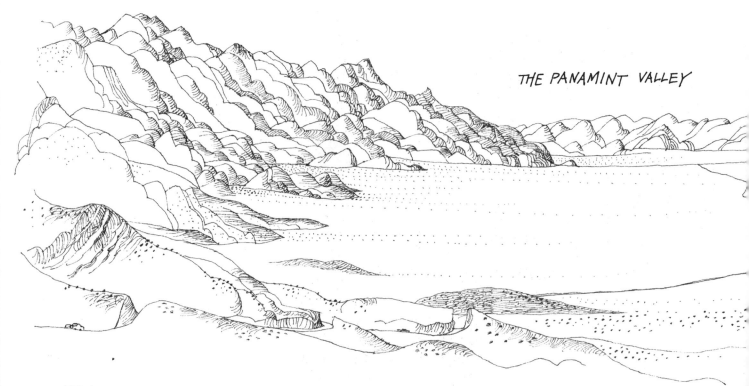

THE PANAMINT VALLEY

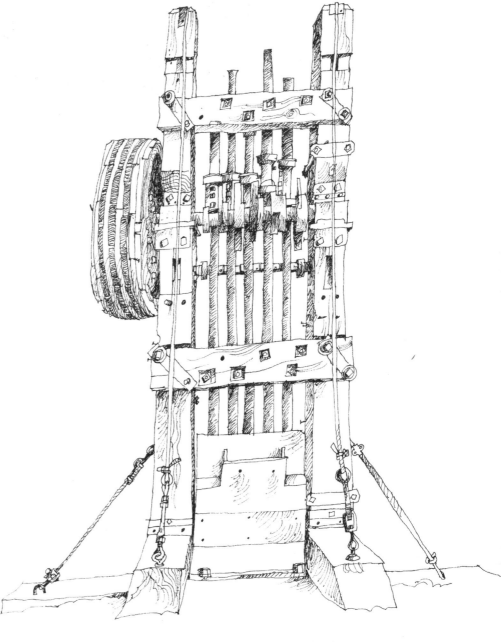

FIVE-STAMP MILL,
RANDSBURG

SHEPARD'S STAGE COACH
ROAD ACROSS PANAMINT
VALLEY, BALLARAT

I visited Ballarat after an
absence of seven years, however, I was
too late to see again that
great desert personality,
"Seldom Seen Slim". He had
died, and is buried on Boot Hill.
I sketched Ballarat's old general store
looking toward Shepard's Canyon
across the valley. The scar of the
old stagecoach road that Mr.
Shepard cut from Ballarat and Darwin
Falls in the 1890's is still visible.

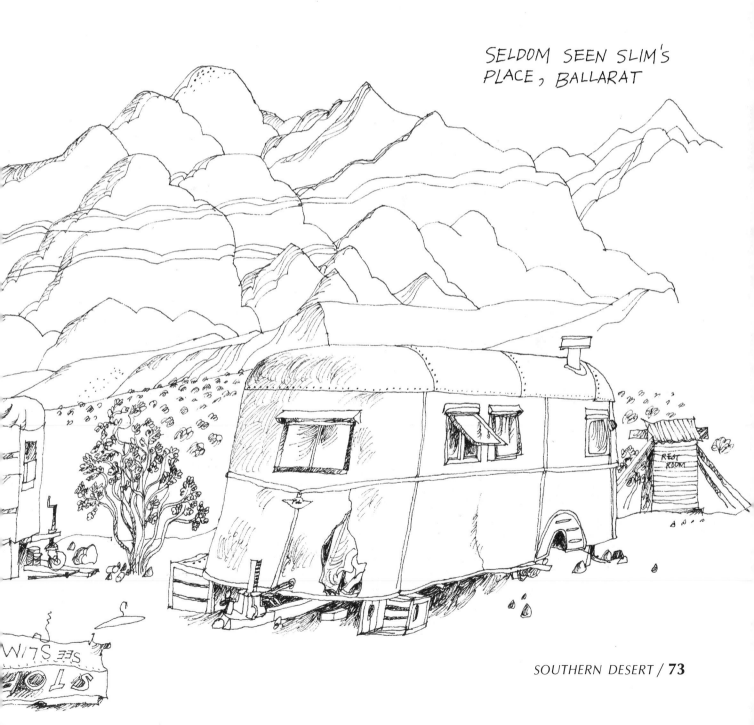

SELDOM SEEN SLIM'S
PLACE, BALLARAT

When High and Dry Keeler was a Waterfront Town

It's hard to believe that at one time sleepy Keeler was a rip-roaring place with rows of saloons, a bustling Chinatown, and an honest-to-goodness waterfront. Both the Inyo and White mountains were once a miner's dream. Since the discovery of their mineral deposits in the early 1860's, untallied millions have been taken out in gold, silver, tungsten, marble, soda, and borax. In 1872 the lead and silver bars from Keeler's smelters were accumulating faster than they could be hauled around Owens Lake by freight wagon, so miners used them like bricks, to build shelters. The surplus was finally handled by construction of an 85-foot steamer that carried 70 tons of bullion a day across the 18 miles of blue water between Swansea and Cartago. Where a navigable Owens Lake lay before 1940, when the Los Angeles Aqueduct diverted its principal inlet, are today dazzling white salts. Busy, modern plants take borax and soda from the lake-bed deposits along U.S. 395, but on the 53-mile road that circles the lake there are stretches where the only evidence of the twentieth century is the paved road.

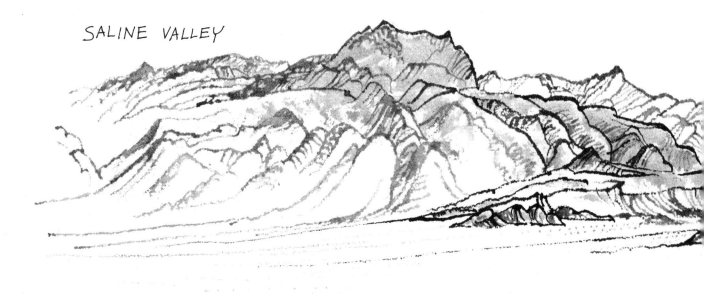

SALINE VALLEY

Saline Valley is uninhabited, so you will need plenty of gas and water for the 80-mile trip. The road is dirt for the most part. You will be astonished by the silent and somewhat forbidding desert landscape here. The only sound for me was the distant squawk of a big, western crow flying high above. There are many things to see, including the ruins of an old salt works, a salt lake, sand dunes, wild burros, and geologic formations of startling design, ending in a forest of piñon pine above the north end of the valley. I hope not too many people go through Saline Valley when you go, for the real pleasure was in being absolutely alone in such a vast and beautiful expanse of the earth's surface.

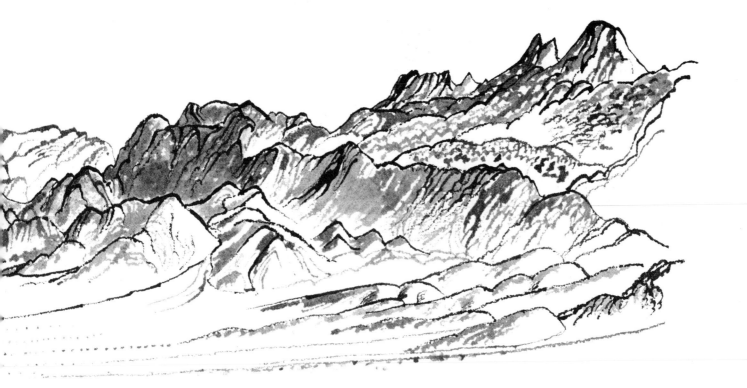

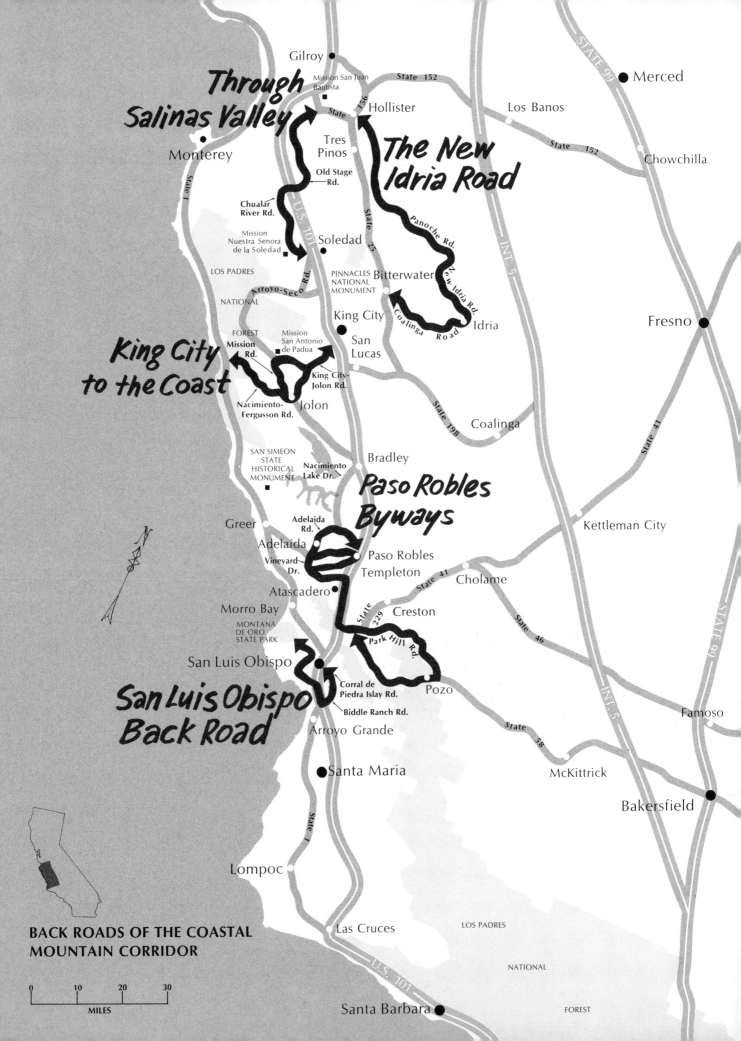

Through
Salinas Valley

Gilroy

Mission San Juan
Bautista

State 152

Los Banos

Merced

Hollister

The New
Idria Road

Chowchilla

Tres
Pinos

Monterey

Old Stage
Rd.

State 156

State 25

Panoche Rd.

Chualar
River Rd.

Soledad

New Idria Rd

Mission
Nuestra Senora
de la Soledad

Fresno

Arroyo-Seco Rd.

LOS PADRES

PINNACLES
NATIONAL
MONUMENT

Bitterwater

INT. 5

NATIONAL

King City

Coalinga Road

Idria

FOREST

Mission
San Antonio
de Padua

San
Lucas

King City
to the Coast

Mission
Rd.

King City-
Jolon Rd.

Nacimiento-
Fergusson Rd.

Jolon

State 198

Coalinga

SAN SIMEON
STATE
HISTORICAL
MONUMENT

Nacimiento
Lake Dr.

Bradley

Paso Robles
Byways

Kettleman City

Greer

Adelaida
Rd.

Adelaida

Paso Robles

Templeton

Cholame

State 41

Vineyard
Dr.

Atascadero

Creston

State 229

Park Hill Rd.

State 46

Morro Bay

MONTANA
DE ORO
STATE PARK

San Luis Obispo

Corral de
Piedra Islay Rd.

Pozo

Famoso

State 58

San Luis Obispo
Back Road

Biddle Ranch Rd.

Arroyo Grande

McKittrick

Bakersfield

Santa Maria

Lompoc

BACK ROADS OF THE COASTAL
MOUNTAIN CORRIDOR

Las Cruces

LOS PADRES

NATIONAL

U.S. 101

0 10 20 30

MILES

Santa Barbara

FOREST

State 1

State 99

INT. 5

State 41

U.S. 101

San Luis Obispo, Monterey, San Benito
Counties — Earthquake Country

THE COASTAL
MOUNTAIN CORRIDOR

**The highway that hugs the coast between San Luis Obispo and Monterey, and
the fast freeway that parallels it farther inland, give access to roads that
wind through some of California's most dramatic ocean scenery, unspoiled
mountains, inland valleys, and agricultural land.**

State 1 twists above a rugged shore, often cloaked in fog or mist, where
cypresses cling to high bluffs and the ocean swirls over beaches or in and out
of rocky tide pools. On the inland side of the highway, a few unpaved roads
climb steeply into forested hills where deer and wild boar roam freely. Other
gravel or dirt roads follow ridgetops that offer views of ocean and mountains.
Between the Carmel-Monterey area at the north and San Simeon at the south,
the coast is wild, lonely, and windswept.

U.S. 101 takes an inland route, through the rich farmland of the Salinas
Valley. East and west of the freeway, quiet two-lane roads lead through
furrowed fields and crop lands into peaceful hills and valleys spread with
vineyards and orchards.

Early California history can be relived throughout this central coastal
region. In Monterey, one can stand at the edge of the bay claimed for Spain
by its discoverer, Juan Rodriguez Cabrillo, and visit restored buildings that are
reminders of the time when this city was first the Spanish and then the
Mexican capital of California. In San Juan Bautista, one can stand in the old
plaza where stagecoaches traveling between Monterey and the gold fields
rattled to a halt in the colorful days of the 1860's. Elsewhere in the coastal
mountains and valleys, one can stroll through gardens and cloisters of missions
founded by Franciscan padres some two centuries ago.

THE COAST SOUTH OF
MORRO BAY, MONTANA
DE ORO STATE PARK

San Luis Obispo Back Road

Not far from San Luis Obispo are the coastal bluffs of Montana de Oro State Park. Returning on Los Osos Road try Prefumo Canyon Road, just 1½ miles before reaching 101, for hills, farms, and views; then on to 101. Go east from Highway 101, at Pismo Beach, onto Hinds Avenue. Hinds becomes Price Canyon Road and goes to Edna Valley.

At Biddle Road I crossed the floor of the valley and going toward San Luis Obispo sketched that big bump in the landscape, Islay Hill. Approaching San Luis Obispo you will see housing developments marching up Los Osos Valley, houses taking the place of crops.

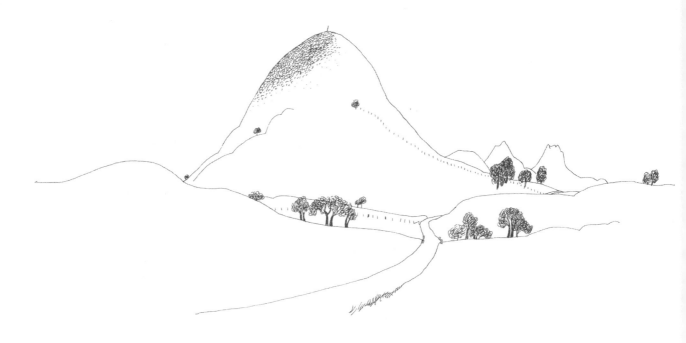

ISLAY HILL, CERRO
SAN LUIS OBISPO AND
BISHOP'S PEAK

Byways East and West of Paso Robles

Five miles east of 101, on Highway 58, is Santa Margarita. Here is where the road to Pozo begins.

There's a hundred-year-old saloon at Pozo with tractor seats for barstools. Continuing on Pozo Road, then Park Hill Road, I came across an incredible animal farm. Turkeys were gobbling, chickens cackling, ducks chasing ducks, geese honking, and all kinds of goats walked their new offspring. A shaggy, bearded Nubian goat nibbled the grass near my shoe. There were muddy, grunting pigs, bawling calves, braying donkeys, and horses and ponies!

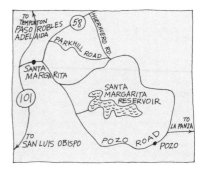

ANIMAL FARM,
PARKHILL ROAD

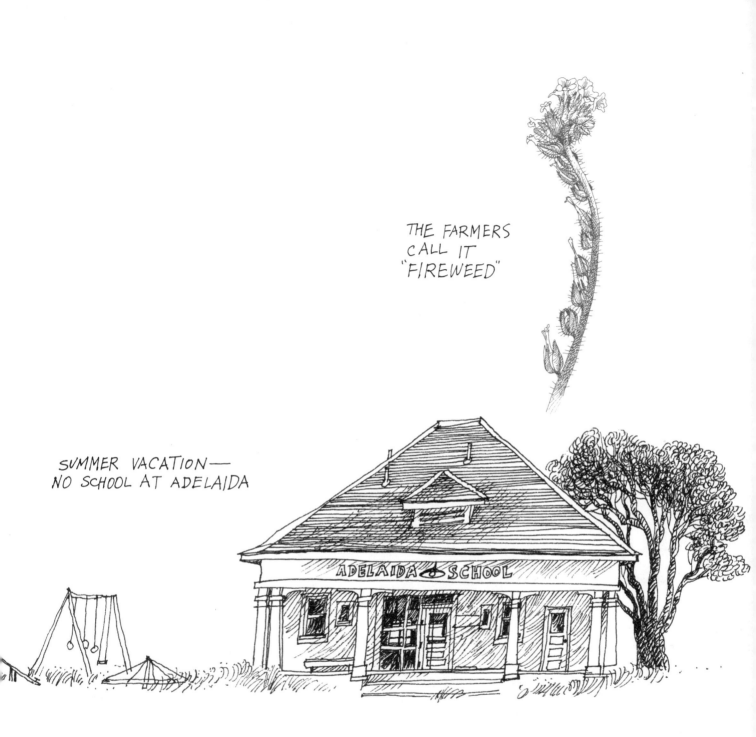

THE FARMERS
CALL IT
"FIREWEED"

SUMMER VACATION—
NO SCHOOL AT ADELAIDA

ADELAIDA SCHOOL

You'll enjoy traveling four roads to Adelaida:
Chimney Rock, Peachy Canyon, Vineyard,
and Adelaida. "People around here
don't pronounce the last "a" in Adelaida," said
the gas station attendant in Paso Robles.
This is barley country, but fireweed, the barley
farmers enemy, bloomed orange in the farmlands.

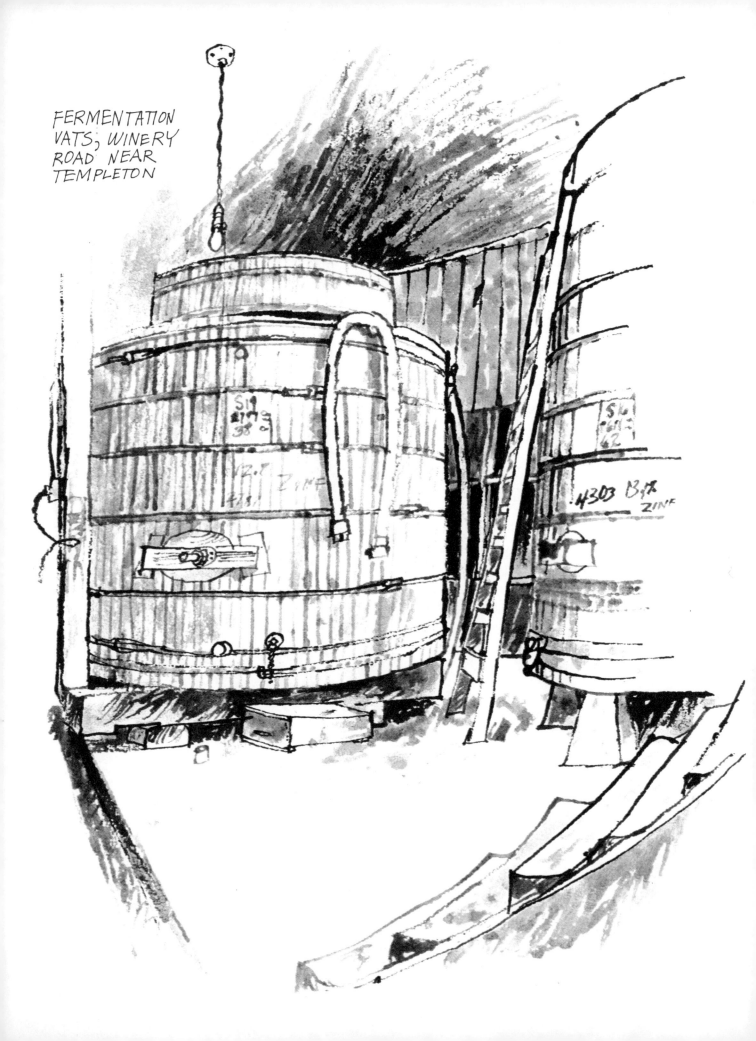

FERMENTATION
VATS, WINERY
ROAD NEAR
TEMPLETON

Off Vineyard Road, near Templeton, there are redwood fermentation tanks at the old Rotta winery. Where the road from Adelaida comes into Nacimiento Lake Road there is "Chimney Rock" with great, steep sides and an eagle's nest on top. It is a most pleasant road to Adelaida, but there no longer is a town there!

EAGLE NEST ON CHIMNEY ROCK

Quiet Route from King City to the Coast

The trip to Jolon from King City and Highway 101 is nineteen miles. You'll pass Sulphur Springs Road along the way, to your right at approximately the 14-mile mark.

I sketched the Episcopal church in Jolon, inspected the old church graveyard on the hill in back, then returned on the Jolon Road to take the Sulphur Springs Road to Mission San Antonio de Padua. It is 5 miles through oak forests, meadows, and a landscape sprinkled with wildflowers.

Two miles from the Mission the Nacimiento-Fergusson Road runs 27 miles to the coast.

ST. LUKE'S CHURCH, JOLON

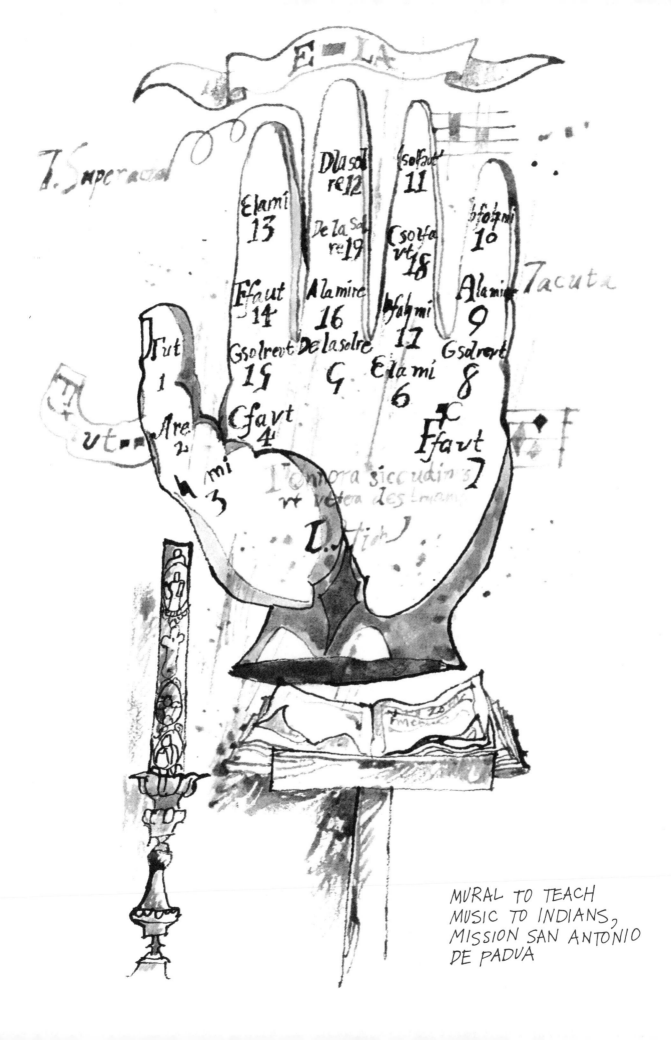

MURAL TO TEACH
MUSIC TO INDIANS,
MISSION SAN ANTONIO
DE PADUA

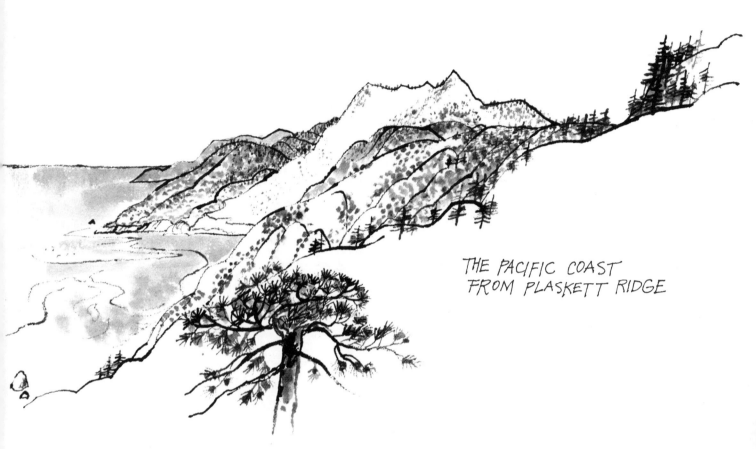

THE PACIFIC COAST
FROM PLASKETT RIDGE

Off the Beaten Path: Mission San Antonio de Padua

The mission that graces the still-pastoral countryside near Jolon, southwest of King City, authentically duplicates the one that was constructed there between 1810 and 1813. To the traveler of today, remote Mission San Antonio de Padua is one of the most charming and interesting of the missions. In its prime, it was the home of some thirteen hundred Indians who tended crops and livestock and worked at various handicrafts. Here the men learned tanning, wine making, farming, building, and stock breeding. The women learned to cook, sew, spin, and weave. Water from the San Antonio River was channeled into an elaborate waterworks to operate the grist mill and to irrigate the fields. Though it is located in the midst of a military reservation criss-crossed with tank tracks, spacious Mission San Antonio de Padua offers more rewards to the traveler than perhaps any other of the California missions.

Another Way through Salinas Valley

Two miles south of Soledad, off Highway 101, the road leads to Soledad Mission.

There are well-kept gardens at the Mission, and the old adobe ruins give atmosphere to the site.
This road becomes Fort Romie Road, then River Road to Highway 68.

MISSION BELL
CAST IN MEXICO
IN THE 1700's,
MISSION NUESTRA
SEÑORA DE LA
SOLEDAD

You feel much closer to the land, especially after sitting on the ground in a broccoli field. I left River Road for Chualar and the Old Stage Road. The Stage Road wasn't through to San Juan Bautista, so I took the San Juan Grade Road over the mountain.

San Juan Bautista is a most pleasant place to visit, with its' large Mission and other well-kept, old buildings surrounding the square. You will enjoy the ancient, gnarled pepper trees, the gardens, and the opportunity nearby to taste Almaden wines.

PEPPER TREE,
MISSION SAN JUAN
BAUTISTA

FARMING THE SALINAS VALLEY

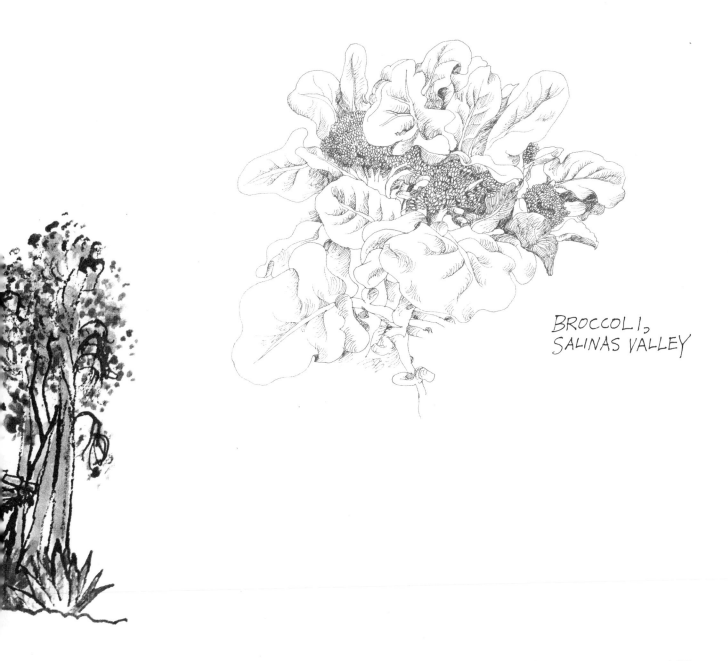

BROCCOLI,
SALINAS VALLEY

South from Hollister
along the New Idria Road

Hollister is eleven miles east of Highway
101 via either 156 or 25 farther north.

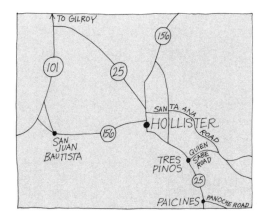

Santa Ana Road, out of Hollister, headed
for green hills yellow with mustard flowers.
I followed the road happily to Quien Sabe
Road where I turned right. Coming out of
the hills there is a picture-post-card view
of the valley with the Immaculate
Conception Church at its center.

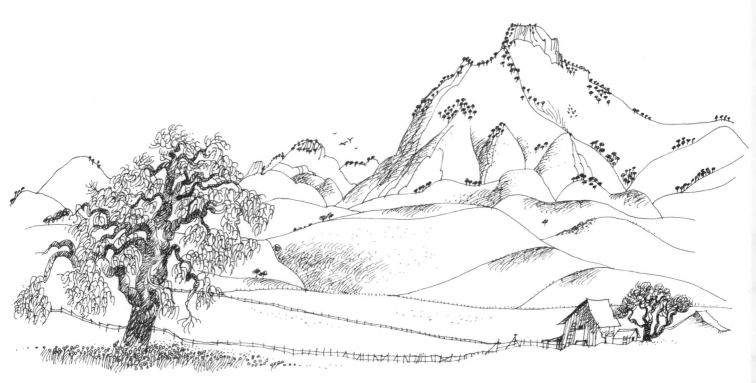

SANTA ANA MOUNTAIN,
NEAR HOLLISTER

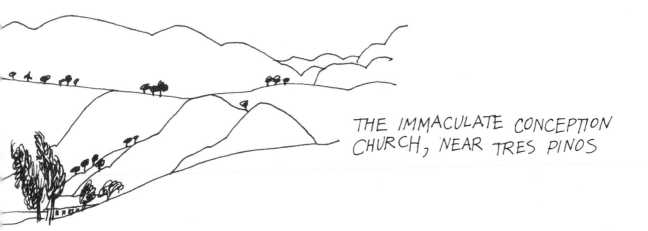

THE IMMACULATE CONCEPTION
CHURCH, NEAR TRES PINOS

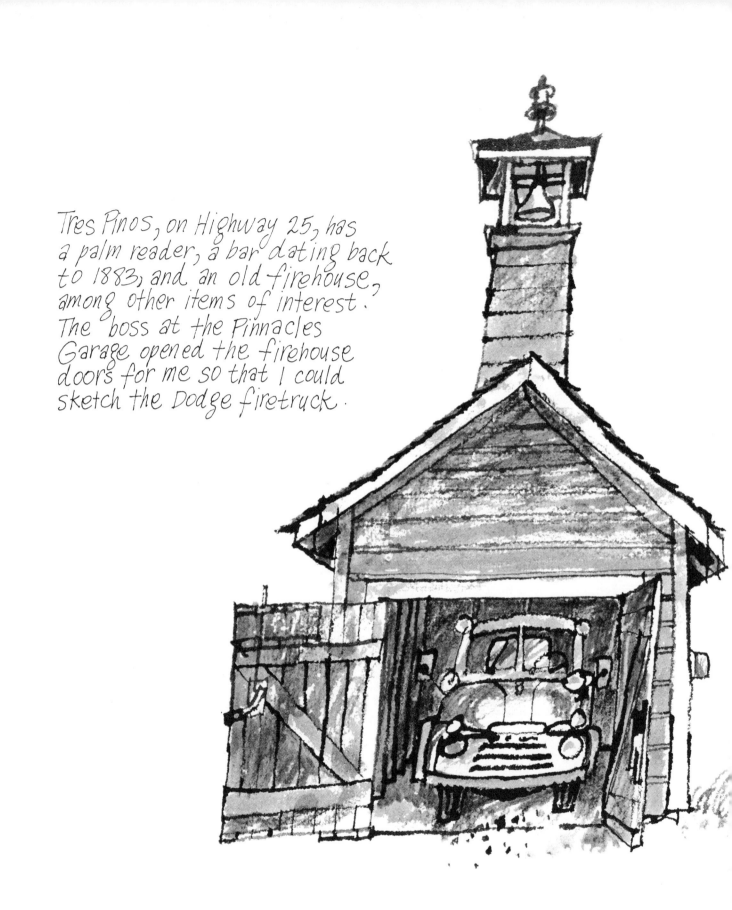

Tres Pinos, on Highway 25, has
a palm reader, a bar dating back
to 1883, and an old firehouse,
among other items of interest.
The boss at the Pinnacles
Garage opened the firehouse
doors for me so that I could
sketch the Dodge firetruck.

The Rugged Rocks of Pinnacles National Monument

For travelers who enjoy hiking, rock climbing, picnicking, and camping, Pinnacles National Monument is an excellent destination for spring or fall. It is just off State Highway 25, 35 miles south of Hollister. It can also be reached via the steep, rutted Clear Creek Road, which climbs over the Call Mountains south of the New Idria Mine and then winds down to the Hernandez Valley and Highway 25. (Road conditions should be checked at the mine office before taking the Clear Creek Road.)

The spires and crags that rise above the canyon floors in Pinnacles National Monument are the result of weathering and erosion of massive lava flows that occurred 20 million years ago. Trails in the monument are in keeping with the fantastically carved and jumbled terrain. They include natural and artificial staircases, footholds and handholds cut into the rock, narrow wooden catwalks, vaulted passageways, crawl-through passages, and even a natural "castle" pierced by a 138-foot, man-made tunnel that opens abruptly onto a concrete bridge over a yawning "moat."

THE LITTLE RED FIREHOUSE
WITH WHITE TRIM, TRES PINOS

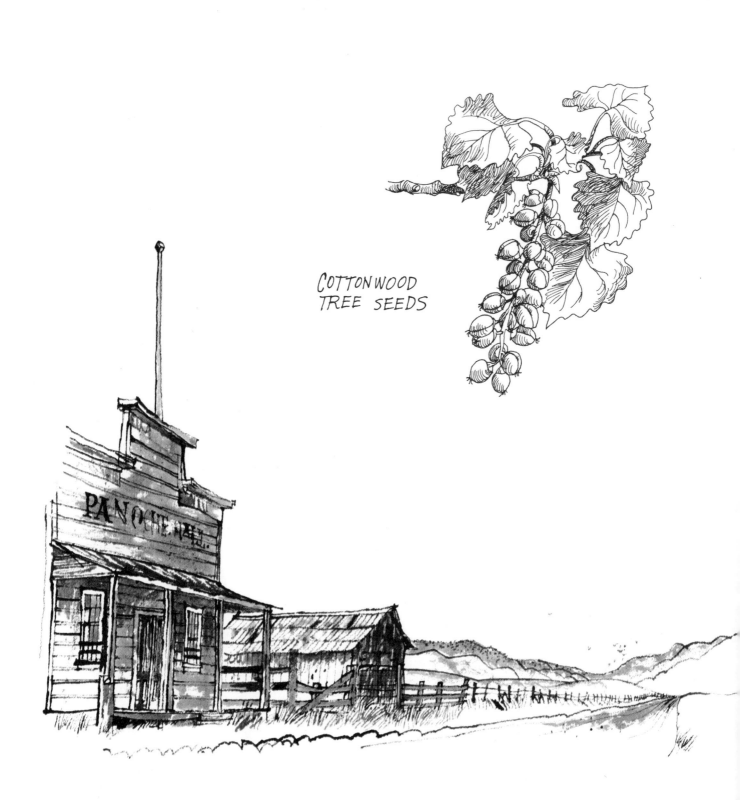

COTTONWOOD
TREE SEEDS

PANOCHE DANCE HALL
AND BLACKSMITH SHOP

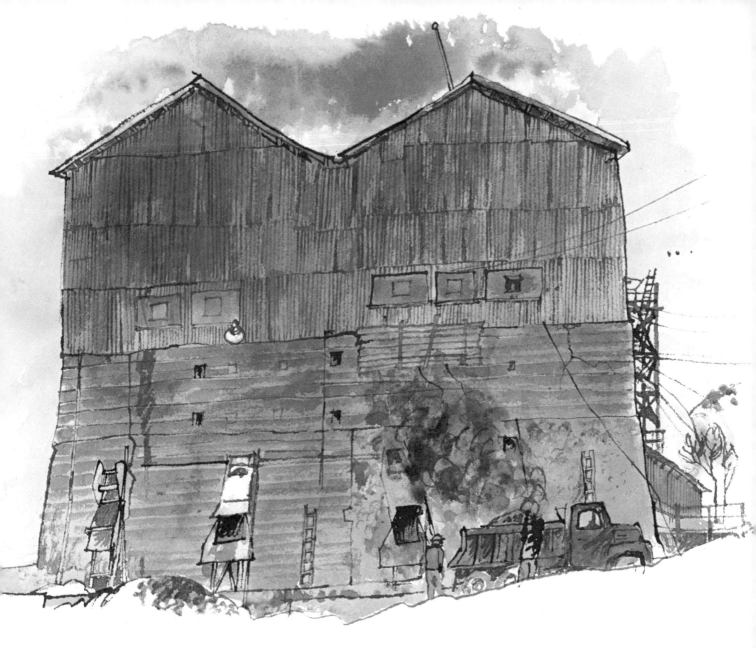

KILN AT NEW IDRIA MINE
(before shutdown)

Panoche Road begins at Paicines. It is 30 miles
to the New Idria Road, and 22 more to the mine.
There are narrow and broad valleys, farms, cattle,
and wildflowers to see, and in wide Panoche Valley
is the deserted Hall, blacksmith shop, two pigeon houses,
a windmill, and other buildings. Springtime is best
for a trip to New Idria. It would be hot in summer.
Clear Creek Road is the rugged way to return, and I
enjoyed it, splashing through the creek bed a number
of times. You need directions at New Idria to make the
14-mile Clear Creek trip successfully, then 16 miles
along Coalinga Road to Highway 25.

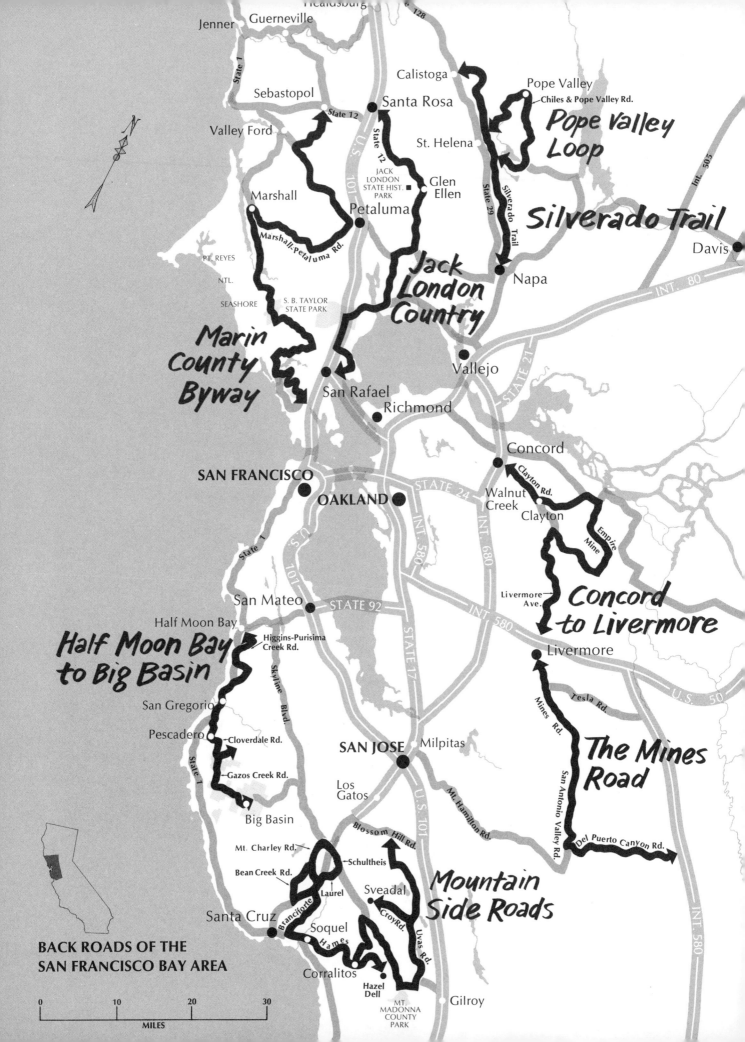

Jenner
Guerneville
Healdsburg
128

State 1
Sebastopol
State 12
Santa Rosa
Calistoga
Pope Valley
Chiles & Pope Valley Rd.

Valley Ford
U.S. 101
St. Helena
State 12
Pope Valley Loop

Marshall
JACK LONDON STATE HIST. PARK
Glen Ellen
State 29
Silverado Trail
Silverado Trail

Marshall-Petaluma Rd.
Petaluma
Davis

PT. REYES
NTL.
SEASHORE
S. B. TAYLOR STATE PARK
Jack London Country
Napa

Marin County Byway
San Rafael
Vallejo
STATE 21

Richmond
INT. 80

SAN FRANCISCO
Concord
Clayton Rd.
Walnut Creek
Clayton
STATE 24
OAKLAND
INT. 580
INT. 680
Empire Mine

San Mateo
STATE 92
Livermore Ave.
Concord to Livermore

State 1
U.S. 101
Half Moon Bay
Higgins-Purisima Creek Rd.
Livermore

Half Moon Bay to Big Basin
Skyline Blvd.
STATE 17
INT. 580
U.S. 50

San Gregorio
Tesla Rd.
The Mines Road

Pescadero
Cloverdale Rd.
Mines Rd.
Gazos Creek Rd.
State 1
SAN JOSE
Milpitas
San Antonio Valley Rd.

Big Basin
Los Gatos
U.S. 101
Del Puerto Canyon Rd.
INT. 580

Mt. Charley Rd.
Blossom Hill Rd.
Mt. Hamilton Rd.
Schultheis
Bean Creek Rd.
Laurel
Sveadal
Mountain Side Roads
Branciforte
Croy Rd.
Santa Cruz
Soquel
Hames
Uvas Rd.
Corralitos
Hazel Dell
Gilroy
MT. MADONNA COUNTY PARK

BACK ROADS OF THE SAN FRANCISCO BAY AREA

0 10 20 30
MILES

Wine Country—Marin and North Bay
Coastal and Mountain Byways

THE SAN FRANCISCO BAY AREA

Developers are busy around San Francisco Bay, and metropolitan centers continue to spread wider and climb higher. But beyond the subdivisions and the city streets, back roads lead to rural areas where cattle graze on rolling hillsides, farms survive, and vineyards glow red and gold in autumn.

Five bridges span the Bay's waters, and many roads link the cities around its edges and lead out from the Bay Area. State 1 winds north and south along the ocean's shore. U.S. 101 follows the western edge of the Bay, and State 17 hugs the eastern shore. State 35 travels the forested spine of the peninsula south of San Francisco. Interstate 80 and 580, and some less-traveled highways, lead east to the cities of the Sacramento and San Joaquin valleys.

Though the peninsula to the south of San Francisco is well-blanketed with civilization on its eastern side, winding roads explore the forested slopes of its mountains and offer glimpses of ocean to the west. Behind the East Bay cities, country lanes meander over the slopes of Mount Diablo and through countryside east of the mountain, where residential communities mix with walnut orchards, dairy farms, and cattle ranches.

North of the Golden Gate, the water-oriented communities of the Marin Peninsula attract residents and visitors in great numbers. High above them are the wooded slopes of Mount Tamalpais. At the base of the mountain, sunlight filters through a stand of virgin redwoods in Muir Woods National Monument.

In winter, migratory waterfowl gather on the shallow marshes of Bolinas Lagoon. To the west, the grasslands of the Point Reyes Peninsula stretch away to steep sea cliffs. Farther north, resorts border the Russian River. Traffic is heavy here in summertime, but not far away on the rural roads are apple country, dairy country, and wine country.

OLSSON OAK, SVEADAL

Santa Cruz Mountain Side Roads

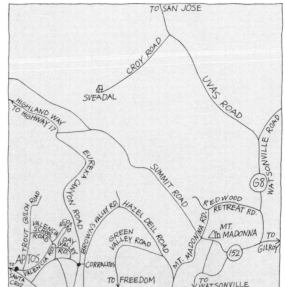

This Santa Cruz mountain journey begins in Santa Clara County. South of San Jose, County Road G8, Almaden Expressway, brings you to McKean and then Uvas Road. West of Uvas Road, 4 miles on Croy Road takes you through the Swedish resort of Sveadal.

King Gustavus, and Louise, of Sweden had been here in 1926 upon the occasion of the dedication of this resort. Continuing on Uvas Road and on Watsonville Road one mile brings you to Bonesio Winery. In 1964 Pietro Bonesio's concrete table was finally broken by the tree planted through its' center. Friends had told him that it would happen, but Pietro said, "I will be dead by that time!" He wasn't. He died at 87 years of age, outliving his table by 3 years.

CONCRETE TABLE AND MULBERRY TREE, BONESIO WINERY

Redwood Retreat Road, off Watsonville Road, leads to Mount Madonna Road and up the mountain to Mt. Madonna County Park. On the park grounds are the ruins of the turn-of-the-century millionaire's — Henry Miller — summer house. I sketched as 2 truant young boys climbed neighboring redwood trees. I heard one say, "Isn't this more educational than spending a day in that old school?"

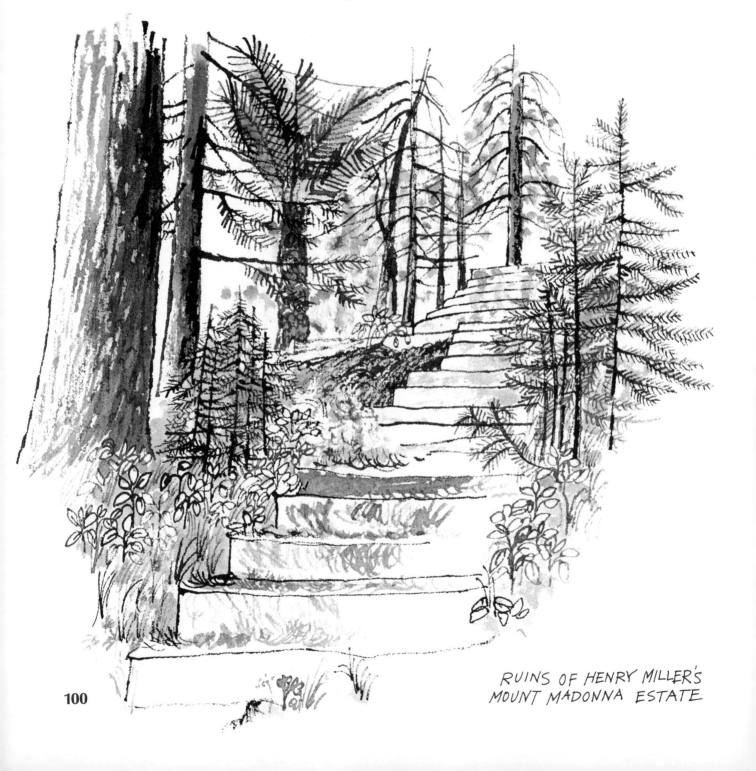

RUINS OF HENRY MILLER'S
MOUNT MADONNA ESTATE

HAZEL DELL SCHOOLHOUSE, NOW DESERTED

Mining Country: Quicksilver South of San Jose

Some of the oldest mining country in California lies at the eastern base of the Santa Cruz Mountains. The center of the area is the town of New Almaden, named for Almaden in south-central Spain. In this foothills region are pockets of rich, dark-red earth that the Indians called **moketka.** White men identified it as cinnabar. In 1824, nearly a quarter of a century before California's gold strike at Sutter's Mill, Don Antonio Suñol worked the moketka briefly, in the mistaken belief that it contained silver. He abandoned his efforts, and New Almaden drowsed until 1845 when Andres Castillero discovered that the red earth contained quicksilver. There were three mines in the Almaden area. The richest and most extensive was at Almaden itself, with more than 100 miles of tunnels honeycombing the red hills. Six miles north of New Almaden was Enriquita mine, named for the daughter of the mine manager. The Almaden and Enriquita together produced quicksilver valued at more than 50 million dollars. The Guadalupe mine, on the banks of the Guadalupe River, was less productive, chiefly because it was a difficult mine to keep dry.

APPLE TREE PRUNING,
COX ROAD

Coming down from Mt. Madonna and the Santa Cruz mountains, enjoyable roads to explore are: Summit, Highland, Brown's Valley, Hazel Dell, Green Valley, Day Valley, Cox, Valencia School, and Trout Gulch Roads.

I traveled along Highway 1, from Aptos, turning toward the mountains again on Branciforte Drive. Along here you can make an entertaining stop at "Mystery Spot." Granite Creek Road and Glenwood Drive bring you to Bean Creek Road, a most pleasant backroad. It ends in Scott's Valley and a sea of glittering mobile homes.

North on Highway 17 I traveled east onto Laurel Road and Schultheis Road. I stopped to sketch a great pen of chickens, guinea hens, ducks, drakes, and geese. It was breeding season and there was much strutting, clucking, and chasing going on.

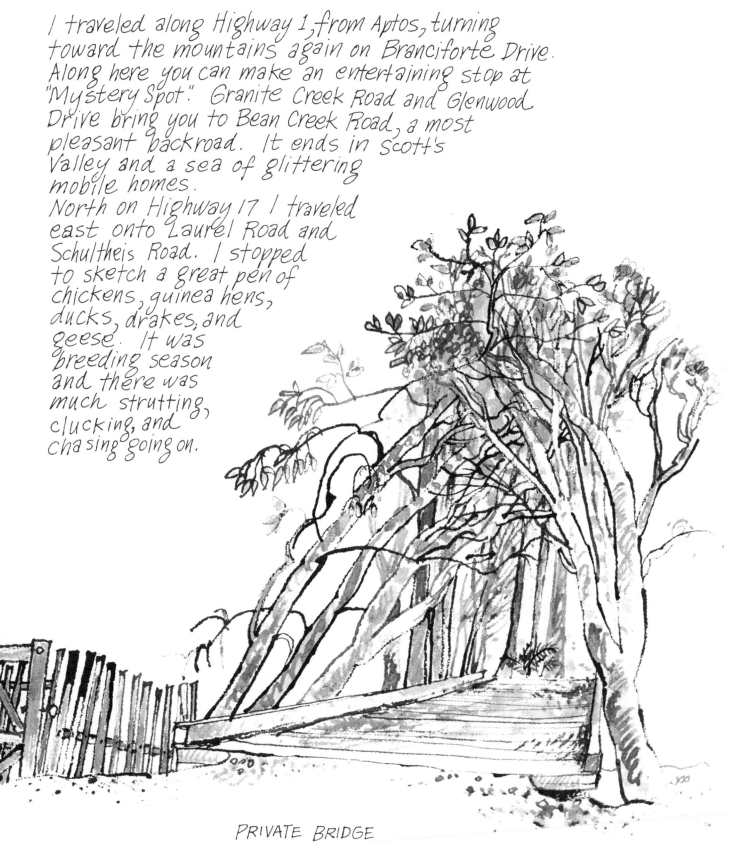

PRIVATE BRIDGE
ALONG BEAN CREEK ROAD

I showed my drawing to the
family that owned the farm,
and they knew each winged
creature by name. I was
flattered that I could have
caught individual likenesses.
From Schultheis Road you can turn
right onto Woodwardia Highway,
then left on Summit Road
North, across Highway 17
to Mountain
Charley Road.

HILLSIDE FARM,
SCHULTHEIS ROAD

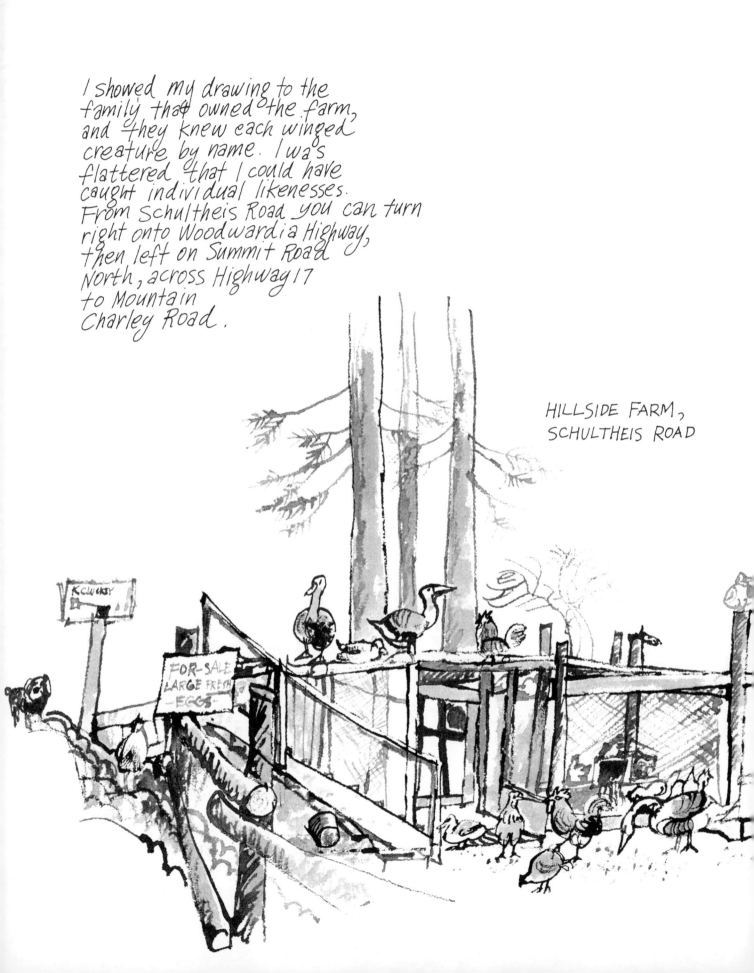

LOG CABIN,
MOUNTAIN CHARLEY ROAD

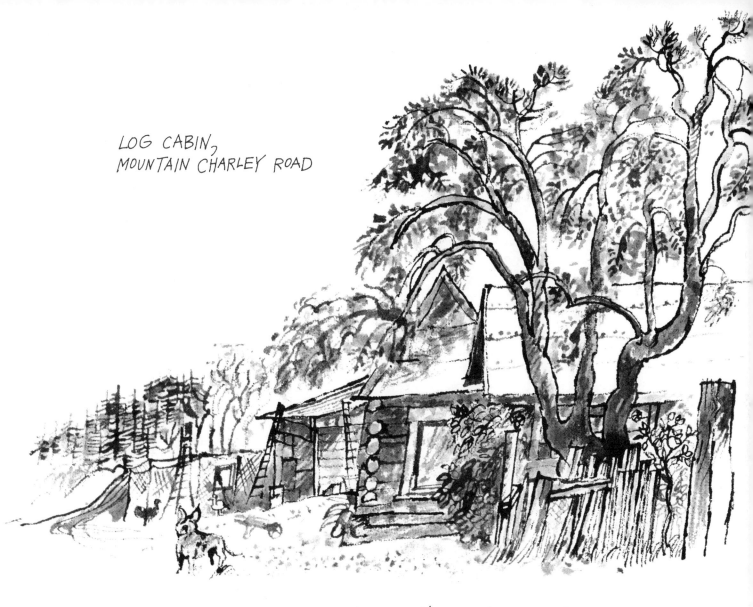

A sign at the entrance to
Mountain Charley Road says,
"An early pioneer toll road named
in honor of M.C. McKiernan who
survived a hand to hand battle
with a grizzley bear near here
on May 10, 1854 — speed limit —
20 mph — sound horn on blind curves".
I rode Mountain Charley at 10 mph,
or less. At the crest is an old
cabin made of logs. It is
supposed to be over 100 years old.
You exit onto Glenwood Drive,
not far from Highway 17.

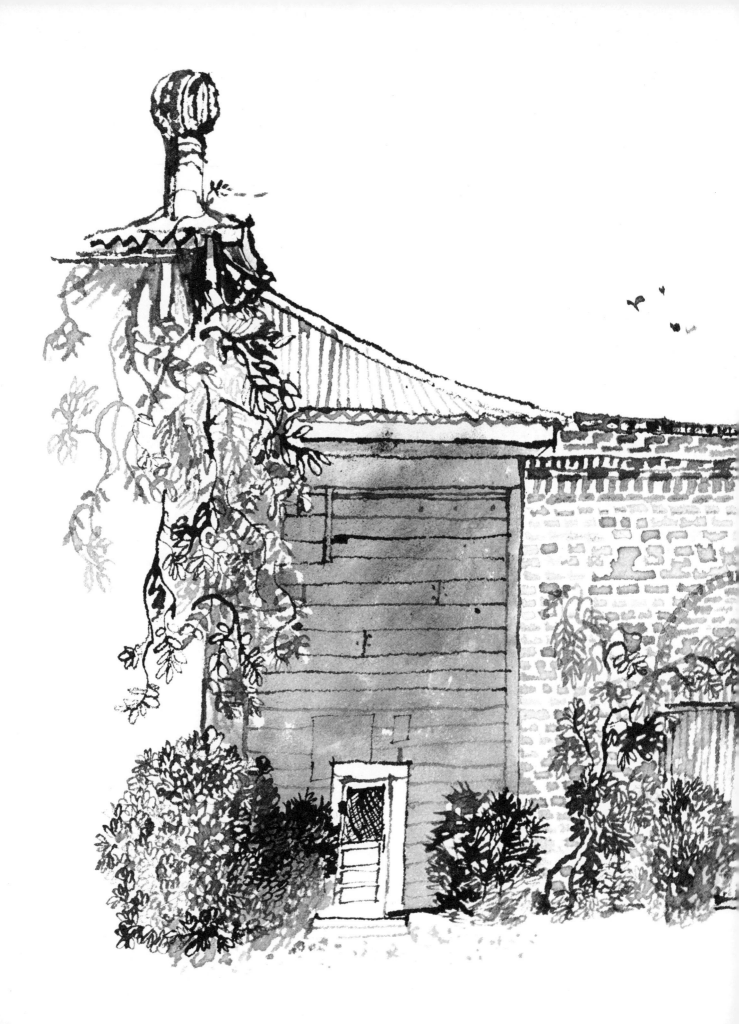

South from Livermore along the Mines Road

Two miles south of Livermore, the Mines Road branches off Tesla Road. Upon reaching the Bayou Road in San Antonio Valley you may proceed toward Lick Observatory, or go east along Del Puerto Canyon Road to Interstate 5.

I sketched the 1883 Concannon Winery where, to my taste, some of California's finer wines are made.

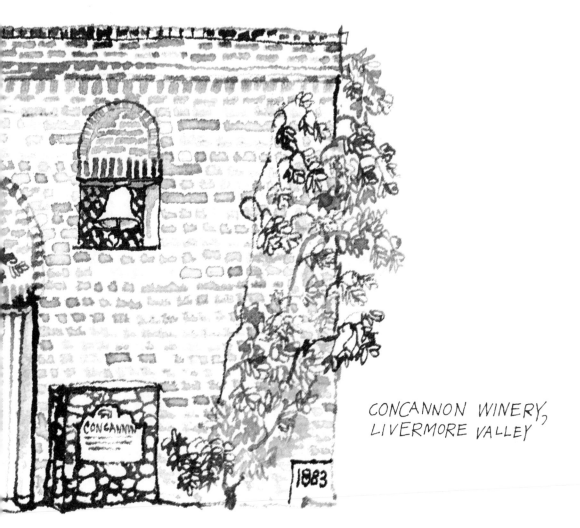

CONCANNON WINERY,
LIVERMORE VALLEY

CONCANNON

1883

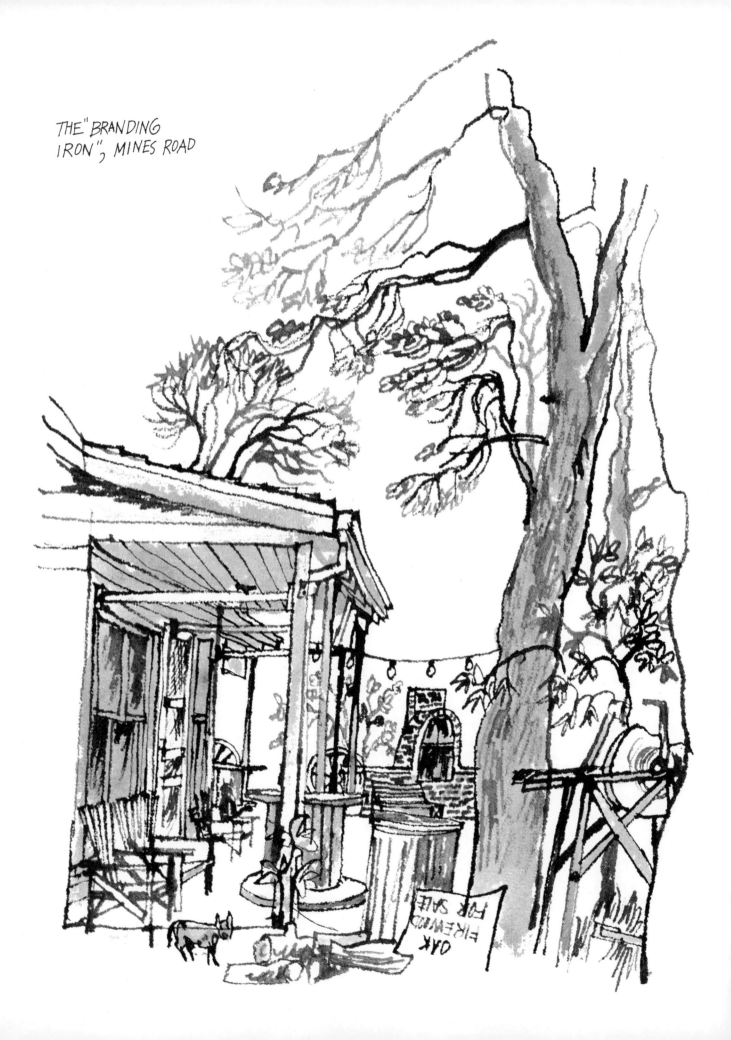

THE "BRANDING
IRON", MINES ROAD

OAK
FIREWOOD
FOR SALE

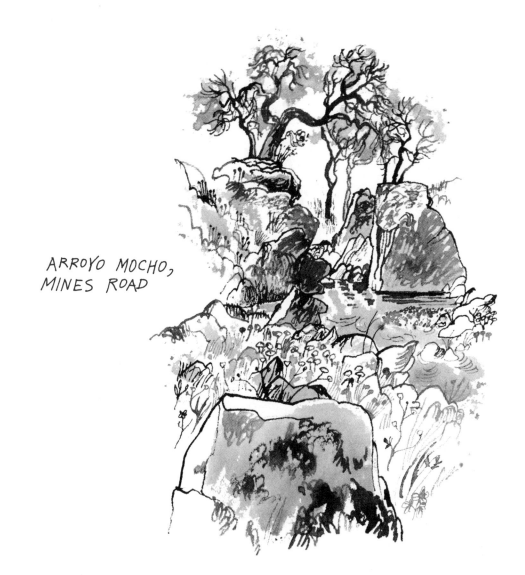

ARROYO MOCHO,
MINES ROAD

At the "Branding Iron," Ruth, the co-owner, gave me two brown eggs fresh from mother hen for my breakfast. The grey cat rubbed against my leg as I sketched. A mule nearby scratched loudly and made undignified noises. In the morning, wildflowers were out before this artist. There were dwarf lupines, tidy tips, indian paint brush, fragonia, and goldfields, among others. Millions of flies gathered around freshly splattered cow plops. These were avoided. A drawing was made where dandelions and buttercups grew in profusion along the bed of the Arroyo Mocho stream.

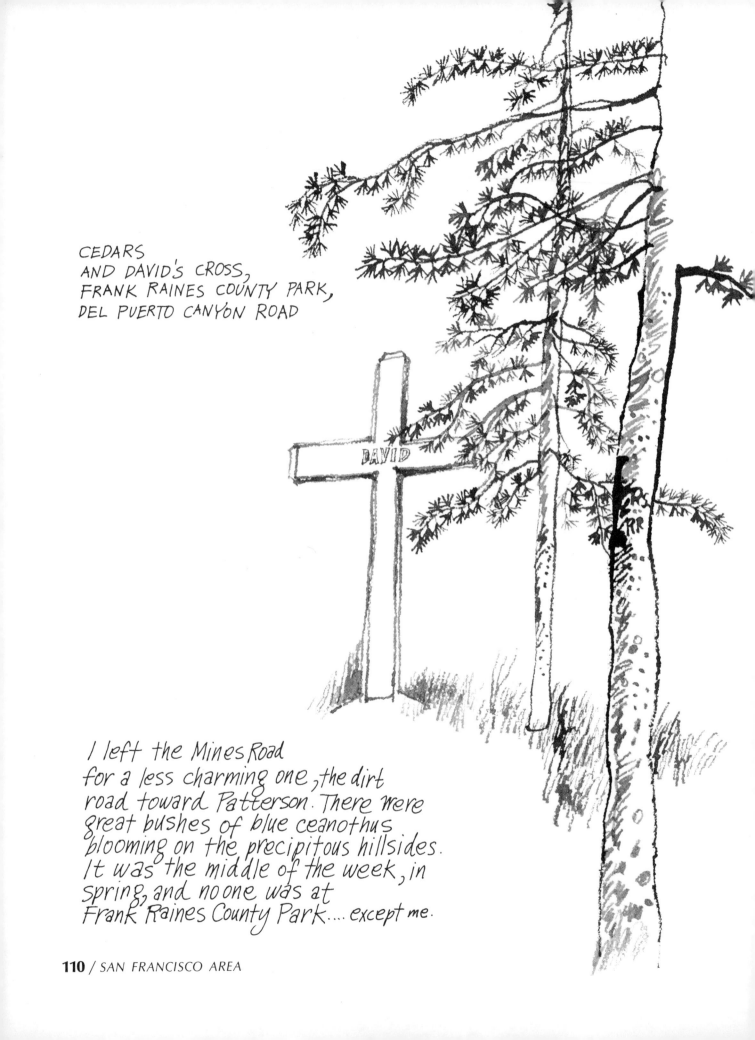

CEDARS
AND DAVID'S CROSS,
FRANK RAINES COUNTY PARK,
DEL PUERTO CANYON ROAD

I left the Mines Road
for a less charming one, the dirt
road toward Patterson. There were
great bushes of blue ceanothus
blooming on the precipitous hillsides.
It was the middle of the week, in
spring, and no one was at
Frank Raines County Park.... except me.

The Highest Road in the Bay Area

Southwest of Interstate 5/580, and continuing from Mines Road, sinuous San Antonio Valley Road follows the northern slopes of the Mount Hamilton Range, and opens to beautiful views of the valley of Arroyo Mocho. Just south of the Del Puerto Canyon Road junction, San Antonio Road turns west and becomes Bayou Road. It climbs through low-brush, scrub-grass cattle country, fed by several small, summer-dry creeks, to the 4,209-foot summit of Mount Hamilton. This is the highest road summit in the Bay Area. Atop the mountain is James Lick Observatory, open every Saturday and Sunday. Visitors can view the world's second-largest reflector telescope from a small gallery in the domed building that houses it, and then see the 36-inch refractor telescope in use since 1888. West of the summit, Mount Hamilton Drive winds for 19 panoramic miles down through wooded slopes of pine, oak, and manzanita, and past neatly manicured farms and apricot orchards, to Alum Rock Avenue in San Jose.

MADRONE BERRIES

SOME BAY AREA WILDFLOWERS

SELF-HEAL

MONKEY FLOWER

Back Road—Half Moon Bay to Big Basin

Higgins-Purisima Road begins a series of backroad explorations off Highway 1. It starts one mile south of Half Moon Bay.

You travel past farms and cows and rolling hills, then turn sharply back where the valley has become narrow, and moist, and where suddenly there are redwoods, firs, and ferns. I reached Stage Road via Verde Road, Lobitos Creek Cutoff, Tunitas Creek Road, and Highway 1. Stage Road begins about a mile and a half south of Tunitas, through San Gregorio and across Highway 84. At Willowside Ranch begins the magnificent eucalyptus arcade. Stage Road ends at Pescadero and a short distance east of here is the road to Butano State Park.

EUCALYPTUS ARCADE,
STAGE ROAD

WHITEWASHED BARN
PURISIMA CREEK ROAD

STUMP ALONG
THE GAZOS

Redwood Parks in the Santa Cruz Mountains

Six parks in the Santa Cruz Mountains protect remnants of the primeval redwood forest that once extended from the southwest corner of Oregon all the way to the Santa Lucia Mountains south of Monterey. Big Basin Redwoods State Park (on State 236), established in 1901, is the oldest park in California's state park system. It encloses a handsome stand of mature trees, and its nature lodge has excellent exhibits. Portola State Park and San Mateo County Memorial Park (both west of State 35, Skyline Boulevard, and east of Big Basin), are popular day-use and camping parks. Henry Cowell Redwoods State Park (State 9, north of Santa Cruz) stretches for more than two miles along the San Lorenzo River. It is a day-use park, with 13 miles of trails. Butano State Park (east of State 1 and south of the town of Pescadero) and Forest of Nisene Marks State Park (north of State 1, just below Santa Cruz) can be used for hiking and for picnicking.

Leaving Butano State Park camping area on Gazos Creek Road a sign says "IMPASSABLE IN WET WEATHER." Douglas Firs were the first big trees along this road. They dripped with lichen, especially the dead trees. Forest growth became more lush as I drove on. Red and white alders, maples, and redwoods made a dark, damp valley where ferns grew in abundance. 14 miles of narrow, winding road through thick forest ends at Big Basin Redwood State Park. The sign at this end of Gazos is more forbidding...... "HAZARDOUS IN SUMMER, IMPASSABLE IN WINTER."

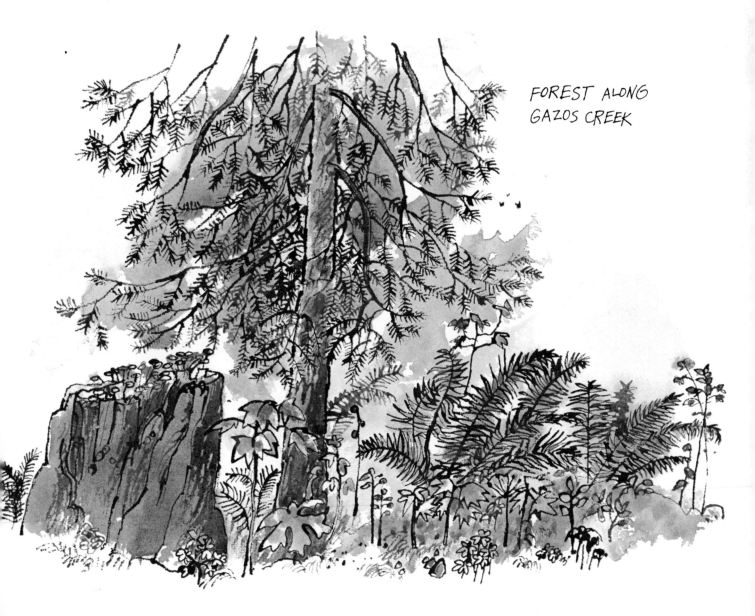

FOREST ALONG
GAZOS CREEK

BUCKEYE TREES,
BLACK DIAMOND WAY

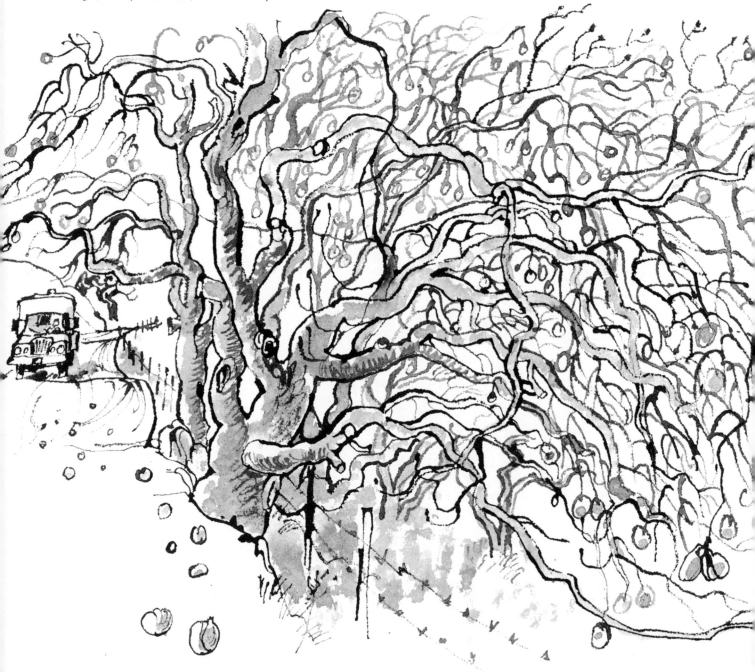

The Long Way from Concord to Livermore

Concord to Clayton is 7 miles. Here you find the dirt road, Black Diamond Way. It connects with Nortonville and Somersville Roads to U.S. 4. Off Highway 4 at Antioch, Empire Mine, Deer Valley, Marsh Creek, and Morgan Territory Roads give glimpses of Mt. Diablo as they wend through canyons, meadows, and rolling hills.

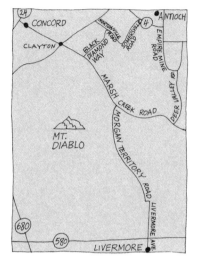

There is a magnificent grove of California Buckeye trees along Black Diamond Way. They grow on a steep hillside and the road passes among them. The Buckeye seeds are as large as tennis balls and hang at the tips of branches. I stopped to sketch and to listen to the musical, crystal-clear songs of meadow larks. Occasionally one of those Buckeye balls would drop with a "bonk" sound to the ground.

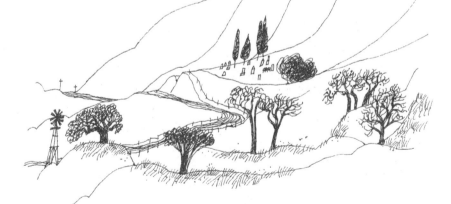

GRAVEYARD OF WELSH MINERS, ALL THAT IS LEFT OF THE COAL TOWN OF SOMERSVILLE

117

Marin County Byway

North of San Francisco, Highway 1 leaves 101 and in 3 or 4 miles you can turn off 1 onto Panoramic Highway.

The Pacific Ocean is viewed on the left, and San Francisco Bay is on the right. A half mile before the German-style Mountain Home Inn is the Tyrolean "Tower House." It was built in 1915 by people from Germany and was open for the public to see at the time I visited. The owner's dog kept mumbling about my presence, but, regardless, my drawing was completed. Higher along this road to Tamalpais peak is the Mountain Theater where plays are given each year in the open air. I drove on Ridgecrest, with views of Bolinas Bay, then down to Alpine Lake, to Fairfax and Lagunitas.

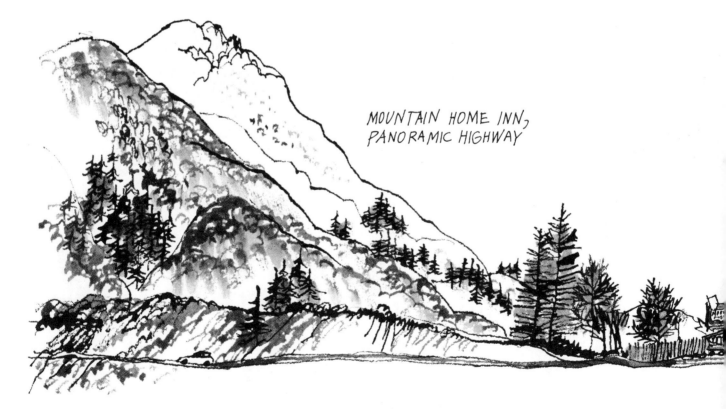

MOUNTAIN HOME INN,
PANORAMIC HIGHWAY

THE TOWER HOUSE,
PANORAMIC HIGHWAY

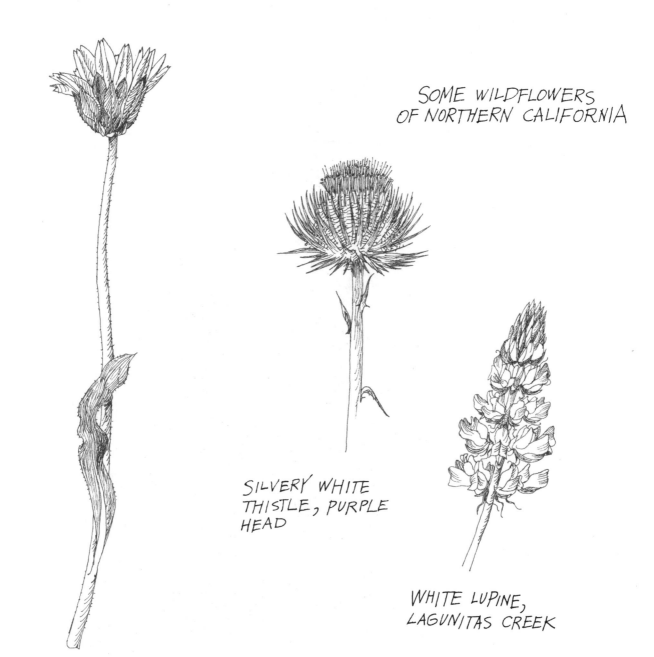

SILVERY WHITE
THISTLE, PURPLE
HEAD

WHITE LUPINE,
LAGUNITAS CREEK

BRIGHT YELLOW
MULE-EAR

Sir Francis Drake and the Indians

The Coast Miwok Indians considered the Point Reyes Peninsula the abode of the dead, but this didn't stop them from living there. Numerous mounds mark village sites, particularly along the shores of Tomales Bay where the villagers gathered the abundant shellfish. In 1578, Sir Francis Drake landed his ship, **Golden Hind,** in a place that sounds, in his chaplain's account, very much like Drake's Bay. The chaplain described "white bankes and cliffes," foggy weather, and moorlike land. Drake was met by Coast Miwoks and may have given them the Ming porcelains that have since been found in several village mounds.

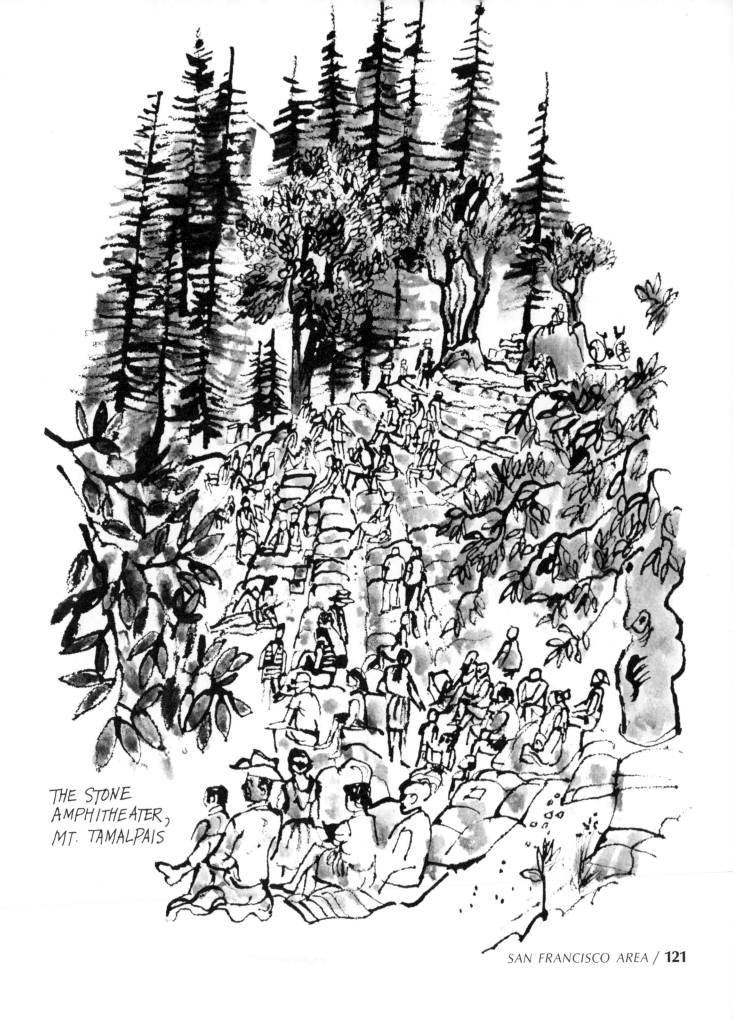

THE STONE
AMPHITHEATER,
MT. TAMALPAIS

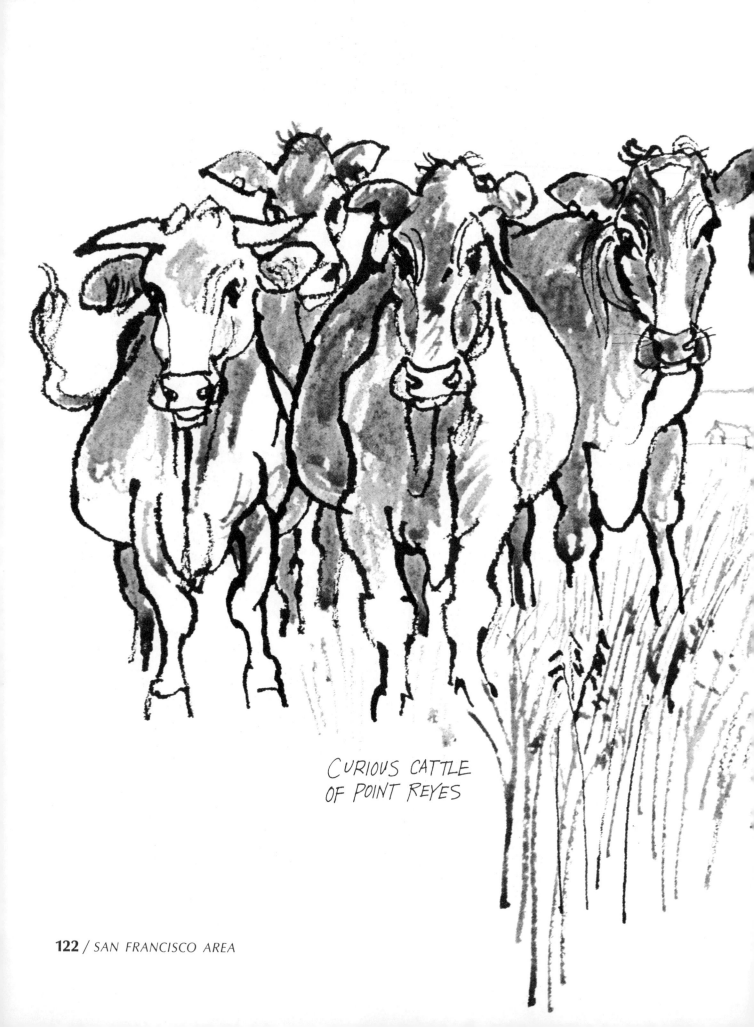

CURIOUS CATTLE
OF POINT REYES

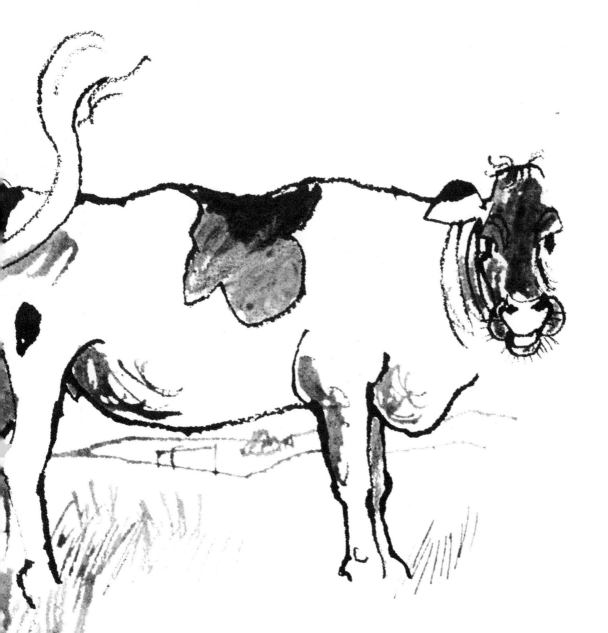

All roads along the coast north of San Francisco are picturesque. I drove Platform-Bridge Road along Lagunitas Creek, the Pt. Reyes-Petaluma Road, and Highway 1 north of Pt. Reyes Station. I sketched cattle that came to stare and chew, working quickly before they returned to munch grass.

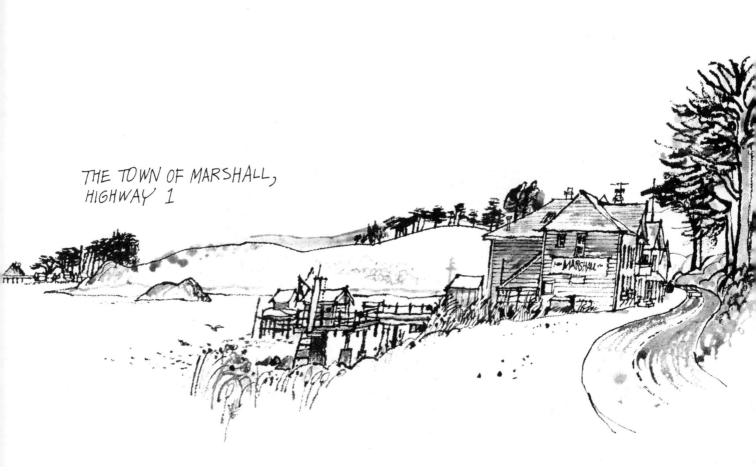

THE TOWN OF MARSHALL,
HIGHWAY 1

At the Marshall Boat Works, the commercial fishing boat
"DONNA" was having its undersides painted as the owner
discussed fishing successes with a fat fisherman friend.
I sketched. The weather was sunny, the air fresh. A bank
of fog was held back by the hills of Inverness across
Tomales Bay. Turn right on the Marshall-Petaluma road
for good views of the bay and the Pt. Reyes National
Seashore area. Farther on there is a good view looking
toward Petaluma with Hicks Valley below. This is
sheep and cattle country and the hills roll along endlessly.

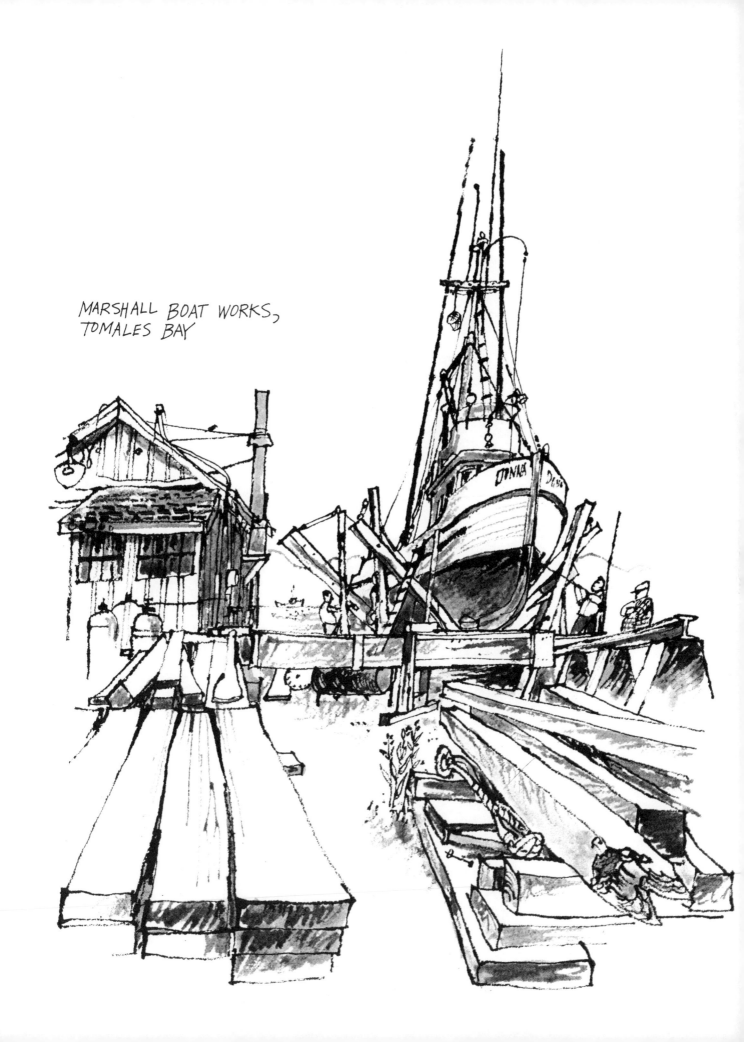

MARSHALL BOAT WORKS,
TOMALES BAY

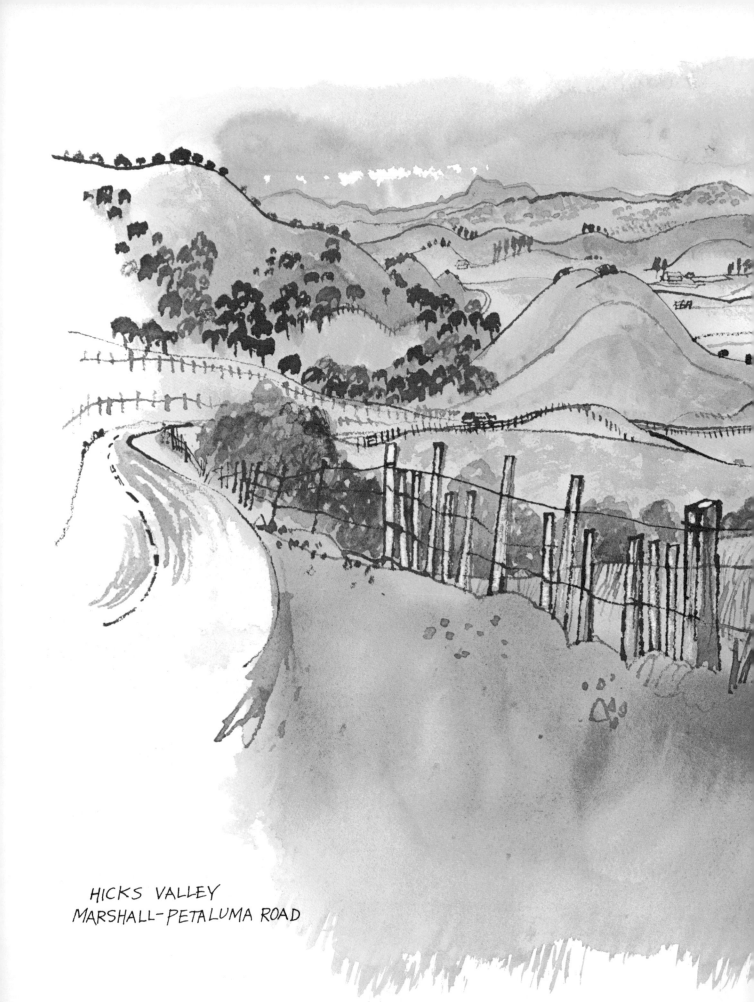

HICKS VALLEY
MARSHALL-PETALUMA ROAD

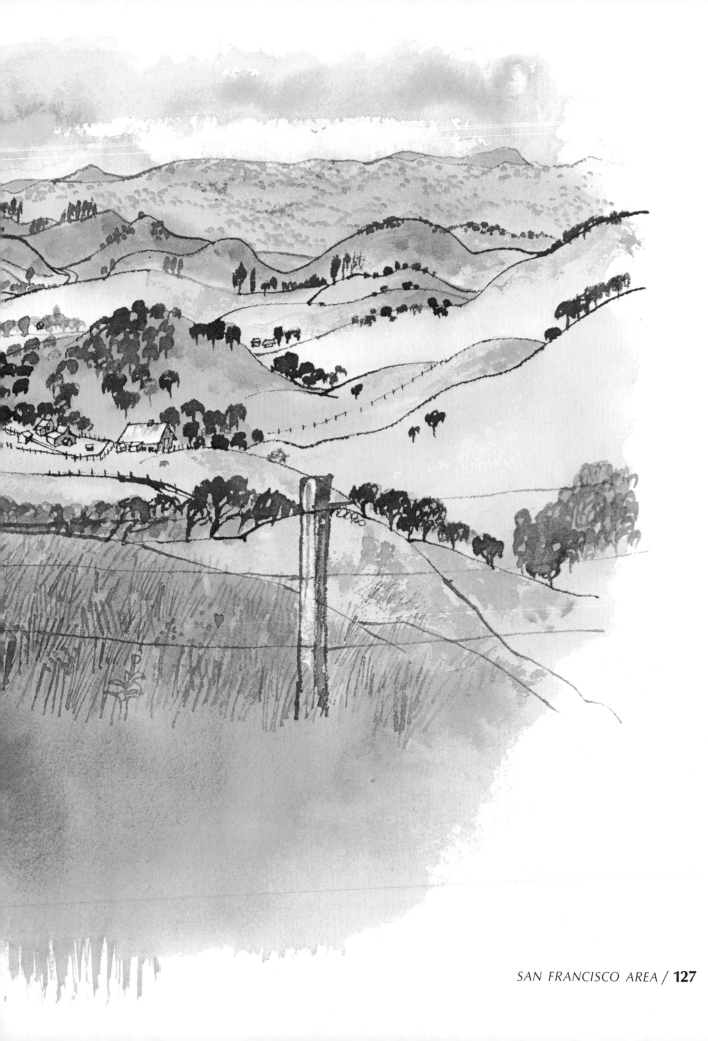

San Rafael to Santa Rosa, via Jack London Country

My route was Mission San Rafael Arcangel, San Rafael, as a starting point, then east along Pt. San Pedro Road, via 3rd Street, to China Camp, past Rat Rock to 101. The Black Point Cutoff, Lakeville Road, Stage Gulch Road, and Arnold Drive through the Valley of the Moon take you to Glen Ellen.

JACK LONDON'S GRAVE

Up the hill one mile is Jack London's place. Learn its history, then let the area's special beauty and mystique become a part of you. Discover the little graves of 2 children, near Jack's own lava gravestone. In his book "Burning Daylight" there is a description of them. Walk through the "Forest of Disappointment," and see traces of the old carriage road between his cottage and Wolf House.

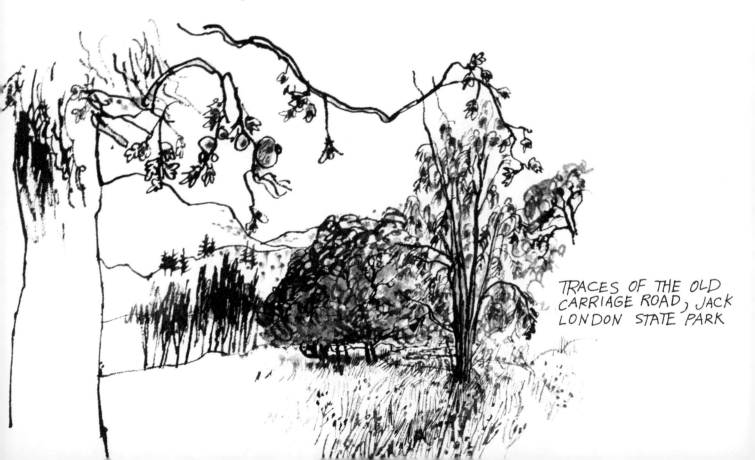

TRACES OF THE OLD CARRIAGE ROAD, JACK LONDON STATE PARK

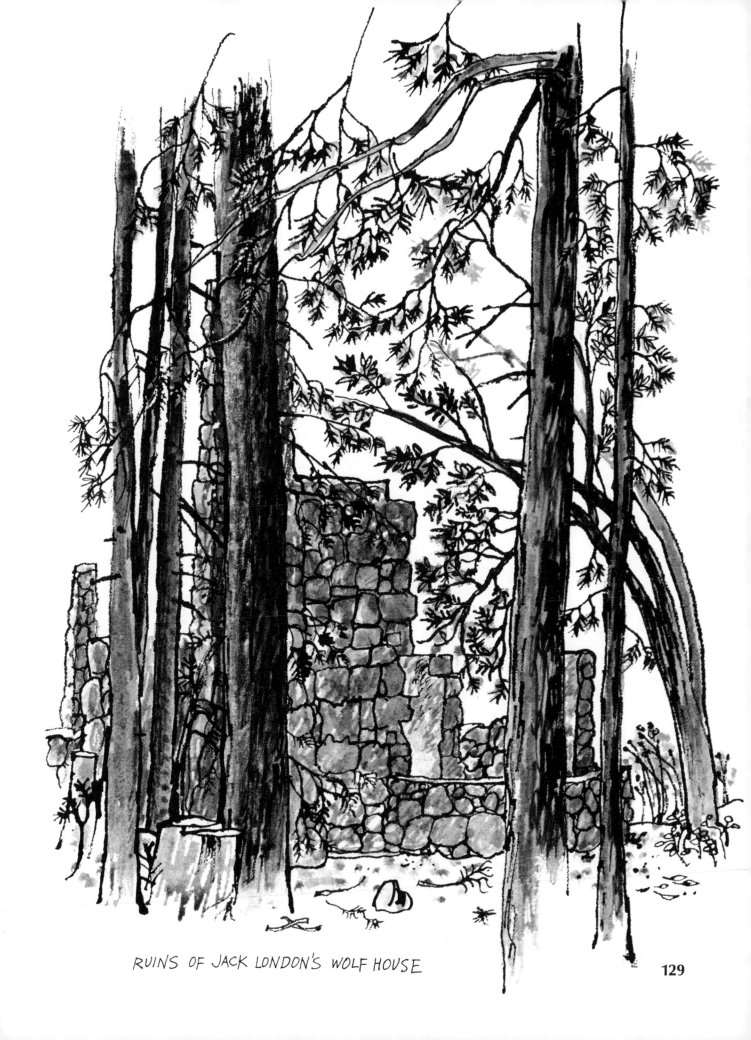

RUINS OF JACK LONDON'S WOLF HOUSE

Wine Country—The Silverado Trail

The easiest way to find the Trail is to go north of Napa on Highway 29 to Trancas Road, turn right, and in two miles go left onto Silverado Trail.

Here, before spring plowing, mustard flowers form a brilliant, yellow carpet amongst young vines. At Taplin Road, near St. Helena, is one of the original 60 or 70 stone bridges that caused this valley to be called "County of Bridges" in 1900. Opposite this stone bridge is an old schoolhouse painted dark green with white trim, the school bell still in its tower.

YOUNG VINEYARD ALONG THE SILVERADO TRAIL

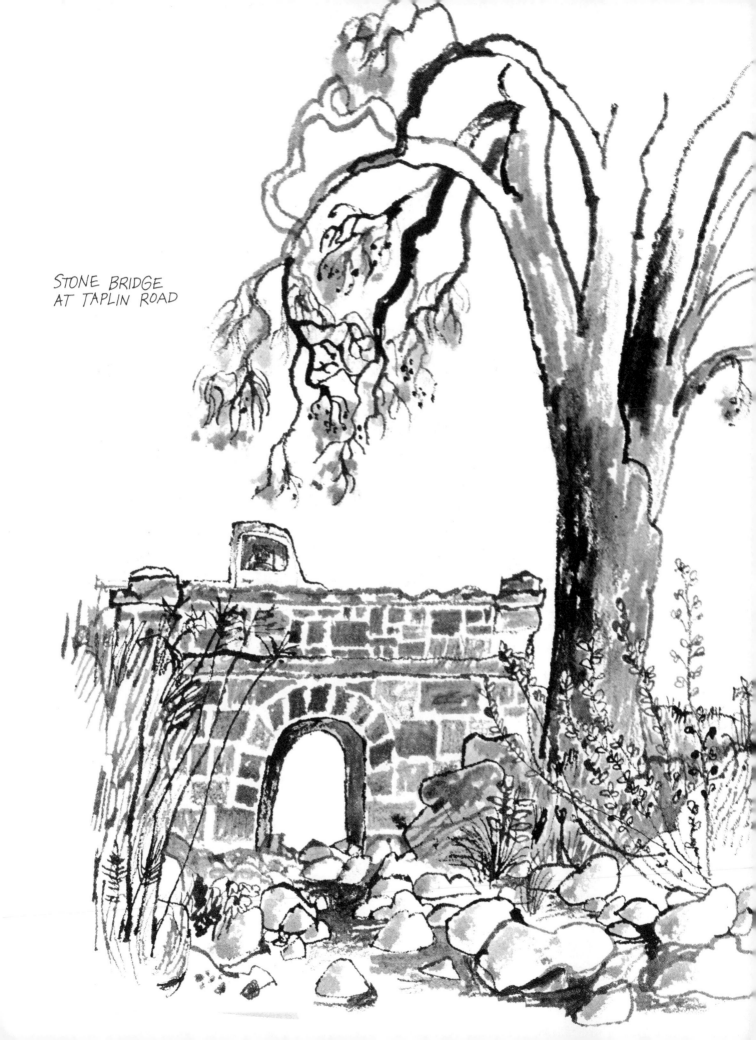

STONE BRIDGE
AT TAPLIN ROAD

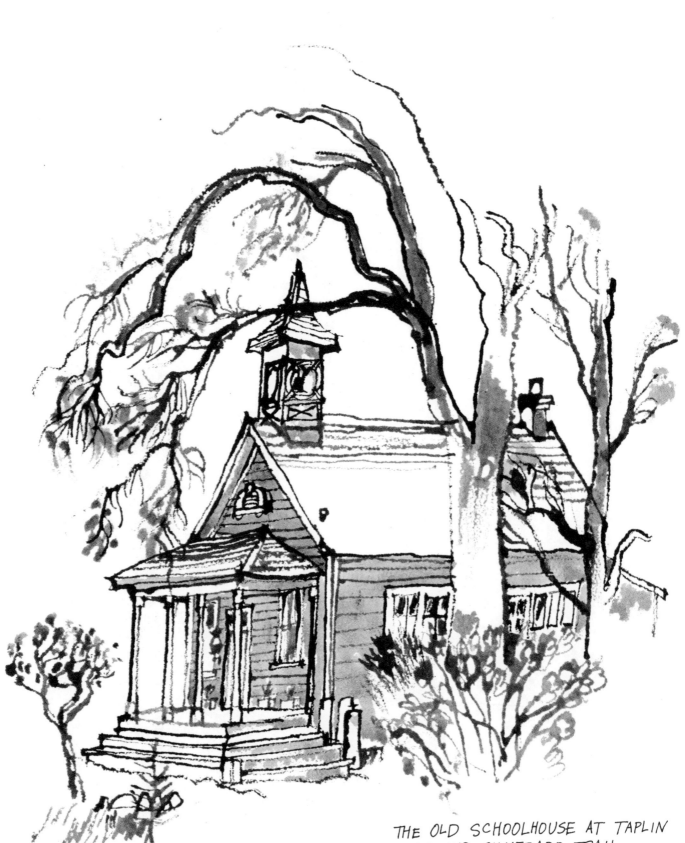

THE OLD SCHOOLHOUSE AT TAPLIN
ROAD AND SILVERADO TRAIL

Silver and quicksilver mining in the mountains north and east of the Napa Valley in the 1800's inspired the name of "Silverado", and in 1921 Silverado Trail officially got its title by a split three to two vote of the Napa Board of Supervisors. Until that time it was known as "The Old Back Road". The curves are continually being removed from the Silverado Trail, to my regret, thus encouraging motorists to speed, and pass all too quickly through an area of great beauty and interest.

THE NAPA RIVER
AT ZINFANDEL LANE

North of the Pope Street bridge you
may turn right on Glass Mountain
Road ½ mile to Glass Mountain
Lane. Along the Lane is Elmshaven,
the former home of Ellen G. White,
respected 7th Day Adventist
writer and leader. It is open
for the public to see.
The trip was 30 miles from
Napa to Calistoga. You can go
another 2½ miles north, on
Highway 29, to drive up
Palisades Road for a closer
look at Calistoga's
"High Rocks."

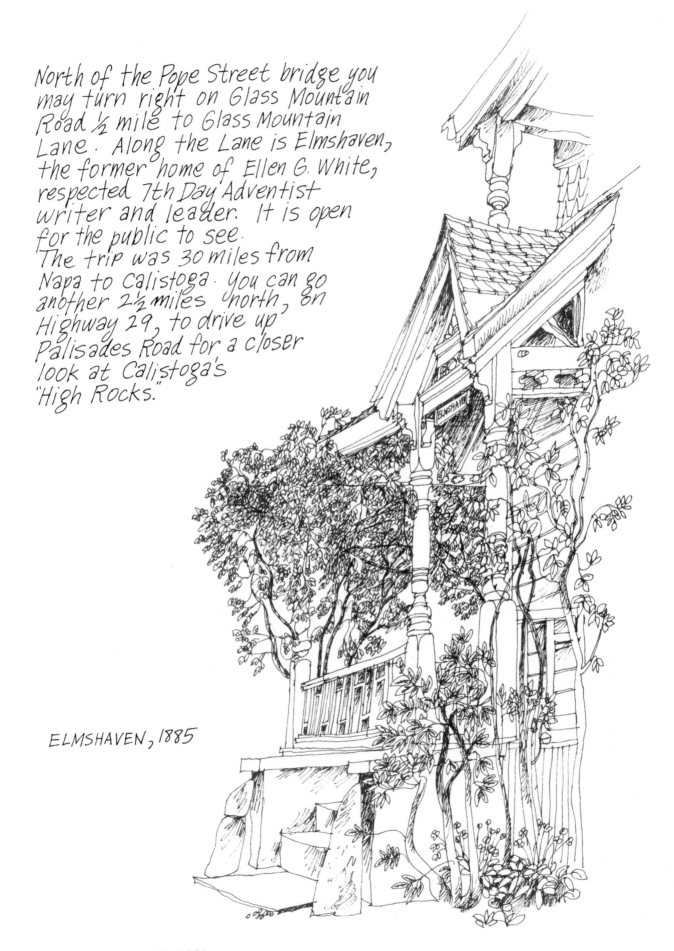

ELMSHAVEN, 1885

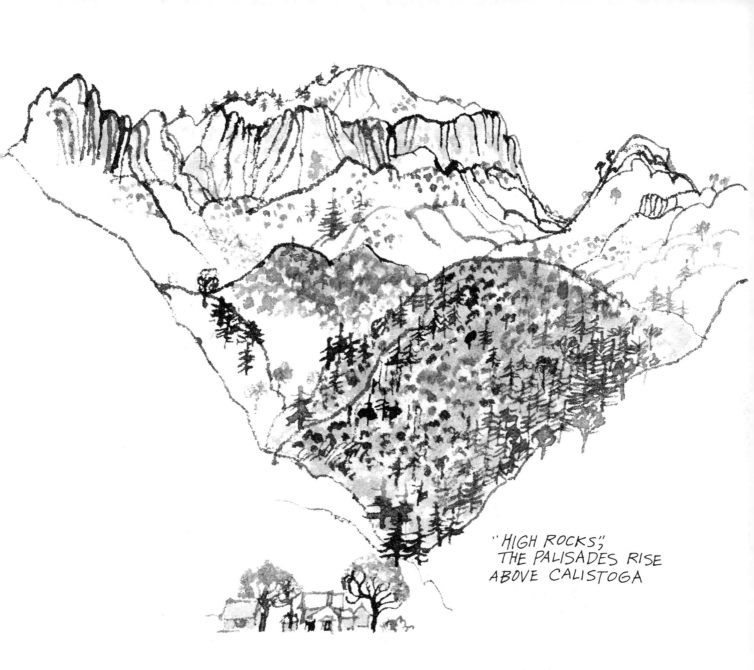

"HIGH ROCKS",
THE PALISADES RISE
ABOVE CALISTOGA

Napa Valley — A Perfect Place for a Honeymoon

Robert Louis Stevenson sojourned in the peace and quiet of northern California for nearly a year in 1879 and 1880. The Scottish writer married an American woman, and they honeymooned during the summer of 1880 in an abandoned bunkhouse of the defunct Silverado Mine on Mount St. Helena in the Napa Valley. In 1883 Stevenson celebrated that happy time in his book **The Silverado Squatters.** The author is remembered in St. Helena today in the Silverado Museum, at 1347 Railroad Avenue. Displaying only Stevenson memorabilia, the museum contains more than 1,500 artifacts including original manuscripts and letters, portraits and photographs of the writer, and even a desk he used when he lived in Samoa.

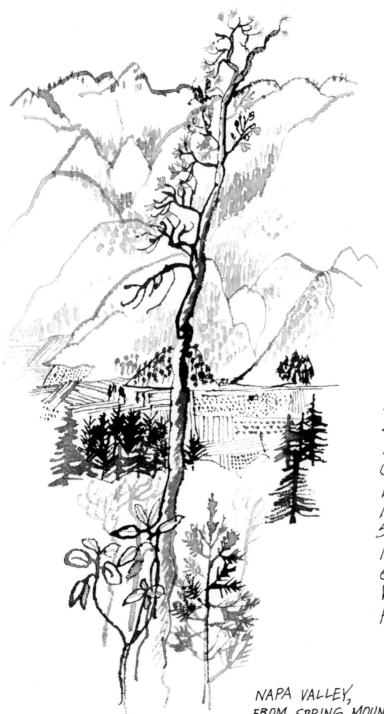

In St. Helena, on Highway 29, turn off at Madrone Street to Spring Mountain Road. This connects with Calistoga Road and Santa Rosa. High in the Mayacamas Mountains, 5½ miles from St. Helena I sketched, looking eastward to the Napa Valley floor and the Howell mountains.

NAPA VALLEY,
FROM SPRING MOUNTAIN ROAD

Pope Valley Loop

There are many roads into Pope Valley. One is from Rutherford on Highway 29, going east across Silverado Trail, to Conn Dam, Hennessey Reservoir, and through Chiles Valley.

I had always wondered what the Pope Valley Store was like inside, and this time I stopped to see. Lately, however, it has been boarded up.

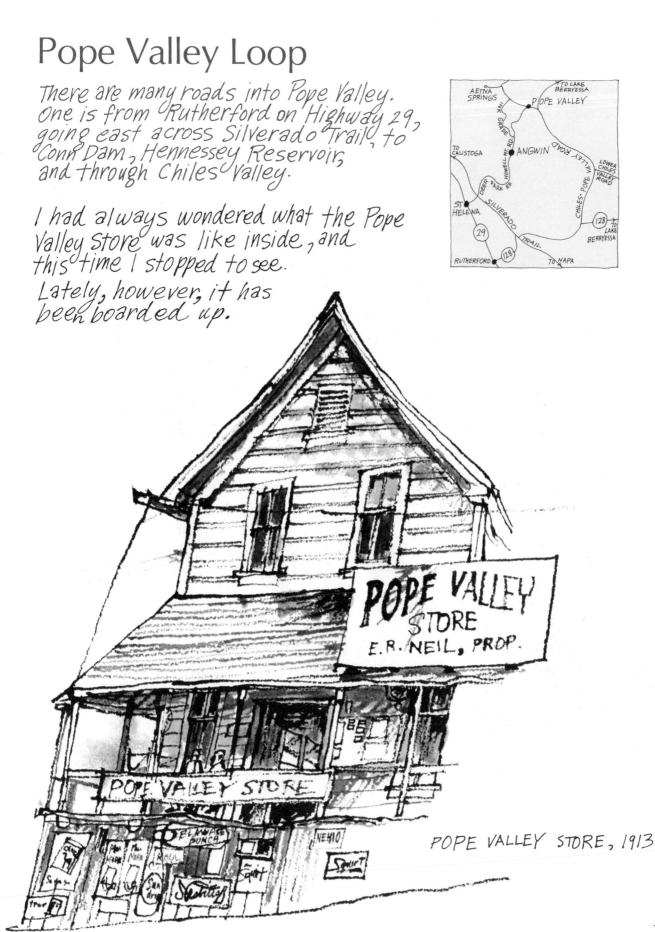

POPE VALLEY STORE, 1913

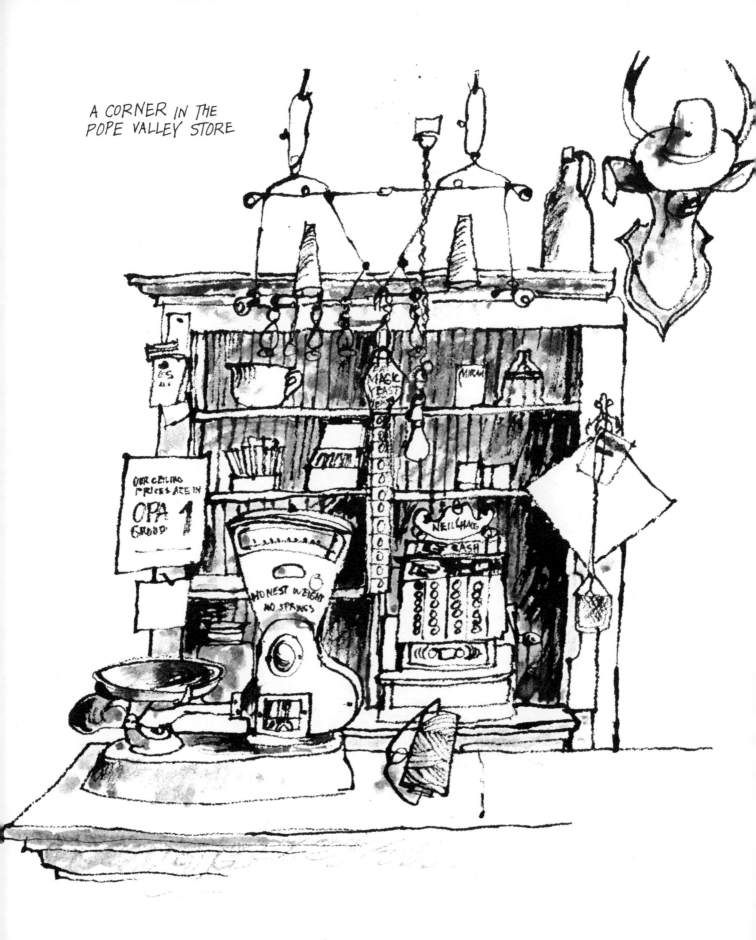

A CORNER IN THE
POPE VALLEY STORE

I couldn't help stopping at Litto Damonte's place north of Pope Valley store. He may be one of the best folk artists in the state. He works with old tires, washing machines, toilets, and other "found" objects, but most of all..... with hubcaps! He makes wishing wells and there are bird houses in profusion. You can see Litto's place from Pope Valley Road, but the permission of the owner would be required to view his art more closely.

The 100-year-old AETNA SPRINGS Resort, with several buildings designed by Maybeck, is farther along, off Pope Valley Road.

You can return to Silverado Trail and Highway 29 via Ink Grade, or much more easily, over Howell Mountain Road past the 7th Day Adventist community of Angwin.

BIRD HOUSE AND TOILET SEAT PLANTER WITH HUB CAPS, LITTO'S PLACE

HUB CAP ARRANGEMENT, POPE VALLEY ROAD

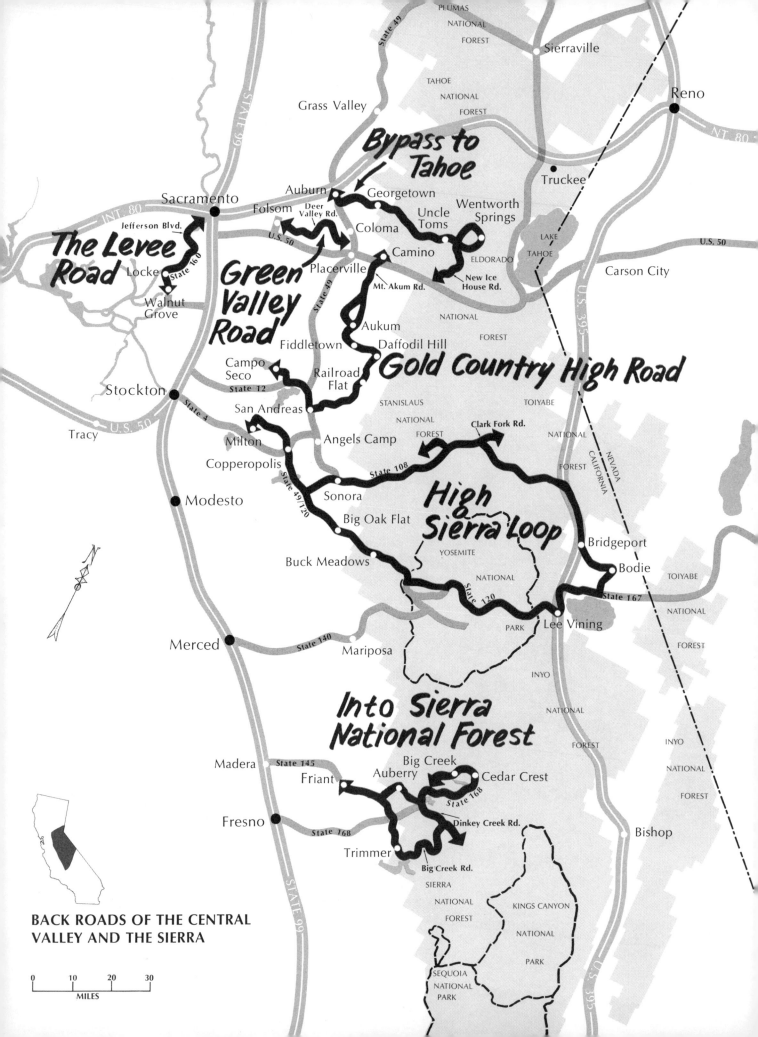

PLUMAS

NATIONAL

FOREST

Sierraville

Reno

Grass Valley

TAHOE

NATIONAL

FOREST

Truckee

INT. 80

Bypass to Tahoe

Auburn

Georgetown

Wentworth Springs

Sacramento

Folsom

Deer Valley Rd.

Coloma

Uncle Toms

LAKE TAHOE

U.S. 50

Jefferson Blvd.

The Levee Road

U.S. 50

Camino

ELDORADO

Carson City

Locke

State 160

Placerville

Mt. Akum Rd.

New Ice House Rd.

U.S. 395

Walnut Grove

Green Valley Road

State 49

Aukum

NATIONAL

FOREST

Fiddletown

Daffodil Hill

Gold Country High Road

Campo Seco

Railroad Flat

State 12

STANISLAUS

TOIYABE

Stockton

State 4

San Andreas

NATIONAL

NATIONAL

Tracy

U.S. 50

Milton

Angels Camp

FOREST

Clark Fork Rd.

FOREST

CALIFORNIA

NEVADA

Copperopolis

State 108

High Sierra Loop

State 49/120

Modesto

Sonora

Big Oak Flat

YOSEMITE

Bridgeport

Buck Meadows

NATIONAL

Bodie

TOIYABE

State 120

State 167

NATIONAL

PARK

Lee Vining

Merced

State 140

Mariposa

INYO

NATIONAL

FOREST

Into Sierra National Forest

Madera

State 145

Big Creek

Friant

Auberry

Cedar Crest

State 168

Fresno

Dinkey Creek Rd.

State 168

Bishop

Trimmer

Big Creek Rd.

SIERRA

NATIONAL

KINGS CANYON

FOREST

NATIONAL

PARK

SEQUOIA

NATIONAL

PARK

BACK ROADS OF THE CENTRAL VALLEY AND THE SIERRA

0 10 20 30

MILES

Side Roads West of State 99—The
Sacramento Delta—Gold Country

CENTRAL VALLEY AND THE SIERRA

Between the low mountains of California's coast ranges and the rugged granite peaks of the Sierra Nevada, the great Central Valley forms a tapestry of field crops, pasture lands, orchards, and residential areas. Arrow-straight roads crisscross fields of cotton and potatoes, onions and lettuce, tomatoes and rice.

California's two greatest rivers, the Sacramento and the San Joaquin, come together in a complex of sloughs that forms the Delta region. Here, fishermen try their luck, and cruisers, sailboats, and miscellaneous small craft nose about on the waterways. Sea-going freighters travel deep-water channels to inland ports at Sacramento and Stockton.

One of the most traveled routes between Northern and Southern California, State 99, heads up the east side of the Central Valley; Interstate 5 goes along the west side. Crossing the Valley, Interstate 80 and U.S. 50 connect the cities of the San Francisco Bay Area with the recreation areas in the Sierra Nevada and with cities on the east side of the range. They follow mountain passes along the two main emigrant routes taken by California's early settlers, and they intersect State Highway 49, which weaves its way through once-rowdy mining towns that sprang up across the Mother Lode in the 1850's. Weather and time have tumbled many of the gold-rush buildings. Some towns have disappeared completely in the path of progress and others have become thriving modern communities. Still others now drowse peacefully, surrounded by rolling hills.

East of the Gold Country, the slopes of the Sierra Nevada climb to majestic heights then drop off abruptly to desert-like countryside, where dusty roads lead to old mines in the mountains east of U.S. 395.

Fresno to Madera,
via Sierra National Forest

It is a round about 120-mile way between these two places, but most interesting. Highway 168 out of Fresno goes 35 miles to the Burrough Valley turnoff where the backroads begin.

Burrough Valley, Watts Valley, and Maxon Roads bring you to Trimmer along the bank of Pine Flat Reservoir. I left Trimmer Road to begin the dirt byway, Big Creek Road, on my winding way 29 miles to Dinkey Creek. The elevation gradually changed, and so did the temperature, from a hot 1200-foot level at Pine Flat to a cool 6,000 feet near Dinkey Mountain. You follow Big Creek for many miles, then circle past Cat's Head Mountain, Apperson Ridge, and Secata Ridge to get to where the tall pines grow.

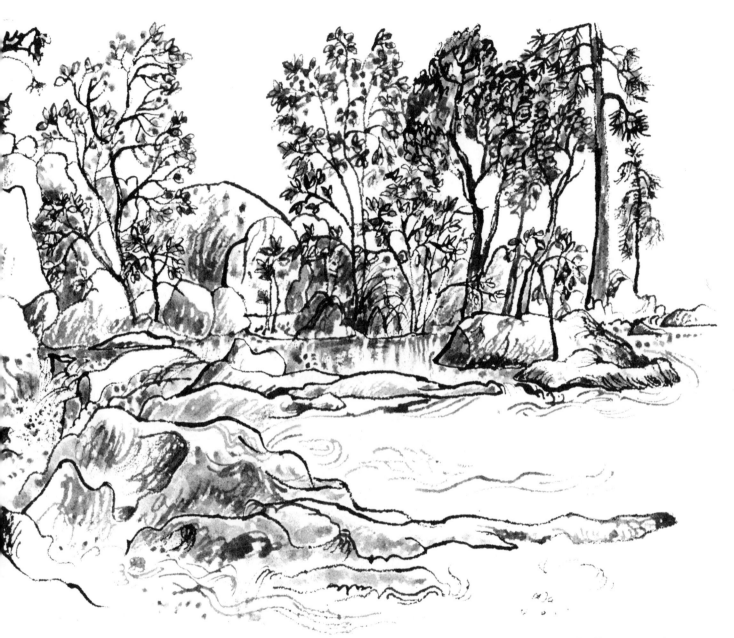

BIG CREEK

FOOTHILLS OF THE SIERRA,
BURROUGH VALLEY ROAD

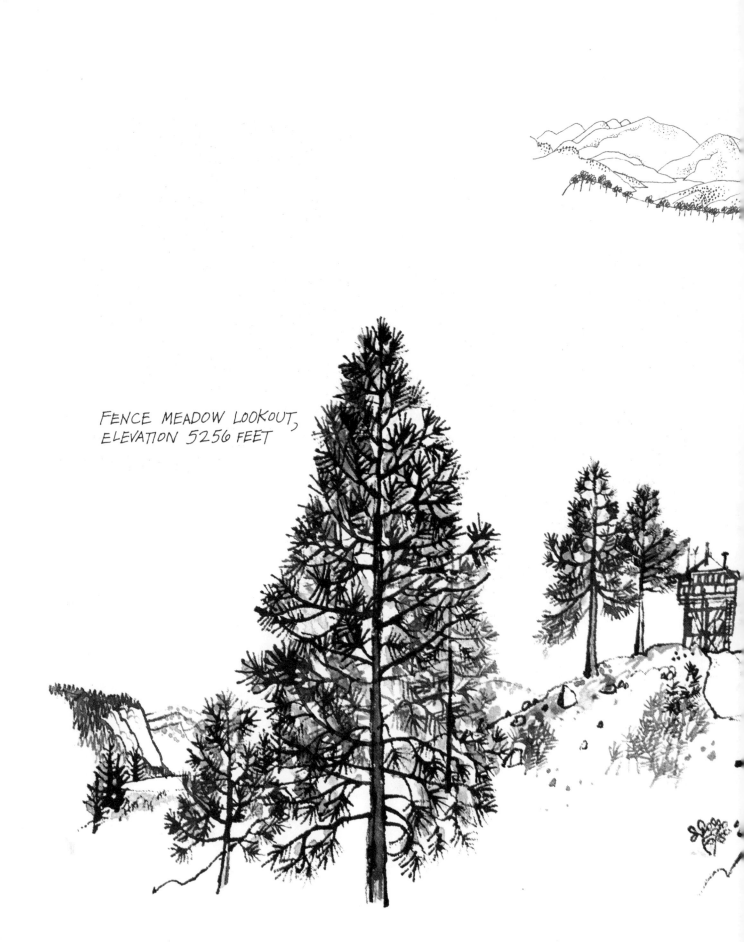

FENCE MEADOW LOOKOUT,
ELEVATION 5256 FEET

APPERSON RIDGE,
PINE FLAT RESERVOIR
ON THE LEFT

I visited the lookout at Fence Meadow. Two tiny dogs barked at me with high, piping barks from their perch atop the lookout tower. The lookout told them to be quiet and yelled to me "Come on up." He opened a trap door, and I climbed the steep two flights to his room with view all around. "It's become so hazy", the lookout said, "I haven't seen the coastal range from here for 6 years. It gets worse every year and some day it won't do any good to have a fire lookout!"

I stopped at Nutmeg Springs. You can follow it to its source 100 feet from the road, where it bubbles from the ground beneath trees and rocks. And one of the trees is a California Nutmeg!

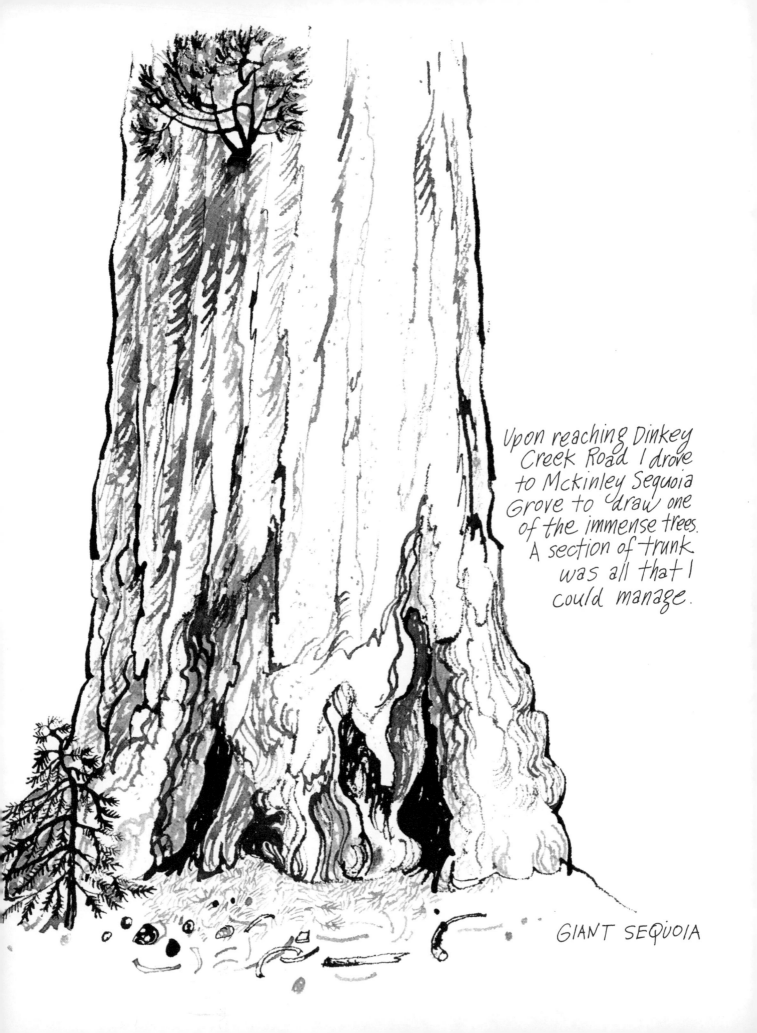

Upon reaching Dinkey
Creek Road I drove
to McKinley Sequoia
Grove to draw one
of the immense trees.
A section of trunk
was all that I
could manage.

GIANT SEQUOIA

The Dinkey Creek Bridge is a satisfying piece of engineering to study. People enjoy fishing near the bridge, walking over it, and looking down and around and, of course, artists sketch it occasionally. Dinkey Road goes past big trees, meadows, and stretches of granite rocks. Wildflowers are abundant, especially the magnificent purple mountain lupine. I sat to sketch a pine tree, but got so bitten by red ants I had to stand to finish the drawing, and there were pesky flies that seemed to be playing a game of "catch-me-if-you-can." They know you cannot catch them, however, so it's not fair!

DINKEY CREEK BRIDGE

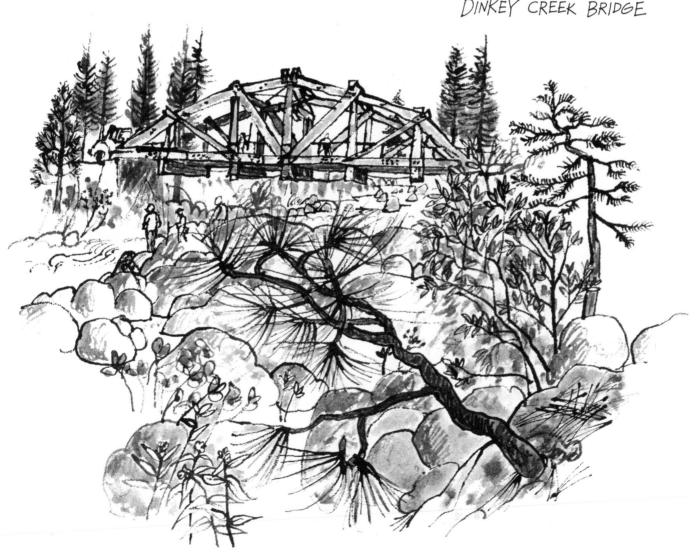

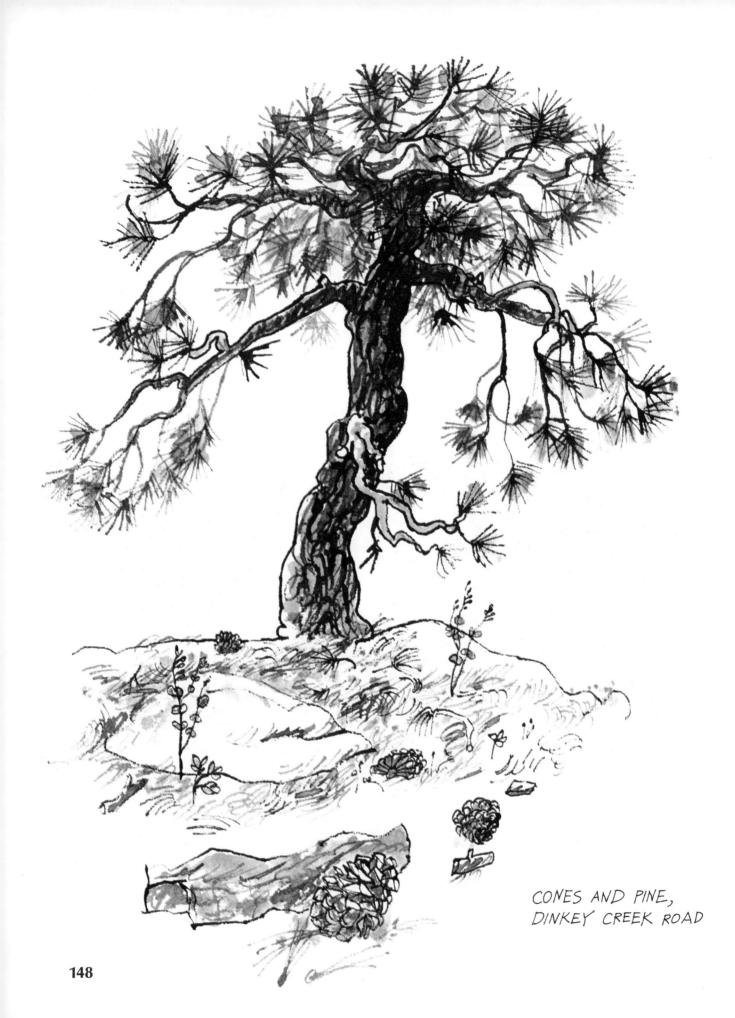

CONES AND PINE,
DINKEY CREEK ROAD

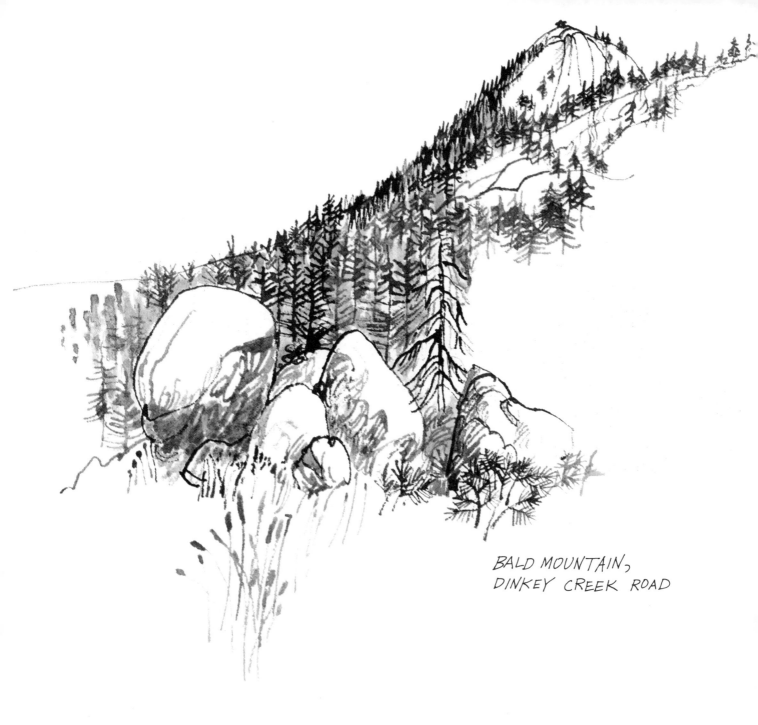

BALD MOUNTAIN,
DINKEY CREEK ROAD

The Big, Big Trees of the Sierra Nevada

The world's largest living things, the Big Trees of the Sierra Nevada (**Sequoiadendron giganteum**), occur in groves along a 250-mile range on the west slopes of the Sierra Nevada. The discovery of these giants is generally credited to the members of the Joseph R. Walker exploration party which crossed the Sierra in 1833, but the trees did not come to the attention of the public until 1852, when the Calaveras Grove was discovered by a hunter named A. T. Dowd, who accidentally came across it while pursuing a bear. Largest of the giants is the General Sherman Tree in Sequoia National Park. It has an incredible height of 272 feet, a diameter of 30 feet at chest level, and a total trunk volume of about 50,000 cubic feet. Oldest is the Grizzly Giant in Yosemite National Park; its age is estimated at 2,700 years.

HUNTINGTON LAKE

Off Dinkey Creek road you can take Highway 168 past Shaver and Huntington Lakes, where people come by the thousands during the summer to escape the heat of the San Joaquin Valley, and to boat, bathe, fish, and camp. There are Tamarack trees and white firs growing at the 7000-foot elevation around Lake Huntington. I chose to take Huntington Lake Road down the mountain to Big Creek. This is a winding road with deep views into the valleys. At Big Creek I sketched the big pipes, called penstocks, and the "Kerckhoff Dome." The penstocks carry water from Huntington Lake into the big power house and move the turbines to make as many as 81,000 kilowatts, if called for. I bought some "grape-ade" children were selling along the road. It was terrible. I told them to add more flavoring and more ice! The Auberry Road 6 miles below Shaver Lake Heights eventually connects with Millerton Road, Friant, then on to Madera via Highway 145.

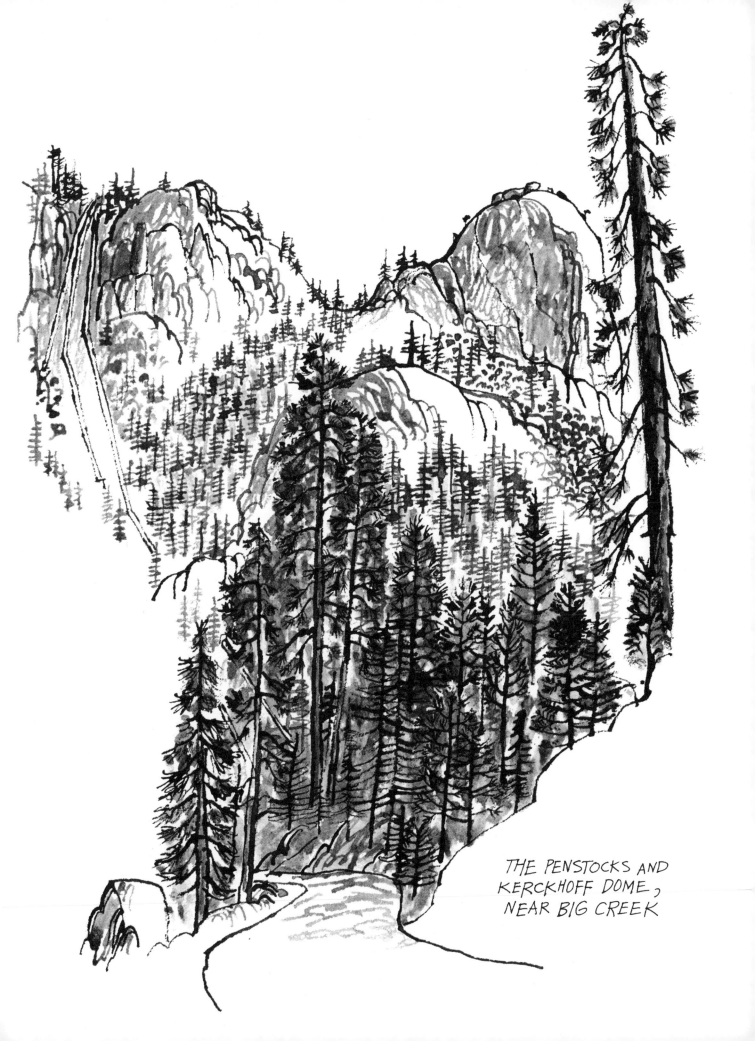

THE PENSTOCKS AND
KERCKHOFF DOME,
NEAR BIG CREEK

Interstate 80 Bypass on the Way to Tahoe

Highway 49 leaves Interstate 80 at Auburn. At Cool you can turn onto the Georgetown Road, Highway 193, to Georgetown.

At Greenwood I sketched a 1934 Ford V-8 fire truck, ready for action, parked on the porch of an ancient dwelling. There were 3000 souls in Georgetown in 1854. They are now memorialized in the large Georgetown cemetery.

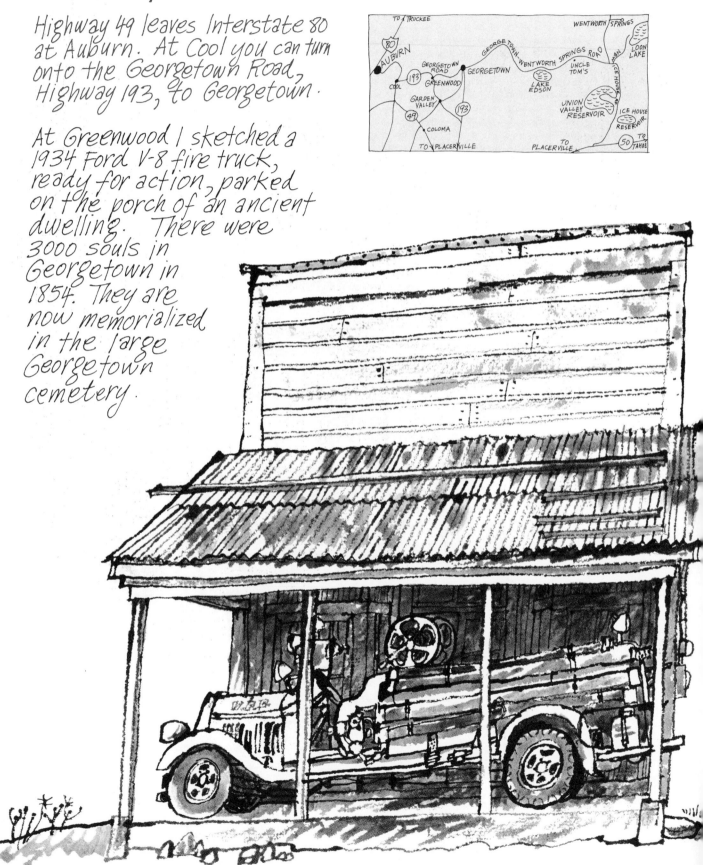

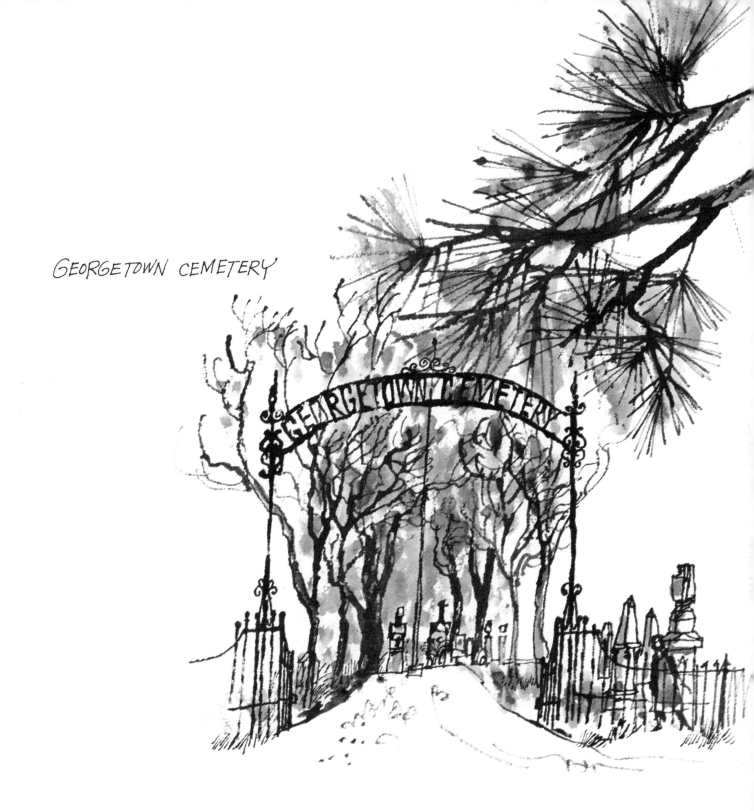

GEORGETOWN CEMETERY

THE GREENWOOD
VOLUNTEER FIRE DEPARTMENT

UNCLE JOHN'S
AT UNCLE TOM'S

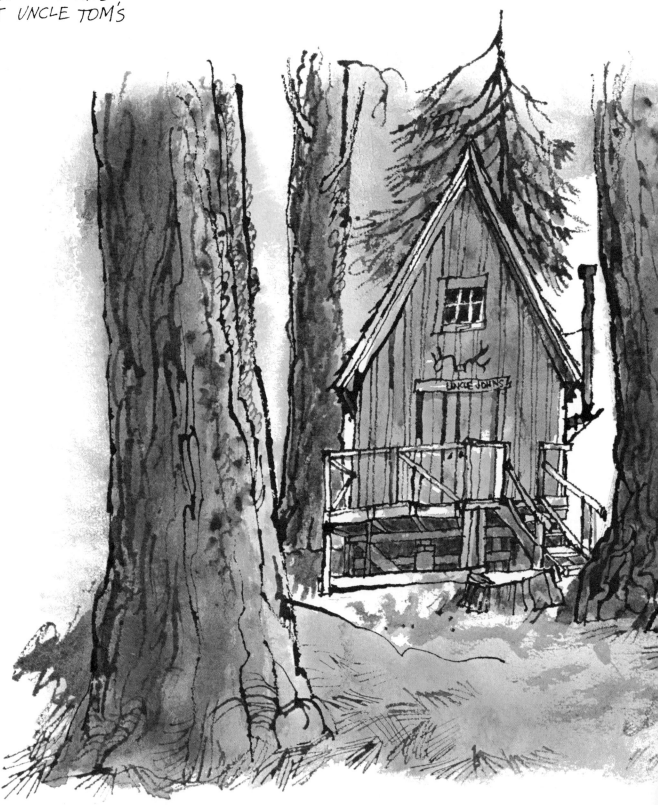

The tiny village of Uncle Tom's is about 10 miles past Edson Reservoir. Uncle Tom was a Negro trapper a hundred years ago, according to Mrs. Archie Lawyer, who runs the small store. She's been there 60 years herself! I sketched Uncle John's cabin nestled among ancient cedars and pines. Uncle Tom's original log cabin was there, too. The timberline Loon Lake is not far from here. You can continue on the new highway from the Loon Lake road to the turnoff for Wentworth Springs. There you can see Lawyer's historic "cow camp" and the old Wentworth Springs Hotel. It is about 30 miles back to Highway 50, then on to Tahoe.

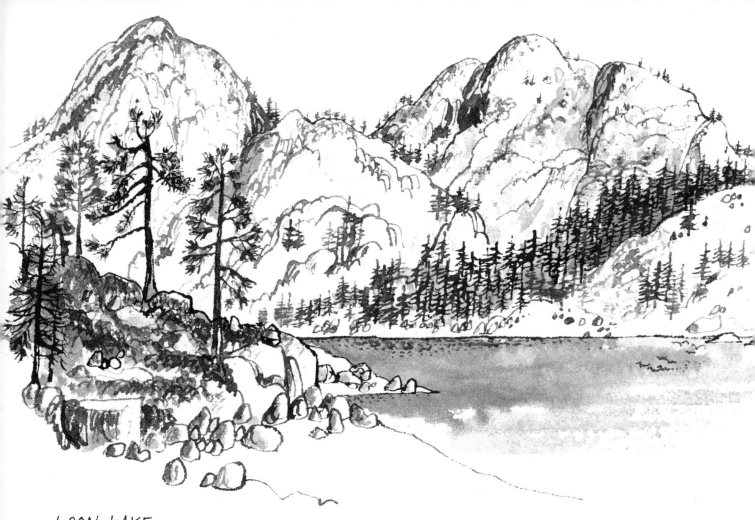

LOON LAKE,
SACRAMENTO'S WATER SUPPLY

Living Memories of the Glitter of Gold

Yankee California had its real beginning in Coloma early in 1848 when James Marshall saw a glitter of gold in the millrace of John Sutter's sawmill. In January of 1848, when Marshall made his discovery, California had about 15,000 inhabitants. Two years later there were 92,000, nearly two-thirds of them in full-time pursuit of the yellow metal. Placerville was once one of the great camps of the Gold Country. Georgetown's streets were lined with miners' shacks and canvas meeting halls. Garden Valley began life as a mining camp called Johnstown, was renamed when its residents turned to truck farming. Greenwood was established by a trapper and his two sons as a supply center for the miners. Today the gold discovery site at Coloma is the focus of the 220-acre Marshall Gold Discovery State Historical Park, which includes old stone buildings, a Chinese store, a blacksmith's shop, horse-drawn vehicles, and a cabin in which Marshall lived. A replica of Sutter's sawmill, constructed with adzed lumber and joined with oak pins, stands about 150 yards southwest of the spot where gold was discovered.

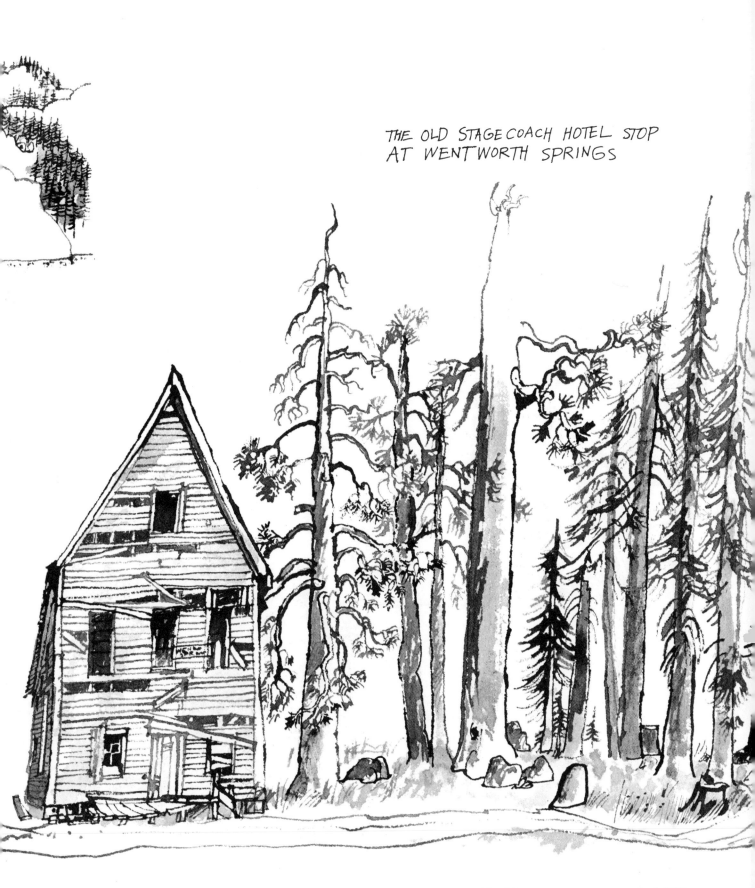

THE OLD STAGECOACH HOTEL STOP
AT WENTWORTH SPRINGS

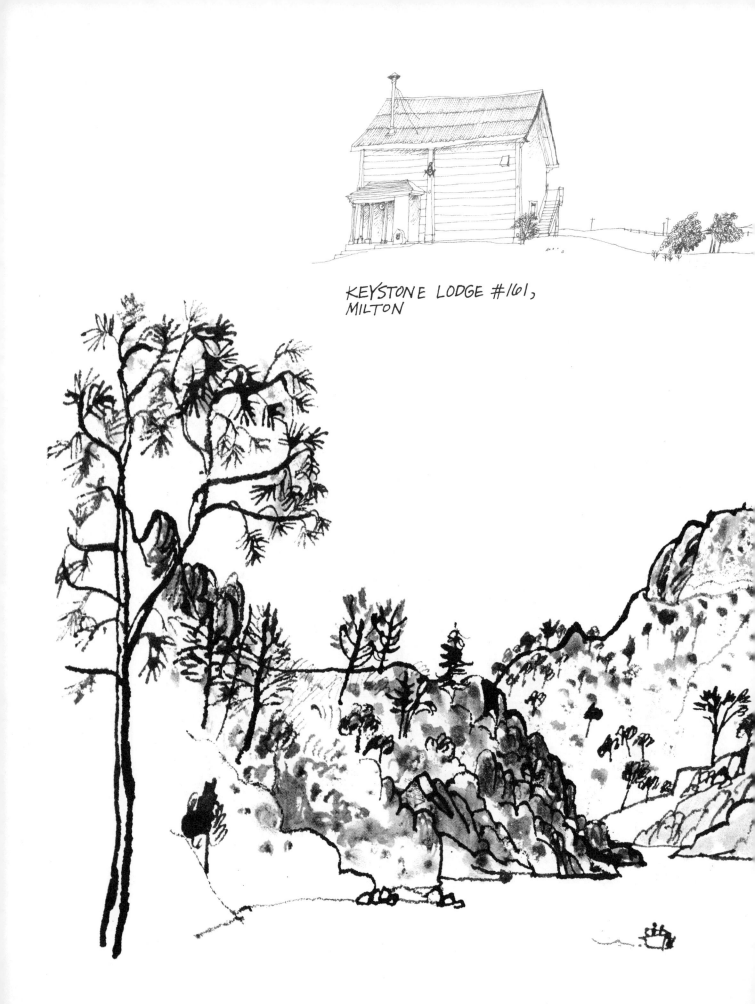

KEYSTONE LODGE #161,
MILTON

High Sierra Loop

25 miles east of Stockton, County Road J14 goes 7 miles to Milton. This began the "High Sierra Loop".

Milton is distinguished only by a huge building, for Milton, that is: Keystone Lodge #161, moved from Copperopolis in 1881. Milton was then a railroad stop between Copperopolis and the city of Stockton, and a more industrious future was predicted for it at that time. Hunt Road begins here and rolls and wanders pleasantly to Copperopolis.

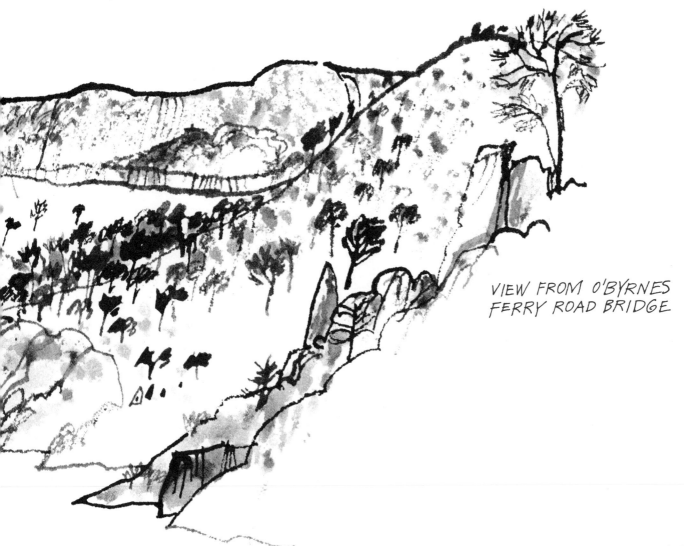

VIEW FROM O'BYRNES
FERRY ROAD BRIDGE

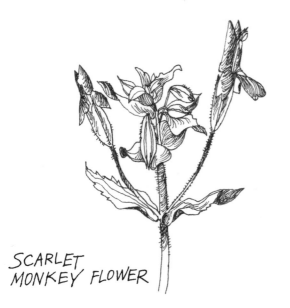

SCARLET
MONKEY FLOWER

MEADOW
MONKEY FLOWER

WHITE AND BRIGHT
YELLOW LOTUS

SOME MOUNTAIN
WILDFLOWERS

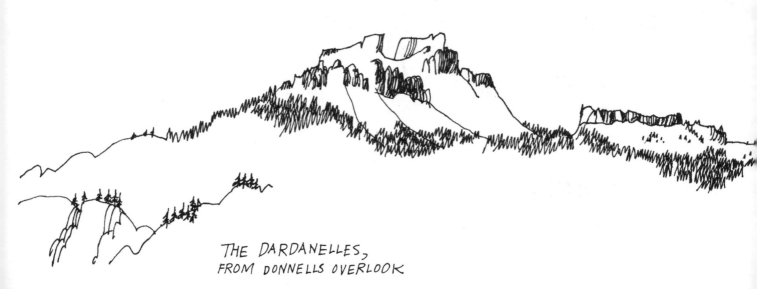

THE DARDANELLES,
FROM DONNELLS OVERLOOK

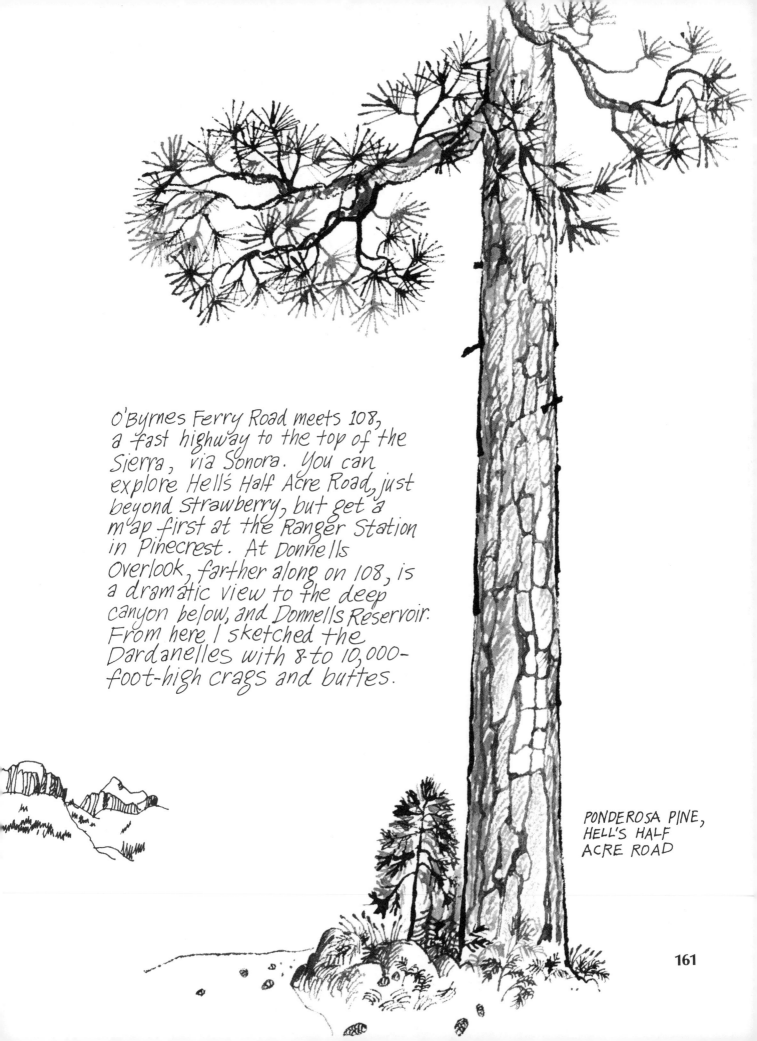

O'Byrnes Ferry Road meets 108,
a fast highway to the top of the
Sierra, via Sonora. You can
explore Hell's Half Acre Road, just
beyond Strawberry, but get a
map first at the Ranger Station
in Pinecrest. At Donnells
Overlook, farther along on 108, is
a dramatic view to the deep
canyon below, and Donnells Reservoir.
From here I sketched the
Dardanelles with 8-to 10,000-
foot-high crags and buttes.

PONDEROSA PINE,
HELL'S HALF
ACRE ROAD

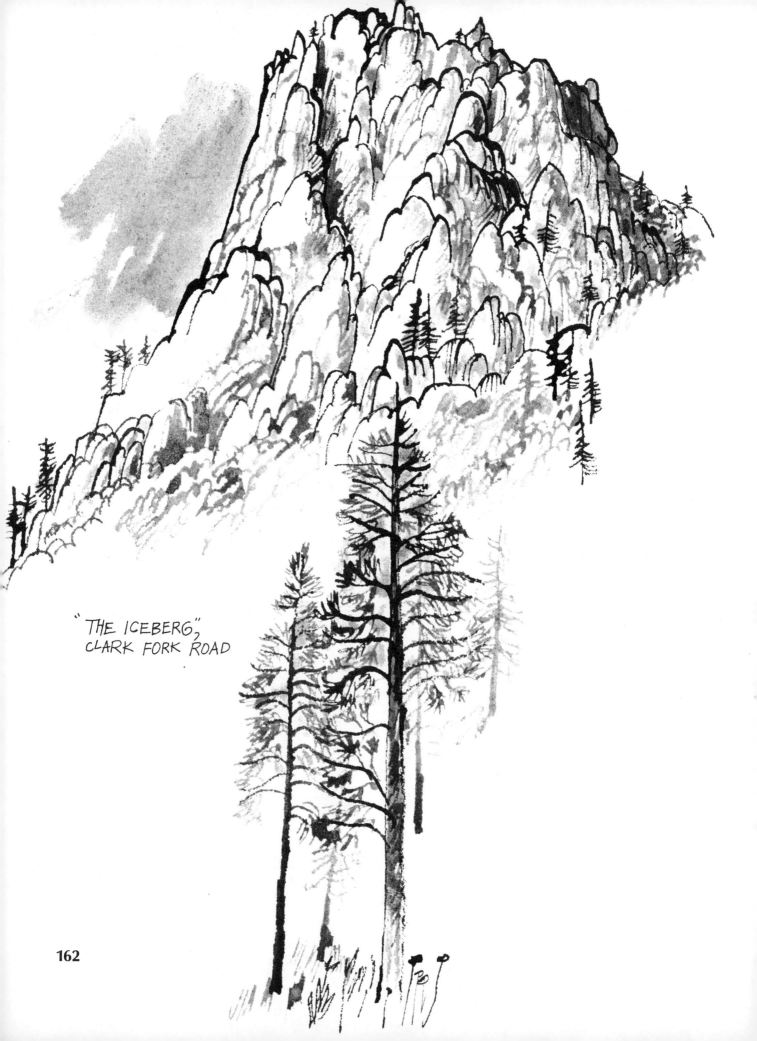

"THE ICEBERG,"
CLARK FORK ROAD

162

I turned off 108 onto the Clark Fork Road, which follows a clear mountain stream running through this glaciated valley. I was most curious about "The Iceberg," so-called on my map. No one could be disappointed in viewing this impressive 8,000-foot chunk of granite. From Sonora Pass, farther along 108, you can see Leavitt Peak towering at 11,570 feet. I sat at the foot of a gnarled pine and sketched, brushing away biting flies.

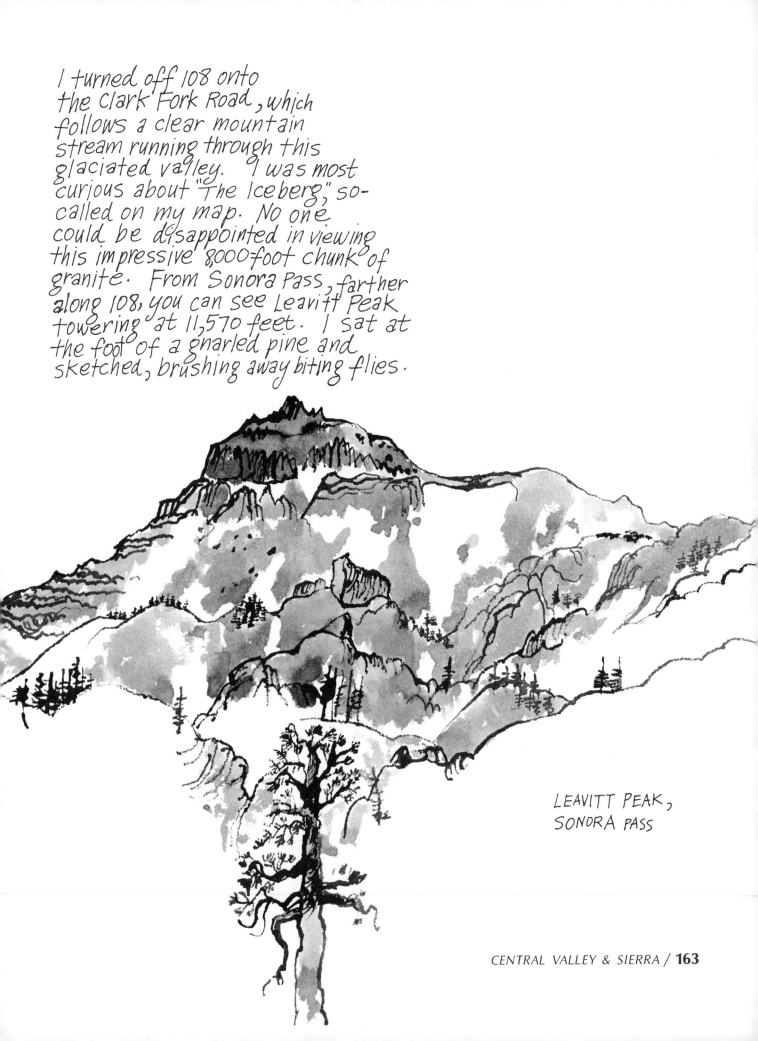

LEAVITT PEAK, SONORA PASS

THE GHOST TOWN OF BODIE

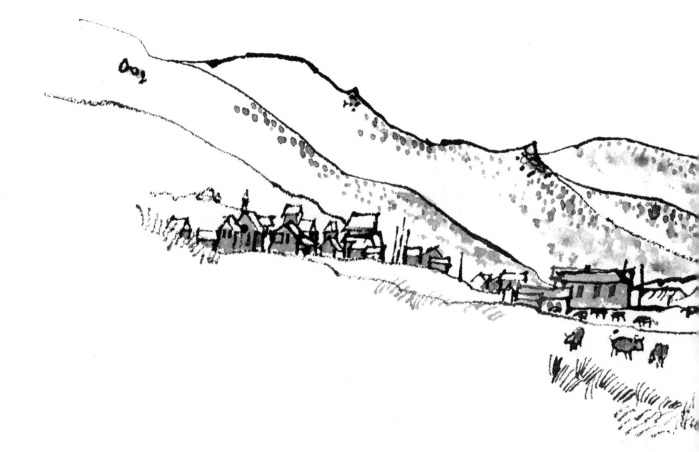

Down from the high Sierra to
Highway 395 and Bridgeport, a lively
tourist town, I traveled farther to
turn onto dusty Bodie Road. Bodie is a
ghost town with more structures preserved
than is usual. Try to be there before the
other tourists arrive, to feel the ghosts
moving about. Take Cottonwood Canyon Road
out of Bodie past weird Mono Lake, then
up over Tioga Pass from Lee Vining.

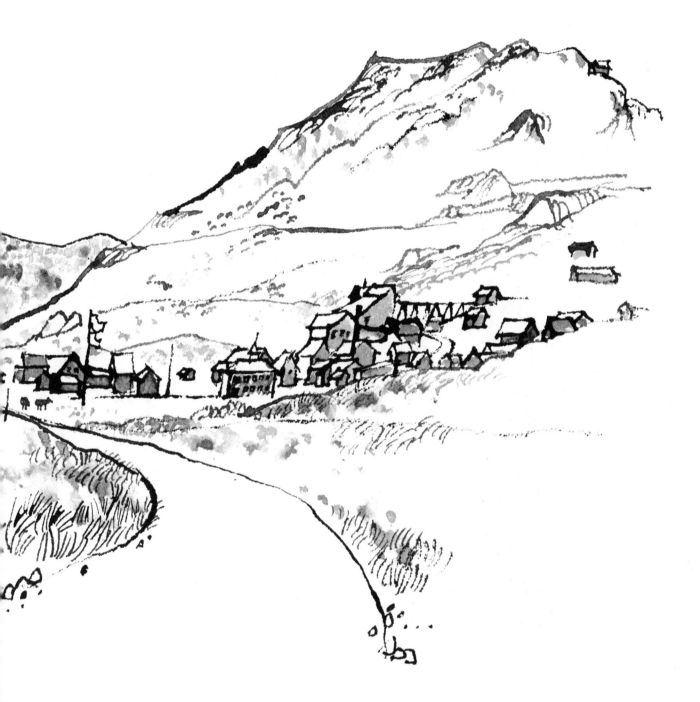

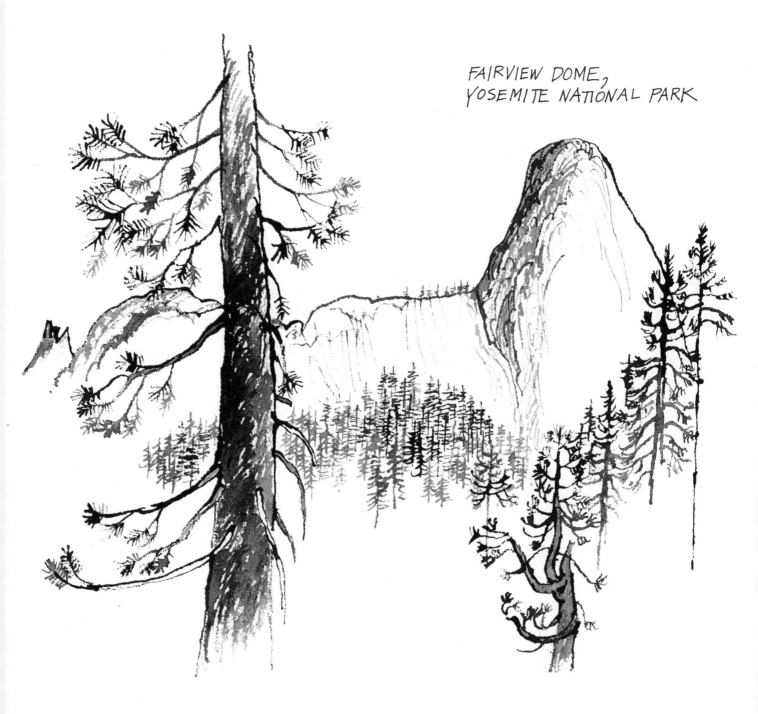

FAIRVIEW DOME,
YOSEMITE NATIONAL PARK

From my camping place along Highway 120 in Yosemite National Park, I began a sketch of Fairview Dome. The mosquitos literally drove me into the camper, so I waited until the following morning and completed the drawing while the bothersome insects were still frozen stiff. My fingertips were somewhat frozen, too.

46 miles from Tioga Pass you can take Tuolumne Grove Road through a great forest of uncut sugar pine and a grove of giant sequoia. You can drive through "Dead Giant", too, if you're not too big.
At the bottom of the Tuolumne Grove Road is Highway 120 to Sonora and points west.

GIANT SEQUOIA,
TUOLUMNE GROVE ROAD

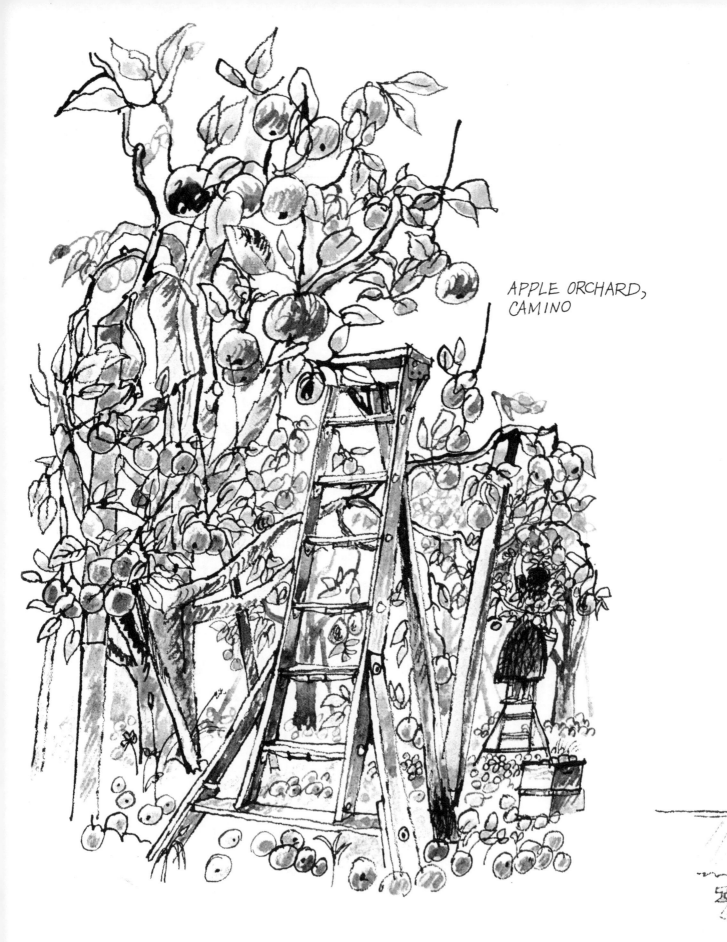

APPLE ORCHARD,
CAMINO

Gold Country High Road

Just 7 miles beyond Placerville, off Highway 50, is the apple and cider town of Camino. The gold country journey begins with the true gold of APPLES.

It is a good idea to get a brochure and map of the area from one of the growers. Mine was obtained at Larson Barn. I stopped to sketch at one ranch where the grower was desperately trying to pick his apples before they fell to the ground and were bruised. He was a little late, for this artist was surrounded by a "Golden Delicious" carpet of gold and green. I could not step without making applesauce. From here, country roads travel to Pleasant Valley, Aukum, Fair Play, and River Pines. Just before turning to Fiddletown, visit the D'Agostini Winery, founded in 1856.

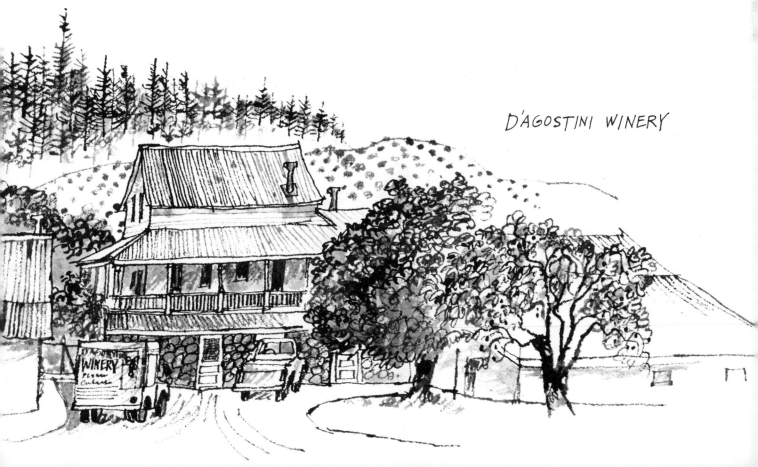

D'AGOSTINI WINERY

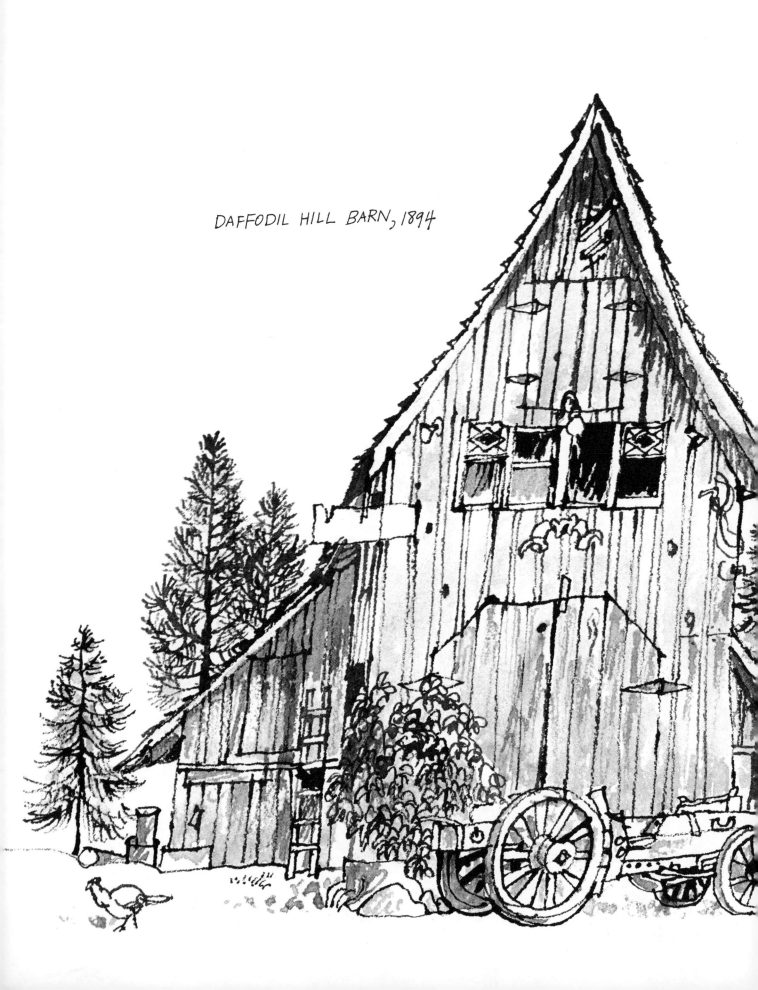

DAFFODIL HILL BARN, 1894

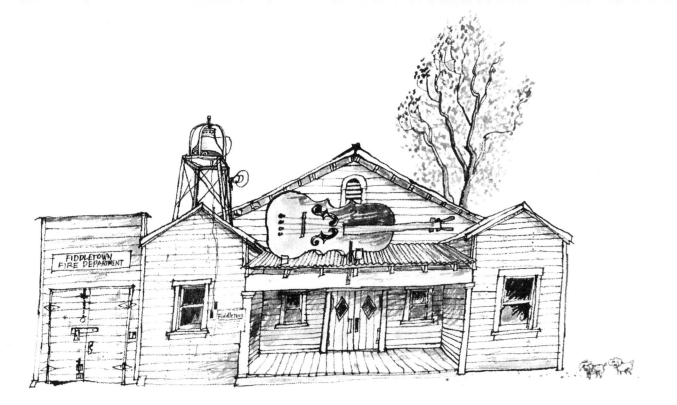

FIDDLETOWN AUDITORIUM

After sketching its big fiddle, I left Fiddletown on Silver Lake Road, turning off to visit Daffodil Hill. Daffodils bloom in March in profusion in this incredible place. It is a garden, a picnic area, and a zoo for fowl of all description.... and a haven for cats. I sketched the barn while cracking walnuts with my feet. They were sweet and good. A 100-year-old chestnut tree dropped large nuts from time to time, their hairy shells cracking as they struck the ground. The caretaker told me stories about Daffodil Hill. One was how in winter, with snow on the ground, peacocks fly into the chestnut tree and won't come down until the caretaker makes a runway. They can't gauge a landing on white snow.

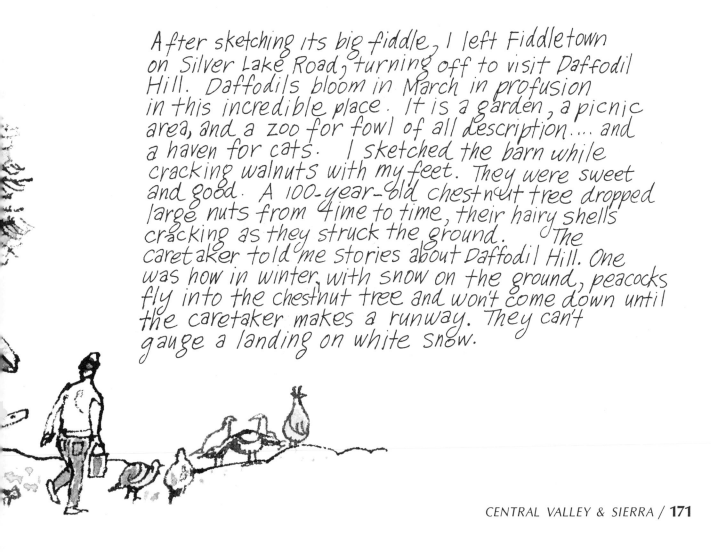

Three miles down Daffodil Hill is the historic town of Volcano, and this entrance to the community is particularly pleasant. It was autumn and the yellow leaves of locust trees fluttered in the air. Once upon a time there were 17 hotels and 37 bars here and it could boast being the largest city in California! Masonic Cave, just outside Volcano, is formed of blue stone and is covered with thick moss. The path to the cave was strewn with yellow and orange maple leaves.

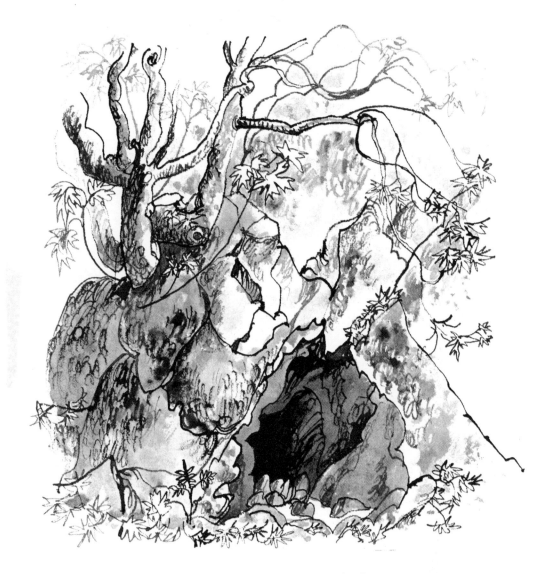

MASONIC CAVE, VOLCANO
MASONIC LODGE, 1853

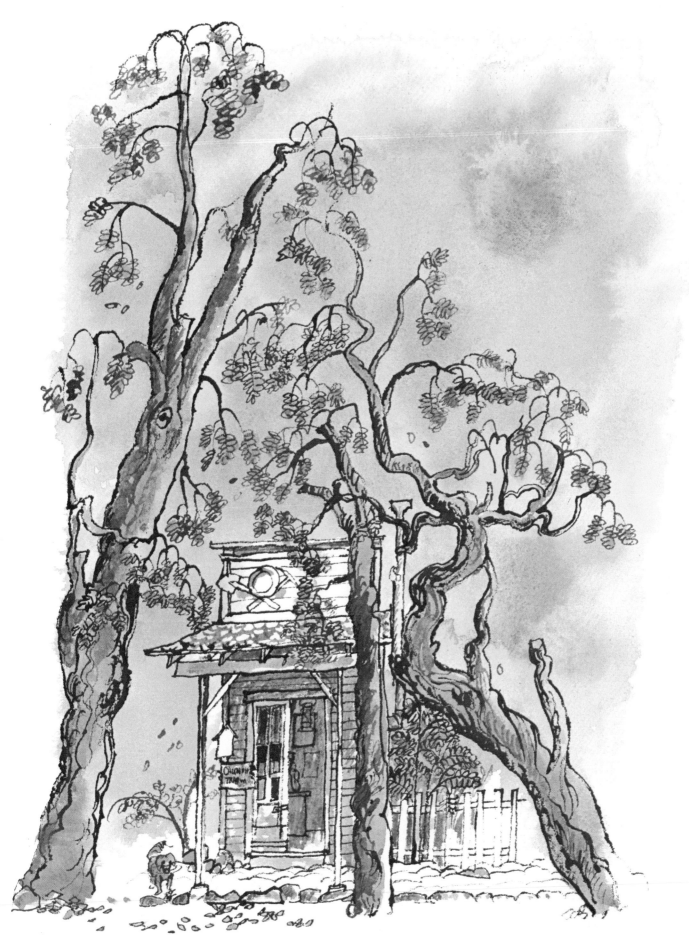

THE OLD ASSAY OFFICE, VOLCANO 173

"CHAW SE,"
INDIAN GRINDING ROCK,
VOLCANO

Miwok Mortars: An Outdoor Indian Kitchen

Within the boundaries of Indian Grinding Rock State Historical Monument near Volcano is the largest bedrock mortar ever found in the western United States. Scattered over a 7,700-square-foot limestone outcropping in the 40-acre park are 1,158 mortar holes and 363 petroglyph designs. Before the Gold Rush, Miwok Indians met here in the fall when the acorns were ripe (from middens and artifacts discovered, it is surmised that many Indians lived here all year). Using the rock, and stone pestles, they ground nuts, berries, and seeds into palatable food. Because of the geological and historical interest of the rock, a replica is in the Smithsonian Institution in Washington, D.C.

Railroad Flat was named for the primitive mule train ore cars used at the "Petticoat Mine". The general store is still in business, although the town has disappeared. The hall above the store was rented to the IOOF in the early days. At Mountain Ranch, farther south, I sketched the entrance to the former "Dance Hall", now a fascinating museum. East of here, at Campo Seco, a town settled by Mexicans, I visited the old cemetery.

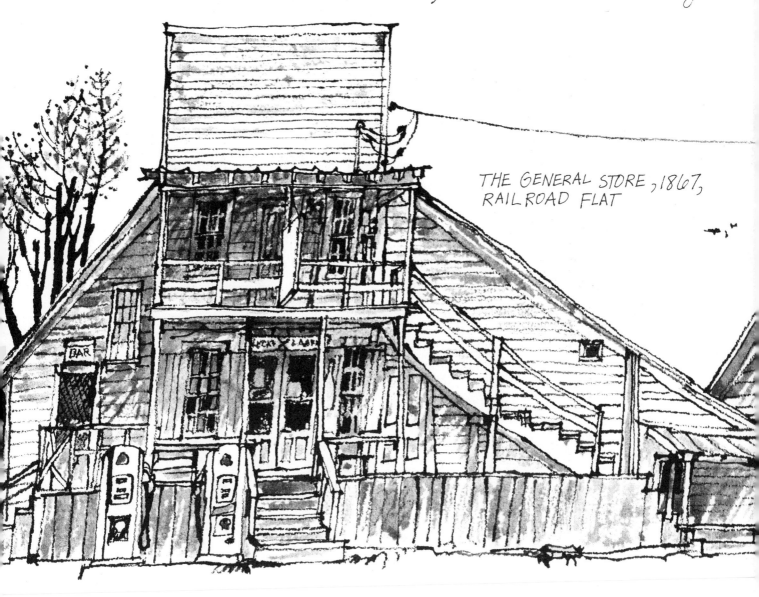

THE GENERAL STORE, 1867,
RAILROAD FLAT

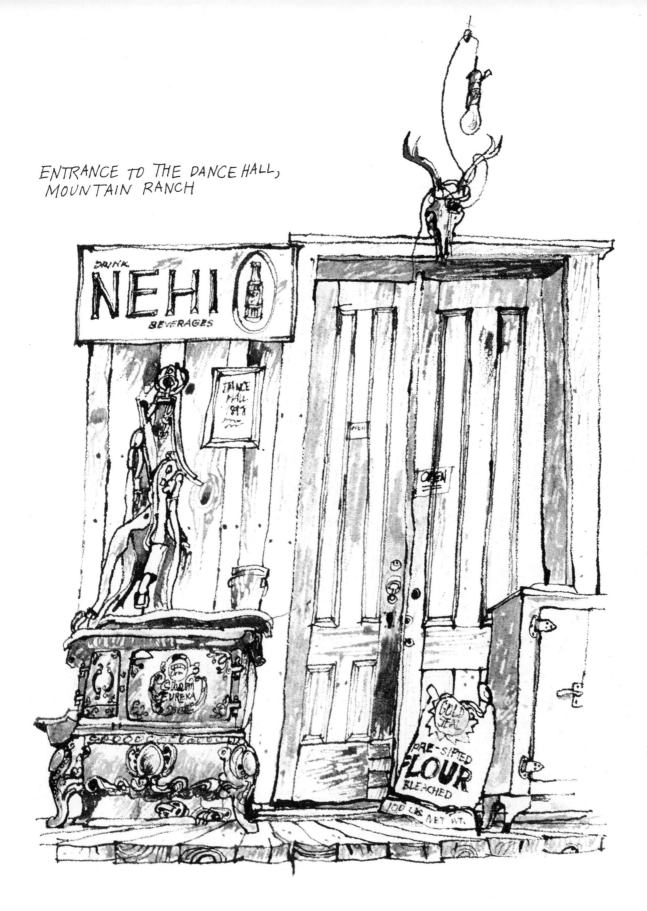

ENTRANCE TO THE DANCE HALL,
MOUNTAIN RANCH

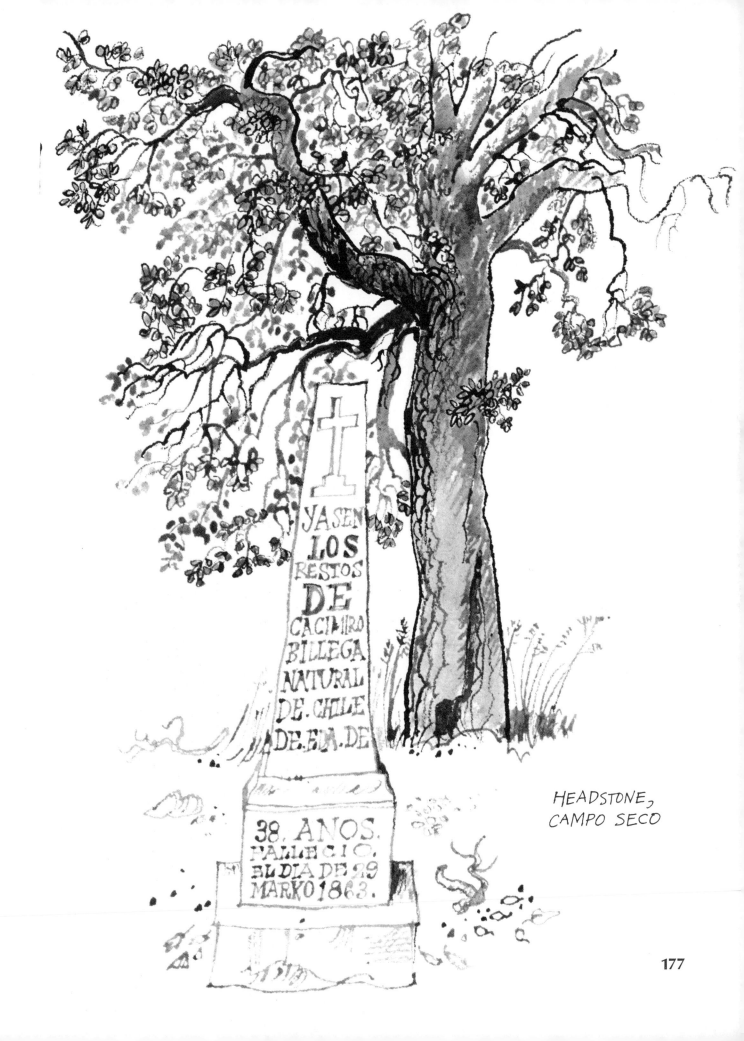

YA SEN
LOS
RESTOS
DE
CACIMIRO
BILLEGA
NATURAL
DE CHILE
DE. E.A. DE

38. AÑOS.
FALLECIO.
EL DIA DE 29
MARZO 1863.

HEADSTONE,
CAMPO SECO

177

South from Sacramento along the Levee Road

Approaching Sacramento from the west on Interstate 80, you turn off at Jefferson Boulevard, then Gregory Avenue to South River Road. You are now on the levee.

The Sacramento River is on your left, and below you, on the right, is the vast farming area of the delta. Pretty country towns along the way are Clarksburg and Courtland. At Locke the experience is varied indeed. This is a town created in 1913 by Chinese merchants. It boomed, then vegetated. It is still vegetating, however, in very few places in California can one feel in touch with the past as in Locke. A movie had been filmed recently in Walnut Grove, and my sketch included some of the atmosphere created by set designers. Visit Isleton next. You are now on Highway 160.

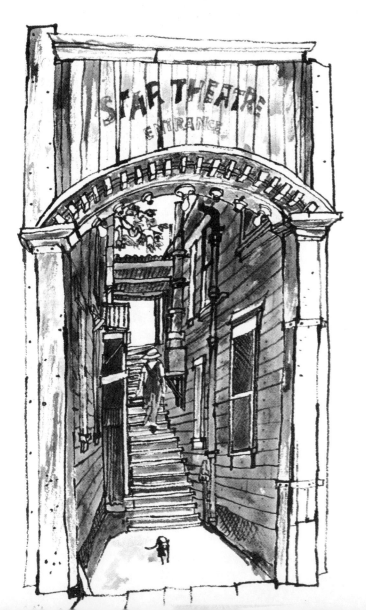

ONCE UPON A TIME THERE WAS THE "STAR THEATRE", LOCKE

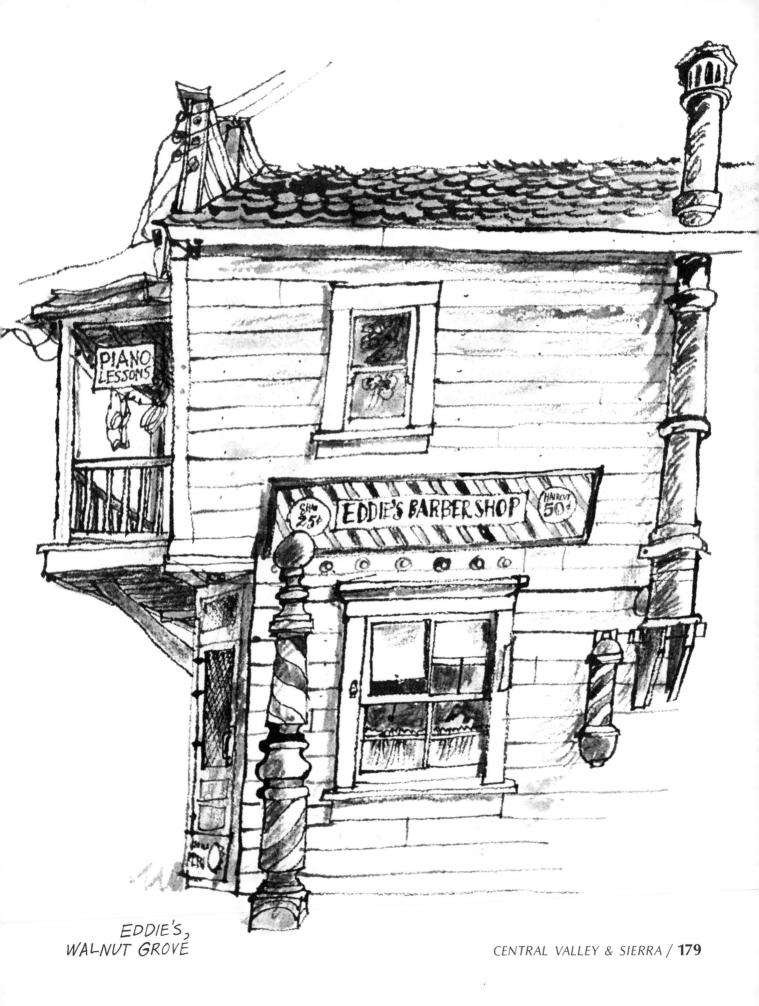

PIANO LESSONS

SHAVE 25¢ EDDIE'S BARBER SHOP HAIRCUT 50¢

EDDIE'S,
WALNUT GROVE

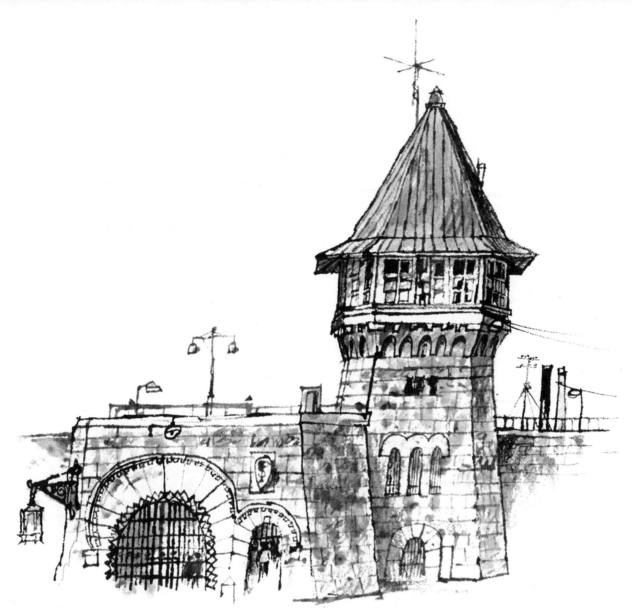

THE EAST GATE,
FOLSOM PRISON

The Green Valley Road
from Folsom to Placerville

Natoma Street, out of Folsom, becomes Green Valley Road, which runs 25, or so, miles to Placerville.

You may drive to the prison, off Green Valley Road, to visit its handicraft shop and see the massive East Gate. Along Deer Valley Road you will pass the 1871 adobe Jacob Zentgraf house. I visited the Zentgraf family cemetery on Starbuck Road. There lie John, Frank, Lambert, William, Jacob Jr., Gabriel, Jacob Sr., his wife, and two without headstones. Jacob outlived them all. An older resident I spoke to said that Jacob Zentgraf gave his boys a bottle of home-made "grappa" every day. That was the reason for their early demise, I was told. Jacob lived to be 89, however, and I'm sure he didn't pass up the grappa. At Jay Hawk Cemetery birds sang in the cypress trees, cowbells tinkled from over the hill, wind whistled eerily in the hollow metal pipes holding up the cemetery sign. Deer Valley Road returns to Green Valley Road at Rescue.

JAY HAWK CEMETERY, DEER VALLEY ROAD

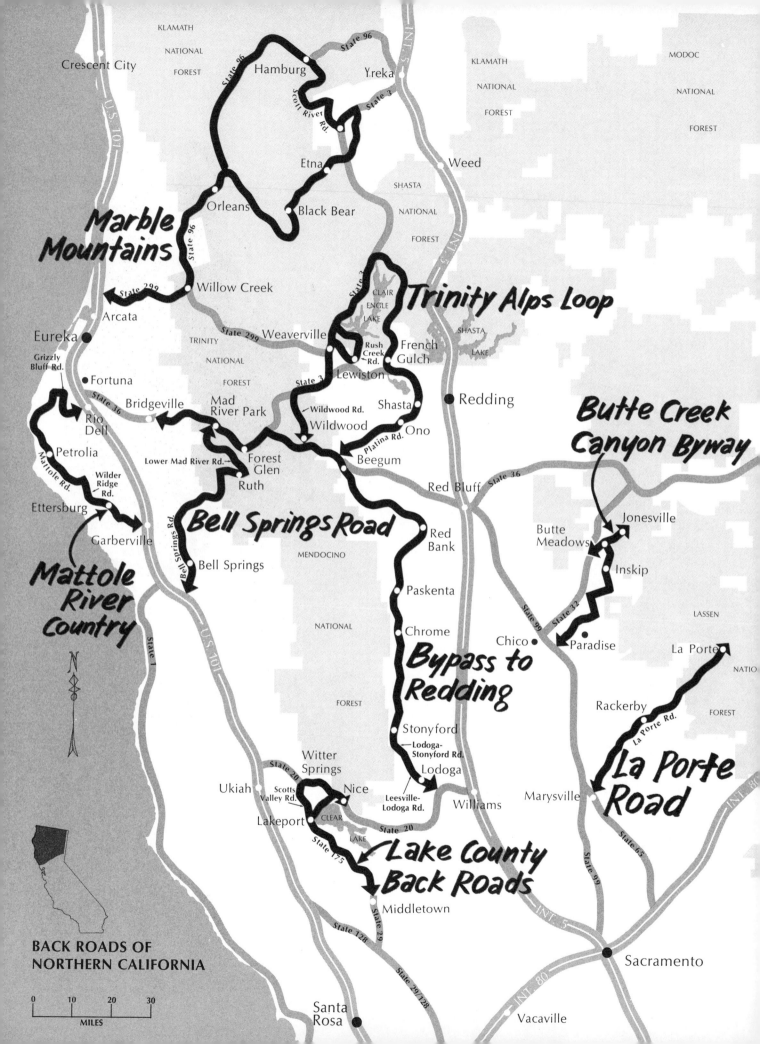

KLAMATH
NATIONAL
FOREST

Crescent City

State 96
Hamburg
Scott River Rd.
Yreka
State 3

KLAMATH
NATIONAL
FOREST

MODOC

NATIONAL

FOREST

U.S. 101

Etna

Weed

SHASTA

**Marble
Mountains**

Orleans

Black Bear

NATIONAL

FOREST

State 96

State 299

Arcata

Willow Creek

State 299

Weaverville

CLAIR
ENGLE
LAKE

Rush
Creek
Rd.

French
Gulch

SHASTA
LAKE

Trinity Alps Loop

SHASTA

Eureka

TRINITY

State 3

Lewiston

NATIONAL

Redding

**Butte Creek
Canyon Byway**

Grizzly
Bluff Rd.

Fortuna

State 36

Bridgeville

Mad
River Park

Wildwood Rd.

Shasta

FOREST

Rio
Dell

Lower Mad River Rd.

Forest
Glen

Wildwood

Ono

Platina Rd.

Petrolia

Mattole Rd.

Wilder
Ridge
Rd.

Ruth

Beegum

Red Bluff State 36

Jonesville

Butte
Meadows

Ettersburg

Bell Springs Road

MENDOCINO

Red
Bank

Inskip

Garberville

Bell Springs Rd.

Red
Bank

**Mattole
River
Country**

N

Bell Springs

NATIONAL

Paskenta

State 99

State 32

LASSEN

**Bypass to
Redding**

Chrome

Chico

Paradise

La Porte

NATIO

State 1

FOREST

Rackerby

FOREST

U.S. 101

Stonyford

Lodoga-
Stonyford Rd.

La Porte Rd.

Witter
Springs

State 20

Nice

Lodoga

**La Porte
Road**

Ukiah

Scotts
Valley Rd.

Leesville-
Lodoga Rd.

Marysville

Lakeport

CLEAR

Williams

State 20

**Lake County
Back Roads**

LAKE

State 175

State 65

State 99

**BACK ROADS OF
NORTHERN CALIFORNIA**

Middletown

State 29

State 128

INT. 80

Sacramento

0 10 20 30
MILES

Santa
Rosa

State 29/128

Vacaville

Trinity Alps—The Humboldt Coast
Coastal Mountain Byways

EXPLORING NORTHERN CALIFORNIA

Across the northernmost portion of California, a varied terrain awaits the back roads explorer. Away from the freeways, this is a lonely land. Fog shrouds beaches tucked between grassy headlands, bluffs rise above booming breakers, redwood groves shelter a multitude of wildlife in parks that protect the tallest trees on earth.

In Northern California, a few easily accessible lakes and gigantic reservoirs lure boaters, water skiers, swimmers, and sightseers. Elsewhere, clear pools and sun-dappled meadows are tucked into mountain vastnesses where trails offer escape from the sights and sounds of civilization.

Three major highways speed traffic in a north-south direction through this part of California, skirting the edges of the quiet country that the back roads reach. Interstate 5, which cuts a swath through the center of the state, crosses Shasta Lake and passes in the shadow of Mount Shasta's snow-capped peak. At the western edge of the state, U.S. 101 follows a winding route through the redwood country and gives access to forest parks and seacoast views. Far to the east, U.S. 395 parallels the California-Nevada border and traverses a completely different landscape of irrigated pastures and open range land, where barns and farmhouses nestle in valleys between sage and juniper-cloaked hillsides.

Connecting these busy freeways, a scattering of state highways reaches east and west: to the resort areas around Clear Lake, to once-lively Gold Rush towns in the Trinity country, through the deep canyon of the North Fork of the Feather River, to Lassen Volcanic National Park. These roads give access to other roads, sometimes gravel or dirt—the back roads that explore lofty peaks, or follow the banks of tiny creeks, or wind through meadows colorful with wildflowers after winter rains.

All of the north-south routes in the upper part of the state are intersected by State 299, which runs east from Arcata, on the coast, to Cedarville and the Nevada border.

Lake County Back Roads

Highway 20 travels the north east shore of Clear Lake through Nice and Upper Lake. Beyond the latter, Witter Springs Road will take you to Bachelor's Valley.

I would rather call it "Valley of the Barns". Because there are so many along the back roads, I have tried to avoid sketching barns, but those in this area are irresistible. On Scotts Valley Road is a barn with so many woodpecker holes the beams look like lace filigree!

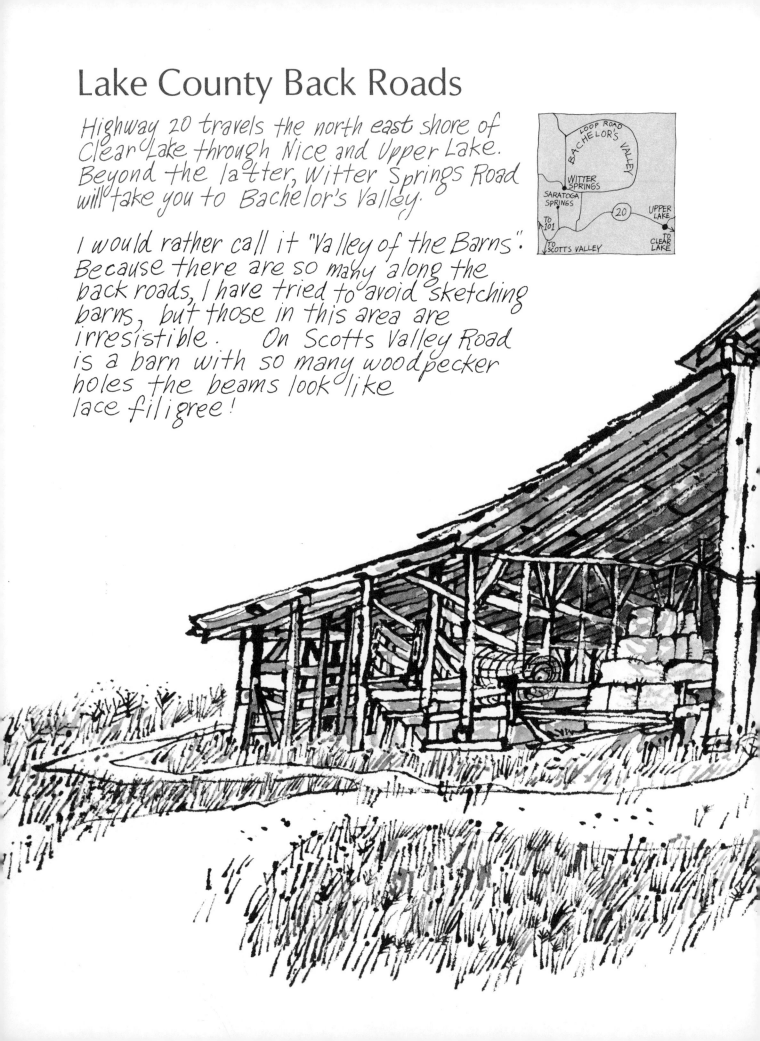

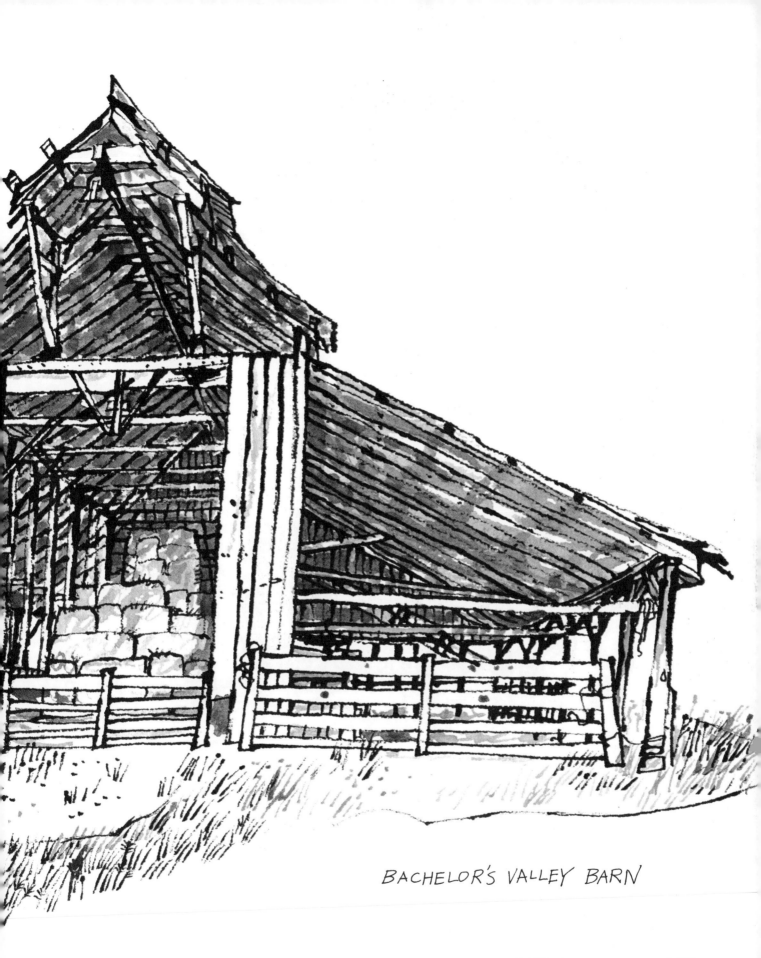

BACHELOR'S VALLEY BARN

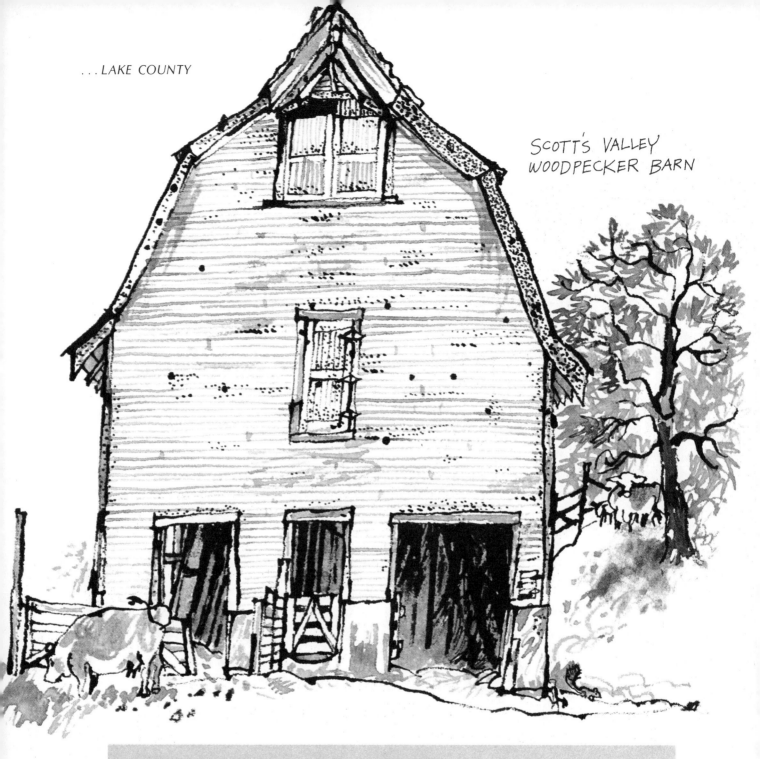

SCOTT'S VALLEY
WOODPECKER BARN

Clear Lake's Bloody Island

Before the white men came to Clear Lake to enjoy the hot springs, the mineral waters, and the abundance of fish, Pomo Indians roamed the countryside around the lake. They wove canoes from the tules that grew along the shore; they lived on fish from the lake, and seeds as well as berries and fruits from the land. Fur trappers arrived in the early 1800's, and they were followed by cattlemen. Cruel treatment of the Indians by two settlers, Andrew Kelsey and Charles Stone, resulted in the deaths of the two men in 1849 and a subsequent bloody massacre of Pomos by the soldiers who retaliated. The Indians were rounded up on a small island at the north end of the lake. More than 100 Pomo men, women, and children were killed, and the island became known as Bloody Island.

East from Marysville along the La Porte Road

From Colusa (west of Marysville) Butte Slough Road and State 20 head east past the curious "Sutter Buttes" to Marysville. Highway 70, above Marysville, then Woodruff, Mathews, and Ramirez Roads will take you to La Porte Road.

This was rolling foothill country, and a distant graveyard on a hill attracted my attention. I walked there to sketch while cattle stopped their grazing to watch.

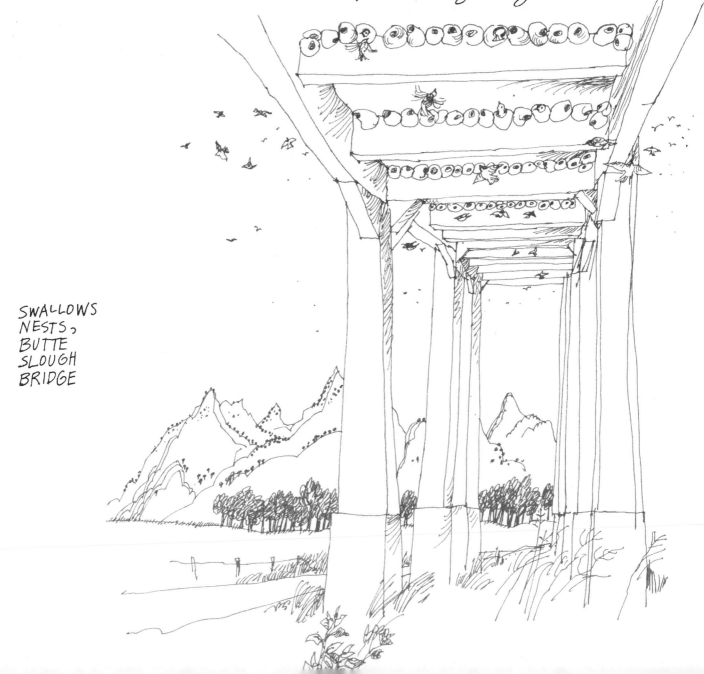

SWALLOWS
NESTS,
BUTTE
SLOUGH
BRIDGE

GRAVEYARD ON THE HILL,
LA PORTE ROAD, THIS
SIDE OF BANGOR

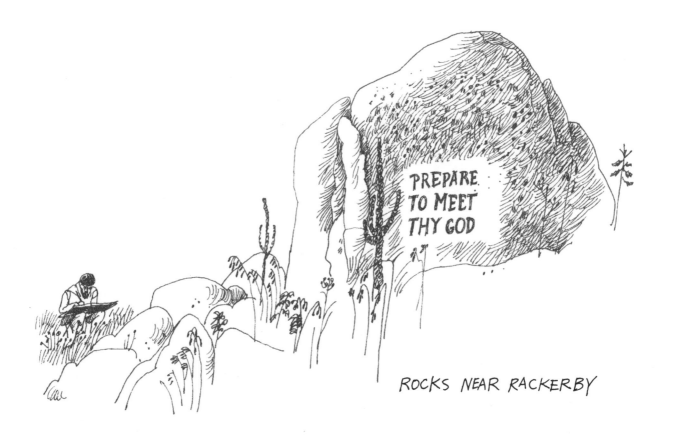

PREPARE
TO MEET
THY GOD

ROCKS NEAR RACKERBY

Past Bangor, and on the way to Rackerby, was a rock with religious slogans printed on it. I was traveling with another artist and you see him "immortalized" in the drawing below. He's sketching the message on the other side of the rock.
Towns along La Porte Road were stage coach stops in the early days of mining. Paul Rackerby is dead but remnants of his town remain.

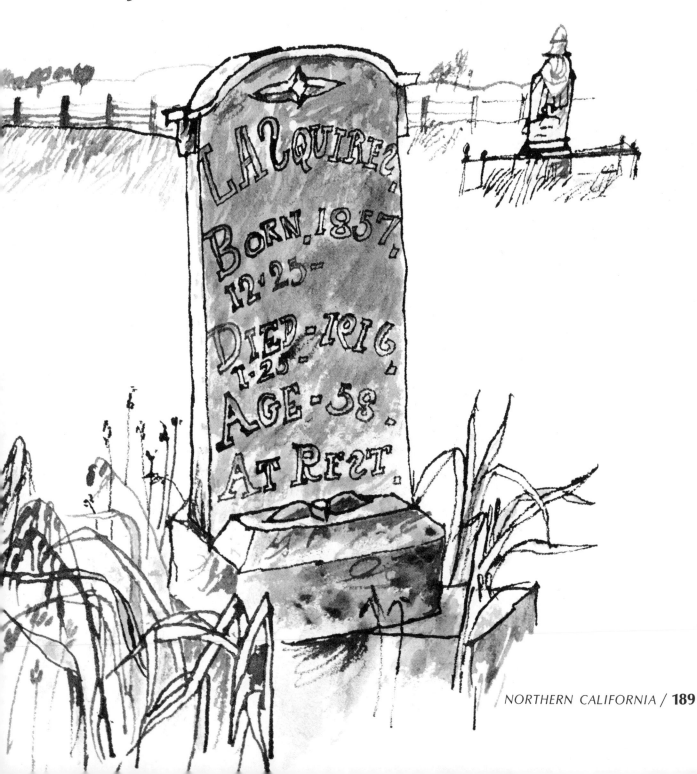

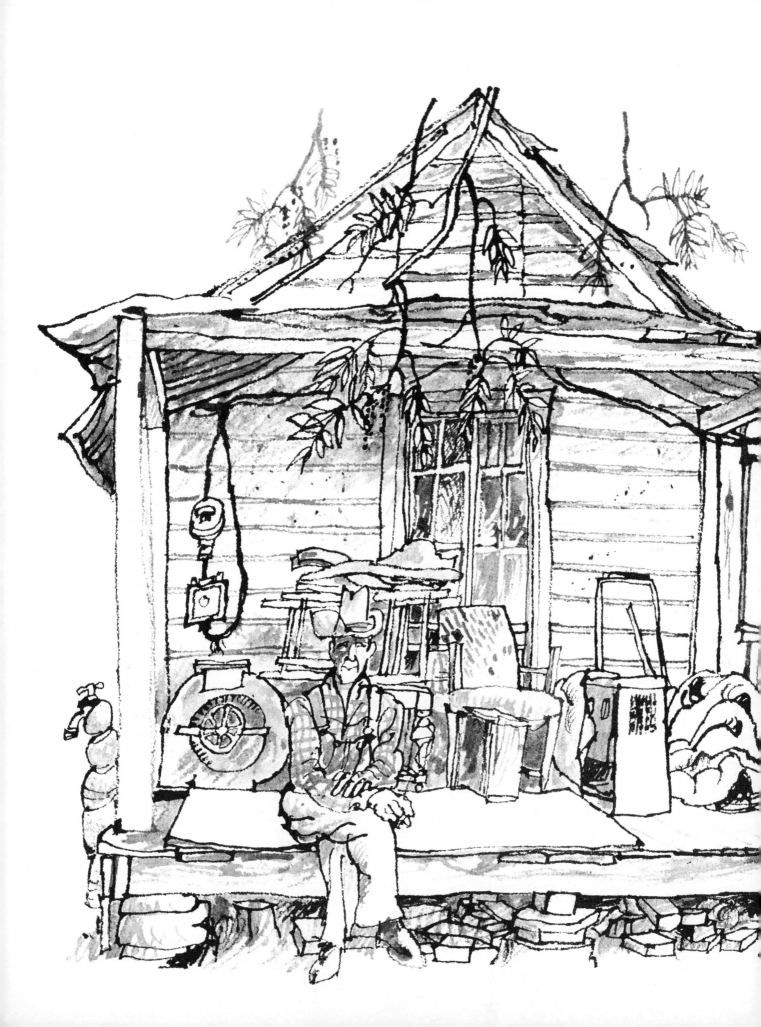

In Rackerby I sketched Clarence Day sitting on the porch of his 100-year-old home, "built with sluice-box and flume lumber," he said. Clarence smoked cigarettes and told me stories about his life, while I sat in the shade of his black walnut tree and worked. He told me details of the 1927 blizzard in Oklahoma and about the time he drove an axe into his foot. Being "stove up" at his lumbering trade, he had to supplement his social security income by salvaging junk. He uses old bedsteads for fences and gates around the house. I was completing my drawing when Day's 14-year-old horse came along for morning "carrot time."

At Strawberry Valley is a store built in 1853. The owner had collected 52,032 beer can tabs and strung them together decoratively as a solution to the litter disposition problem in front of his grocery store.

La Porte was called "Rabbit Creek" in 1850 at the time of the discovery of gold; however, in 1857 the more distinguished name of "La Porte" was given to the town.

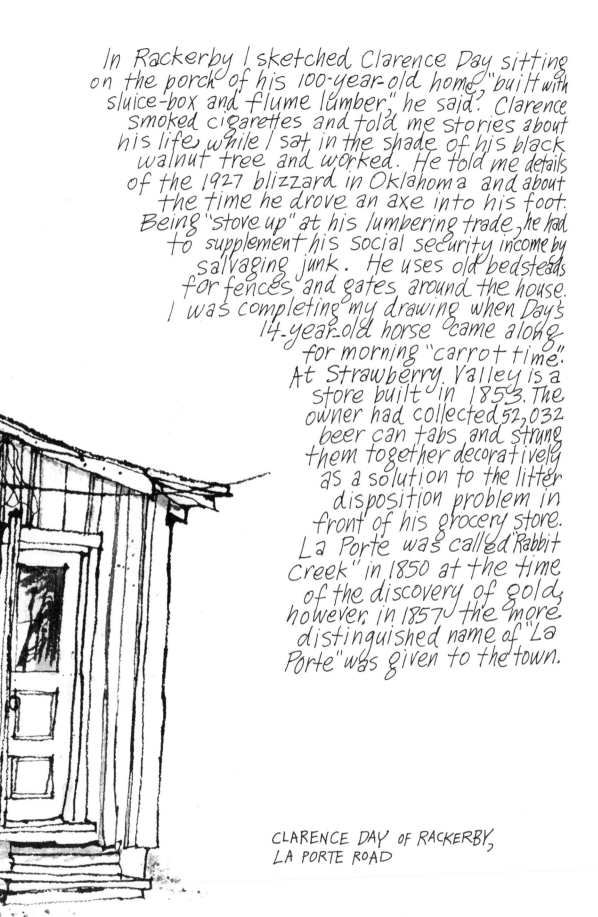

CLARENCE DAY OF RACKERBY, LA PORTE ROAD

Butte Creek Canyon
Byway out of Chico

Butte Creek Canyon and
Humbug Road branch off
of Skyway a few miles
east of Chico and
Highway 99.

HONEY RUN COVERED BRIDGE

Humbug Road goes by a shady
cemetery near Centerville, a
tiny community, and climbs up
and up to Skyway Road and
3000-foot-high Stirling City.
I sketched Red Keller's woodpile
on the main street. Along
came Red as the drawing
was being completed.
He barked in a gruff
voice, after taking a
look, "If I could get
that drawing I'd send
it to my maw and she'd
jump in the air and kick
her heels four times
before she came down....
and she's 84!"
Out of Stirling City
you climb past tall
timber country to
Inskip. The Inn
there is a former
Stage Coach hotel,
the only one left
of the 5 that once
were in business.

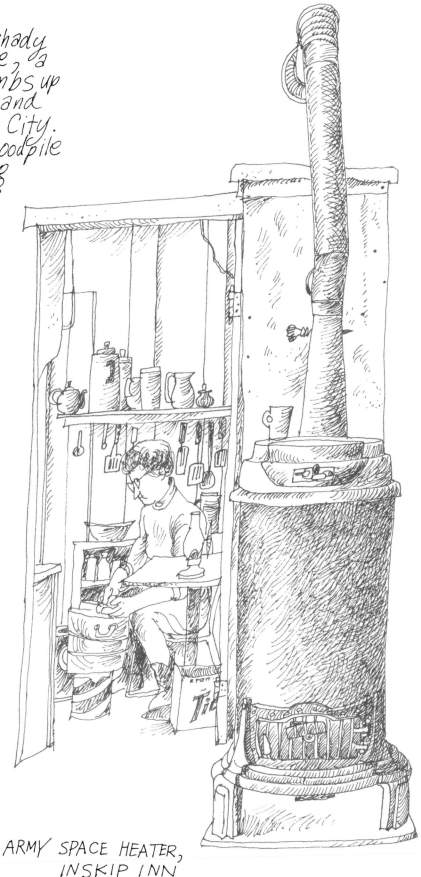

ARMY SPACE HEATER,
INSKIP INN

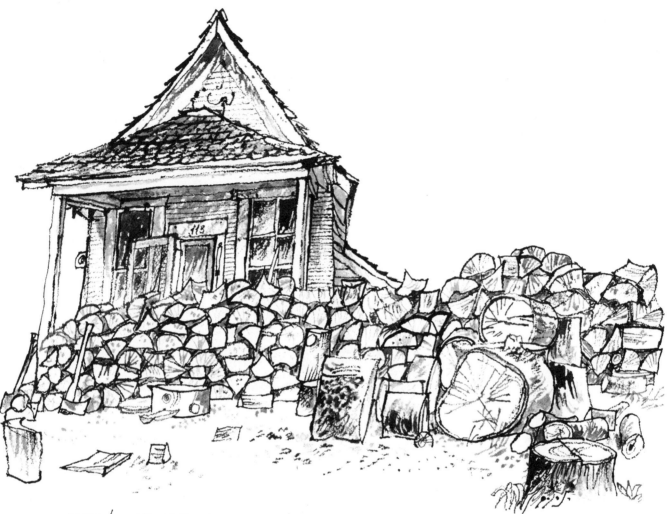

RED'S WOODPILE,
STIRLING CITY

Bull Hill Road goes to Butte Meadows
and Humboldt Road to Jonesville, where
an old hotel and stage coach barn still
stand. You can reach Lake Almanor
from here, if the snow has melted
(I couldn't make it in April), or return
to Butte Meadows and Lomo on
Highway 32 to Chico.

Interstate 5 Bypass to Redding

From Williams on Interstate 5, Highway 20 will
lead you to King and Leesville Roads for the
back road trip north to Stonyford, Elk Creek,
Newville, and Paskenta.

A long-time-dead coyote was strung on a post.
Rugged looking Hereford bulls watched as I
sketched it. In the distance turkey
buzzards sat silently on the branch of a dead tree.
Crickets and birds sang. Poor, rotting coyote!

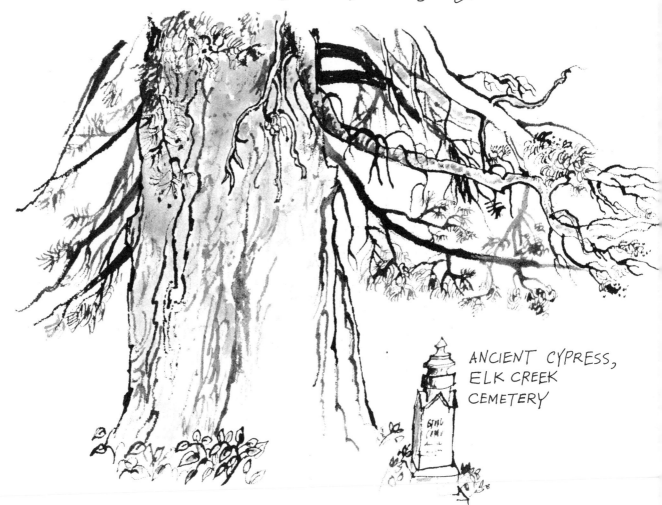

ANCIENT CYPRESS,
ELK CREEK
CEMETERY

Roads to the Past and the Present in the North Country

The gold rush that took place in California's northern Coast Ranges was never as well chronicled as mining in the Mother Lode, yet many millions of dollars in mineral wealth were extracted in the 1850's. Until the California and Oregon Railroad reached Redding in 1872, Shasta was the important city of the north country. Today, Shasta's main street is a historic monument where the façades of old brick buildings speak of the prosperous past. West from Shasta, State 299 parallels the old Trinity Trail, famous in turn as an Indian path, a pioneer trail, and a gold rush wagon road. State 3 to the north was once part of the old California-Oregon Wagon Road, the main route north from Shasta to Callahan and Yreka. Trails laid down originally by miners, prospectors, and cattlemen crisscross the roadless wilderness of the Marble, Salmon, Trinity, and Yolla Bolly mountains. State 96, which skirts the west side of the Salmon Mountains, follows the twisting Klamath River, where many communities that began life as mining camps now cater to droves of enthusiastic fishermen, who come here for some of the best steelhead fishing in the state.

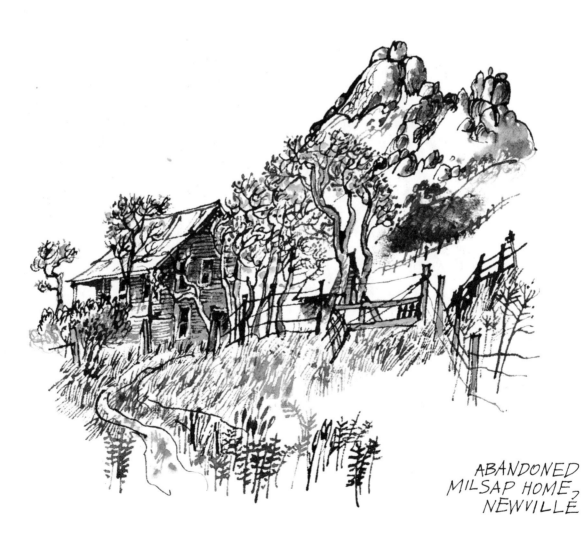

ABANDONED MILSAP HOME, NEWVILLE

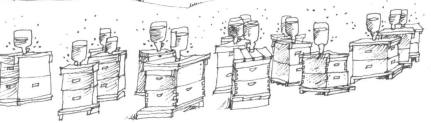

HONEY BEE FEEDERS,
GARLAND ROAD TO PASKENTA

A series of roads brings you to
Highway 36 northwest of
Red Bluff. Leaving Paskenta,
take Corrigan and Lowery Roads.
Be sure to turn north on Hesse,
west on Johnson, and north
again on Masten. Drive slowly
for it is open-range cattle country.
Turn east on Reeds Creek Road
to Vestal Road and through open
gates, past old barns, hills,
mountains, wildflowers, fording
streams from time to time.
You'll make it!
There are several ways to reach
Redding from here. It is
your choice.

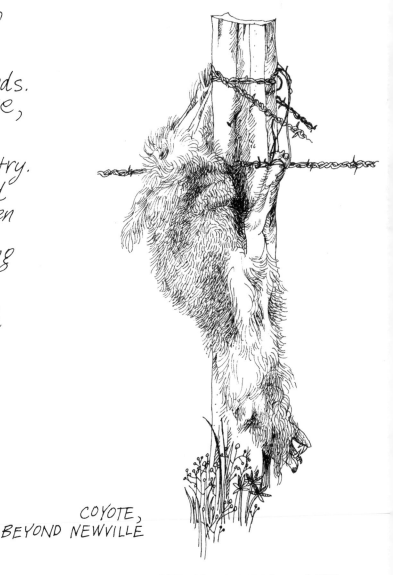

COYOTE,
BEYOND NEWVILLE

The Bell Springs Road into Trinity National Forest

Bell Springs is a gravel road beginning 12 miles north of Laytonville off Highway 101.

There were deer and ground squirrels and views of mountain ranges on both sides of this ridge road. The unusual "Island Mountain" is viewed many times and from differing aspects as you proceed along this backroad. At Harris you have an opportunity to return to Highway 101 at Garberville, or continue, as I did, northeast to Alderpoint and Zenia.

ISLAND MOUNTAIN,
BELL SPRINGS ROAD

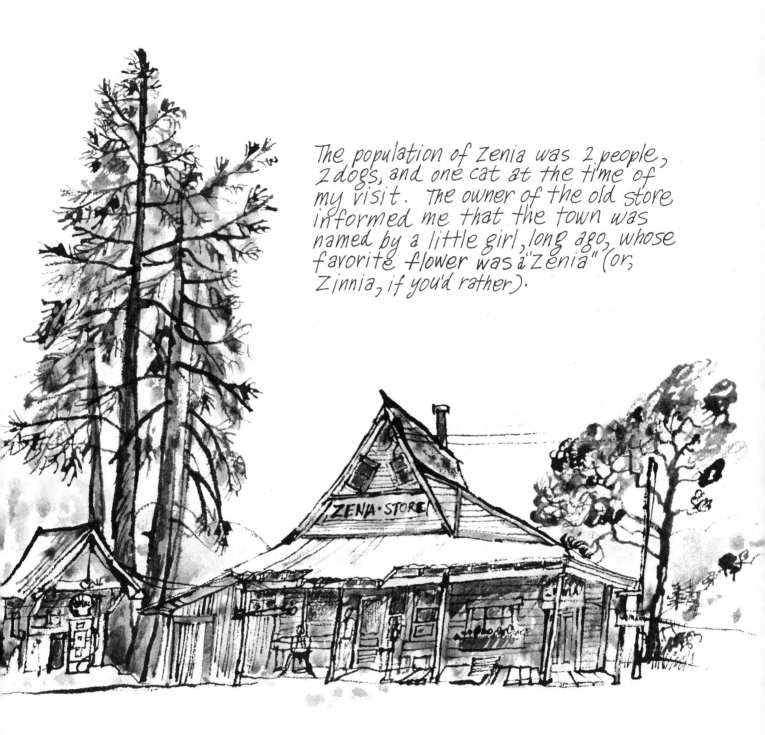

The population of Zenia was 2 people,
2 dogs, and one cat at the time of
my visit. The owner of the old store
informed me that the town was
named by a little girl, long ago, whose
favorite flower was a "Zenia" (or,
Zinnia, if you'd rather).

ZENIA STORE, CIRCA 1910

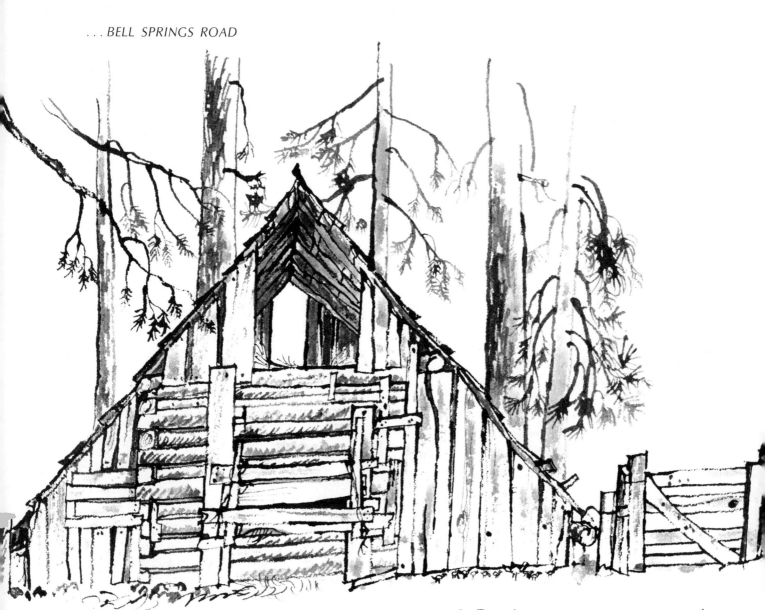

LOG BARN, HETTENSHAW VALLEY

Zenia Road continues through Six Rivers
National Forest. Hettenshaw Valley got
its name from a native plant that Indians
gathered in earlier times for food. They
called it "KETTEN-CHOW", I was told by an
Indian resident at Duncan Ranch.
Zenia Road eventually reaches Ruth
Reservoir and Lower Mad River Road
to Highway 36 and on to Trinity
National Forest.

Mattole River Country

Go west from Garberville and Highway 101 on the old Briceland Road, then 4½ miles farther, to turn north on Ettersburg-Honeydew Road. This is Mattole River Country.

The land is mountainous and covered with forests of young fir, red-berried madrone, and thick stands of tan-bark oak.

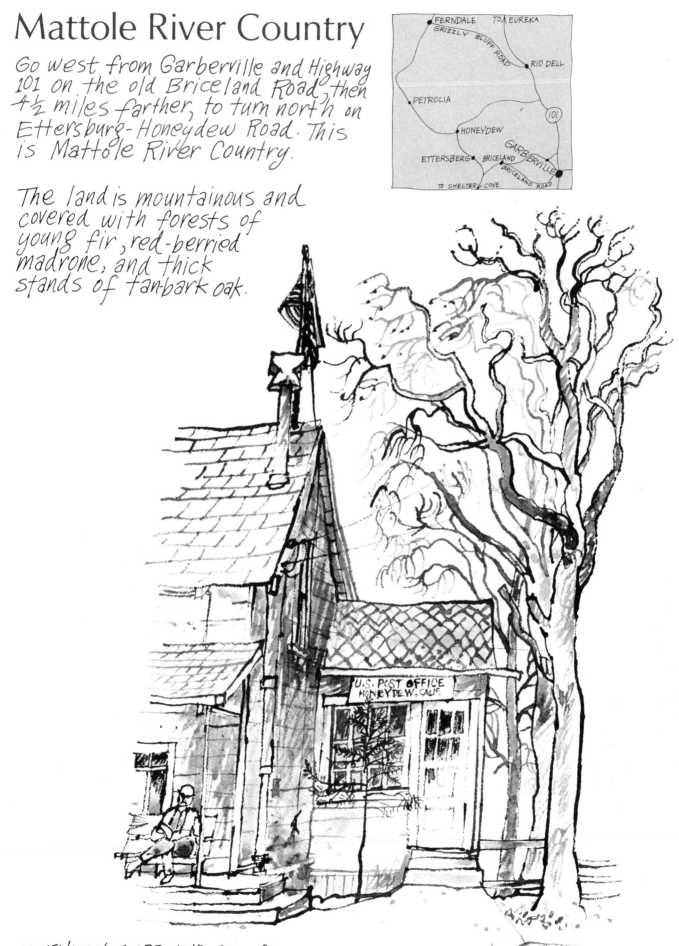

HONEYDEW STORE AND POST OFFICE

The town of Ettersburg has disappeared, but Honeydew Store is still open, and so is the post office. According to the postmaster, in the old days there was a grove of cottonwood trees down by the river. Early settlers found dew each morning on tarpaulins spread beneath the cottonwoods. The dew tasted sweet to them, so the place was named "Honeydew." You drive past Petrolia to the ocean, then inland over the hills to the town of Ferndale. Grizzly Bluff Road from Ferndale takes you past the many-gabled Grizzly Bluff School and on to Highway 101.

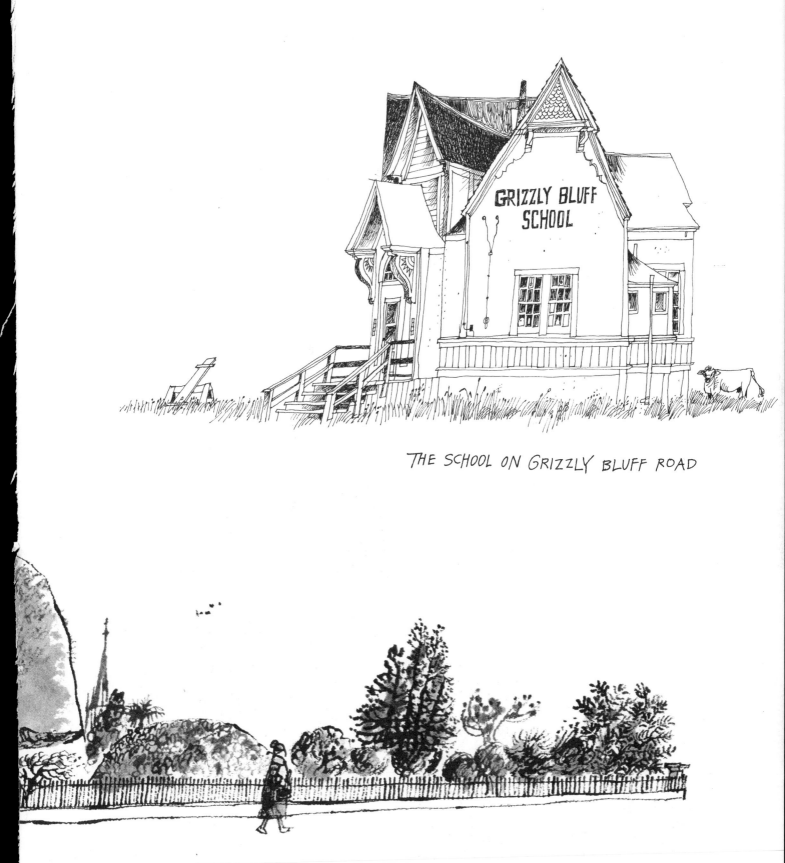

THE SCHOOL ON GRIZZLY BLUFF ROAD

GUMDROP TREES, ARNOLD BERDING HOUSE, FERNDALE, 1875

Trinity Alps Loop

French Gulch is 3 miles north of Highway 299 on Trinity Mountain Road, some 15 miles west of Redding. This begins the loop.

Trinity Mountain Road winds up into Shasta National Forest, and at the top you can see all of the Trinity Alps in blue and purple splendor. Farther on, Mt. Shasta and row upon row of mountain ridges come into view.

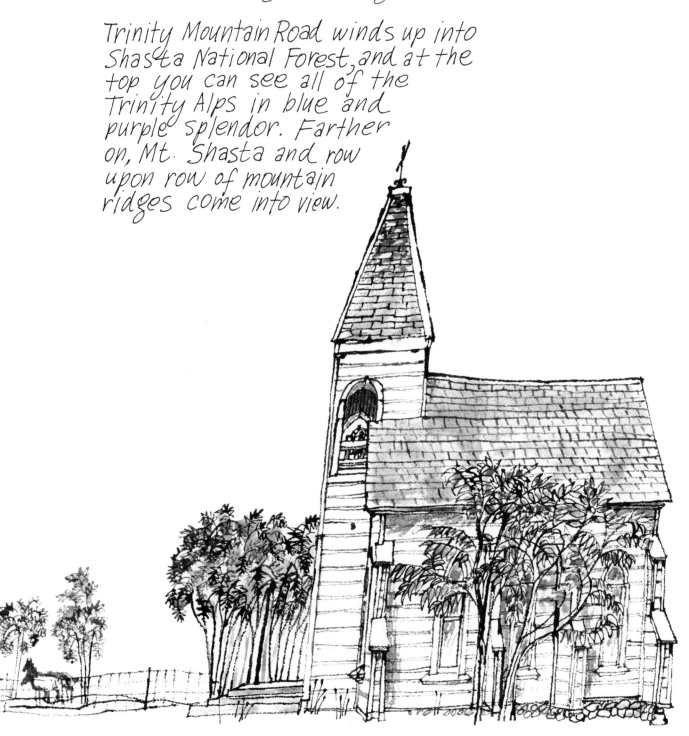

CHURCH AT FRENCH GULCH,
TRINITY MOUNTAIN ROAD

Joss House, 1874, Weaverville.

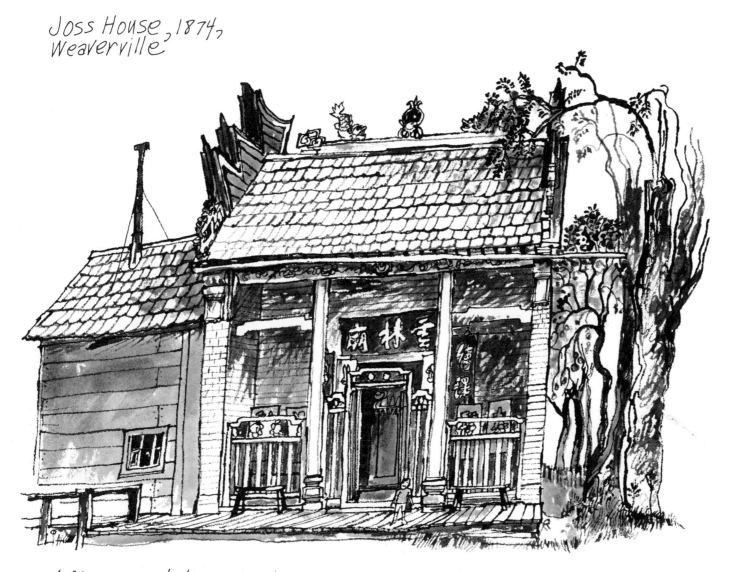

After completing the loop around Lake Engle you can return to 299 at Weaverville to see the 1874 Chinese Joss House. I sketched the edifice from the shade of a locust tree, deep lawn under my feet, my shoes off.

Klamath National Forest and the Marble Mountains Loop

Highway 299 above Arcata on Highway 101 goes east 6 miles to Blue Lake and Korbel. From here north is a trip through dense forests and mountains.

At Willow Creek Highway 96 goes to Somes Bar, Happy Camp, and Hamburg. From here you can go south to Etna, Sawyer's Bar, Forks of the Salmon, eventually returning to Arcata and Eureka.

LOG PILE AT KORBEL

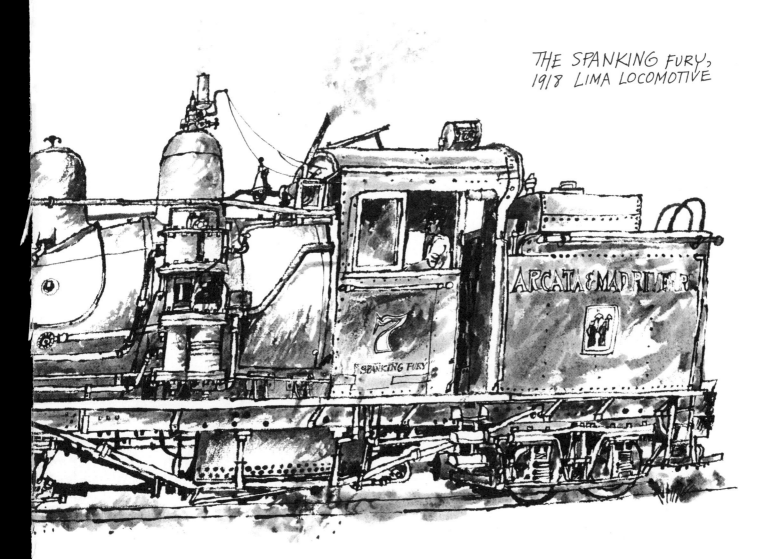

THE SPANKING FURY,
1918 LIMA LOCOMOTIVE

A Rail Trip on the "Annie & Mary"

The oldest railroad west of the Rockies started as the Union Wharf and Plank Walk Company in 1854, hauling freight from deep-water vessels to the town of Union, now Arcata. The first equipment was a four-wheel cart operated on wooden rails and drawn by an old white horse named "Spanking Fury," the name given to the Shay Engine, No. 7, that powers the train today. The line was later extended, with narrow-gauge steel rails. It acquired a steam locomotive in 1875, and in 1881 its name was changed to the Arcata and Mad River Railroad. The nickname "Annie & Mary Railroad" came around the turn of the century, honoring two lady employees. The "Annie & Mary" is still a working railroad today. Its train leaves Blue Lake at 1:30 P.M. daily Monday through Saturday, hauling forest products from Blue Lake to North Arcata and offering a one-hour round-trip excursion to paying passengers.

EPILOGUE

On the backroads of California I re-discovered
the pleasure of driving. It had nothing to do
with haste, and everything to do with taking
time to perceive, with full consciousness, the
earth's ever-changing colors, designs, and
patterns. The most satisfying roads and
byways followed the contour of the land,
and that is why I deplore the gouging and
cleaving of the earth's surface, the
straightening of roads for the sake of
speed. My hope is that the best of the
backroads will be maintained, but not
"improved." We must pick up a share of
the litter left by despoilers, support efforts
toward vehicles that do not pollute the
air, and back measures that will return
quality, beauty, and naturalness to
the land. I believe we must look to the
needs of our planet earth over and above
the immediate needs of mankind.

A bamboo pen, fashioned by myself, was
used for most of the "Backroads" drawings.
Black, waterproof ink was my medium, along
with a bottle of diluted ink for grey tones.
A Rapidograph pen was used for the
line drawings and lettering, and 70 lb. watercolor
paper was the sketching material.
Good traveling!

EARL THOLLANDER

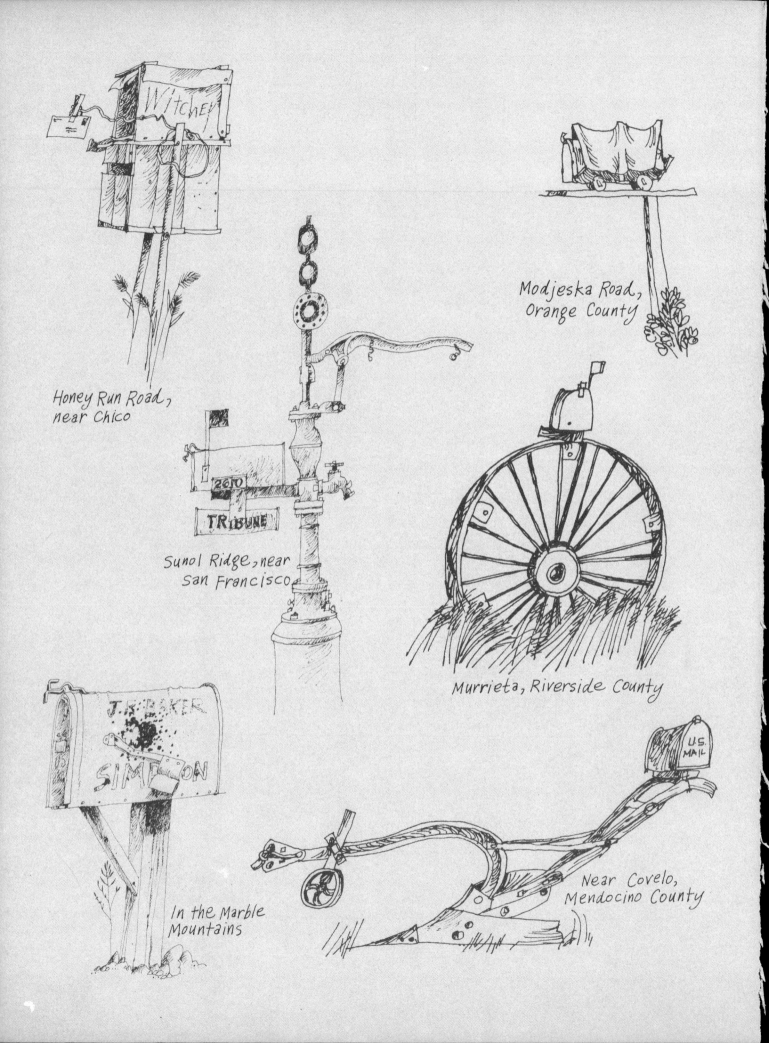

Honey Run Road,
near Chico

Modjeska Road,
Orange County

Sunol Ridge, near
San Francisco

Murrieta, Riverside County

In the Marble
Mountains

Near Covelo,
Mendocino County